Bermuda
Gardens & Houses

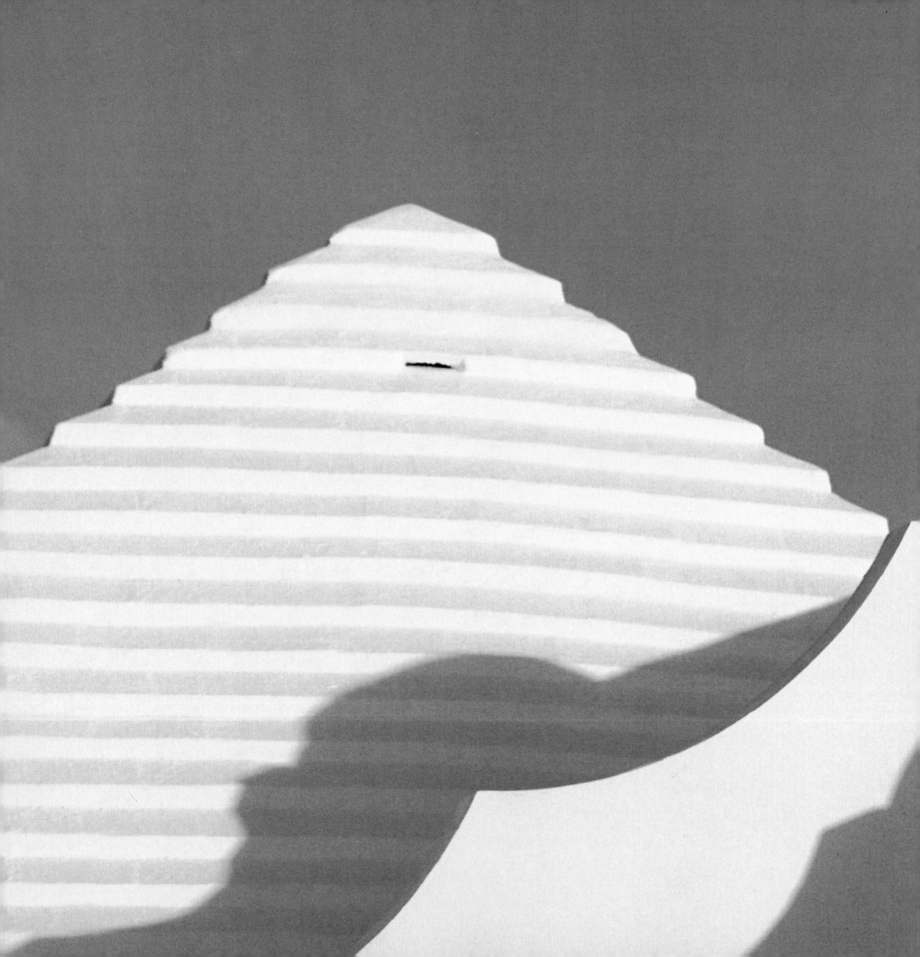

Bermuda
Gardens & Houses

Photographs by Ian Macdonald-Smith

Text by Sylvia Shorto

RIZZOLI
NEW YORK

ACKNOWLEDGMENTS

The authors would like to thank the many people who allowed us access
to their houses. We thank them for their time and patience, their encourage-
ment, and the many sustaining cups of tea. We would like to express our
appreciation to those who helped with the selection of archival photographs,
Karla Hayward of the Bermuda Archives, Tom Butterfield of the Master-
works Foundation, and Rosemary Jones of the *Bermudian Magazine*. We
also thank David Morton, Megan McFarland, Elizabeth White, and
Belinda Hellinger at Rizzoli for their advice, good judgment, and support.

ILLUSTRATION CREDITS

All photographs by Ian Macdonald-Smith except those on pages noted below:
Bermuda Archives (photographs by Wendell P. Colton): 7, 9
Reproduced by permission of the Masterworks Foundation;
 a gift of the Gosling Family (photographs by David Knudsen): 31, 39
Bermudian Magazine (photographs by Walter Rutherford): 13, 20, 24
Private collection (photograph by Walter Rutherford): 23

First published in the United States of America in 1996 by
Rizzoli International Publications, Inc.
300 Park Avenue South, New York NY 10010

Copyright © 1996 by Rizzoli International Publications, Inc.

LIBRARY OF CONGRESS CATALOGING-IN-PUBLICATION DATA
Macdonald-Smith, Ian.
 Bermuda : gardens and houses / photographs by Ian Macdonald-Smith
; text by Sylvia Shorto.
 p. cm.
ISBN 0-8478-1930-2 (hc)
 1. Bermuda Islands—Pictorial works. 2. Bermuda Islands—
description and travel. 3. Gardens—Bermuda Islands—Pictorial
works. 4. Dwellings—Bermuda Islands—Pictorial works. I. Shorto,
Sylvia. II. Title.
F1631.M315 1996 95-48923
972.99' 0022' 2—dc20 CIP

FACING PAGE: Aerial view of the former Royal Naval Dockyard on Bermuda's West End

Designed by Marcus Ratliff, Inc., New York

Printed and bound in Italy

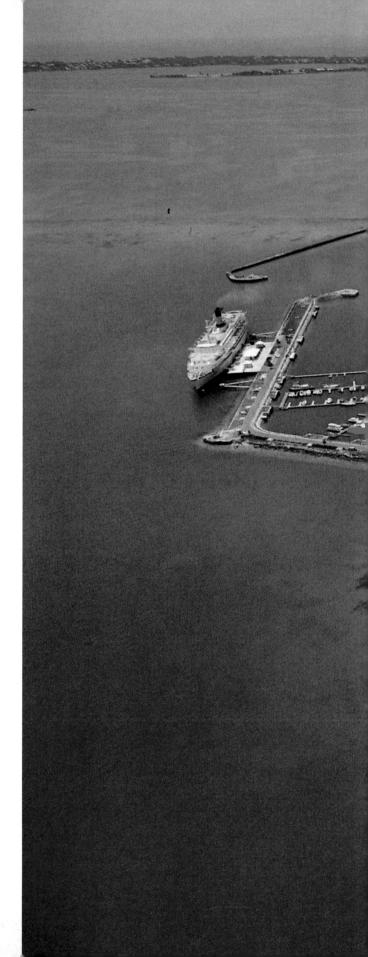

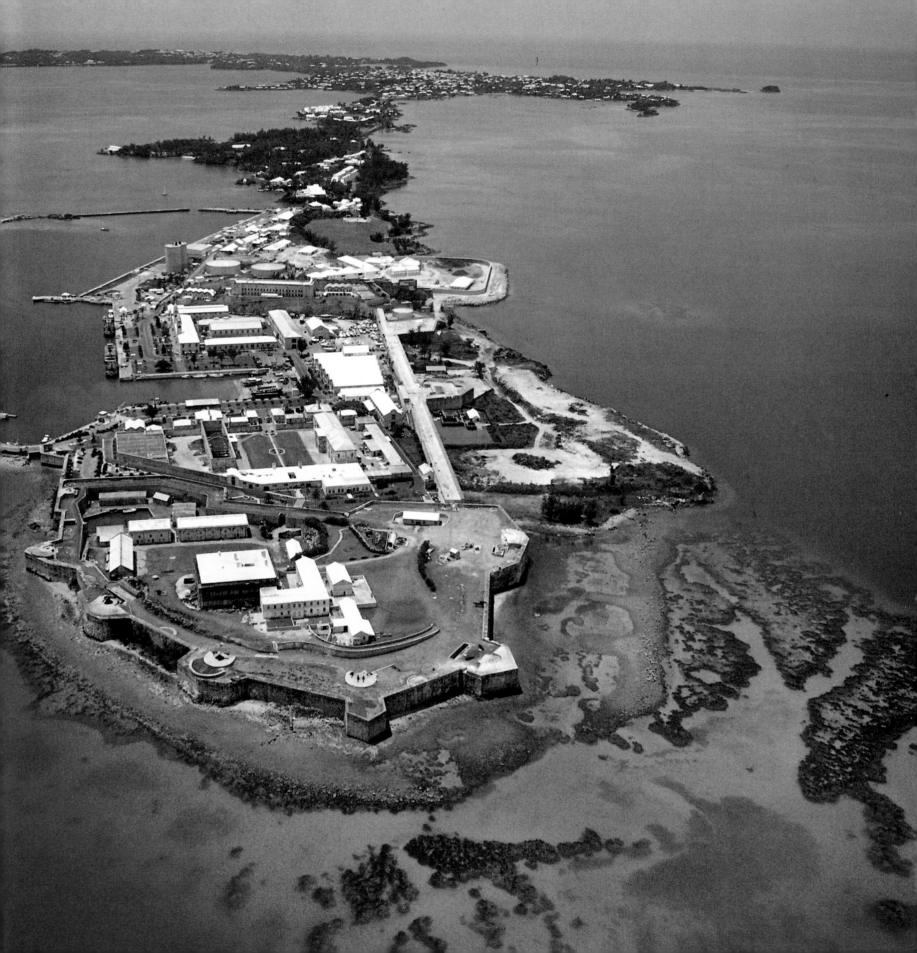

Introduction

by Sylvia Shorto

EVERY SUNDAY AFTERNOON for years my father and a group of his friends met to go walking. They wanted to be out in the Bermuda countryside, with its soft air and wide blue skies, the perfect antidote to a working week in the office. Dressed in shorts and floppy cricket hats, sporting walking sticks and knobbly knees, they strode off paved roads and onto dusty white farm tracks and little-known woodland paths. Their walks almost always included a part of the route once taken by the old Bermuda Railway.

Cars and motorbikes now think they own the road, but in quieter days, Bermuda did not allow cars at all, except for a few official vehicles. You traveled by bike, on foot, or in a horse and buggy. For a short while there was a motor bus, the Scarlet Runner, but it frightened the horses. Then they built the railway.

The Bermuda Railway was like a bridge in time, spanning the island's past and the modern age. It was an eccentric two-carriage shuttle, a strange conveyance that looked like an enormous truck. It ran the length of the island, from the old capital, St. George's, in the East End, through the newer city of Hamilton in the middle of the island, and on to Somerset in the west. Its tracks have long since been torn up, its rolling stock sold; but in the Roaring Twenties, when tourism in Bermuda really was roaring because of Prohibition in the United States (which was unthinkable in Bermuda), better public transport had to be planned to get people safely about. The railway opened in 1931, after almost ten years of legislating, negotiating, and tunneling. It was a very good idea, comfortable and convenient. People used the railway. It stopped at places where you would want to get off, like the aquarium or the hospital or the Front Street shops in Hamilton. First-class passengers rode in splendid wicker chairs, like the ones at home on their porches, while second-class passengers perched on wooden benches. Tradesmen obligingly sent packages out from town to a customer's nearest stop in the country. Many people took their bicycles with them in the

The Bermuda Railway running along East Broadway to the city of Hamilton in the 1930s.

6

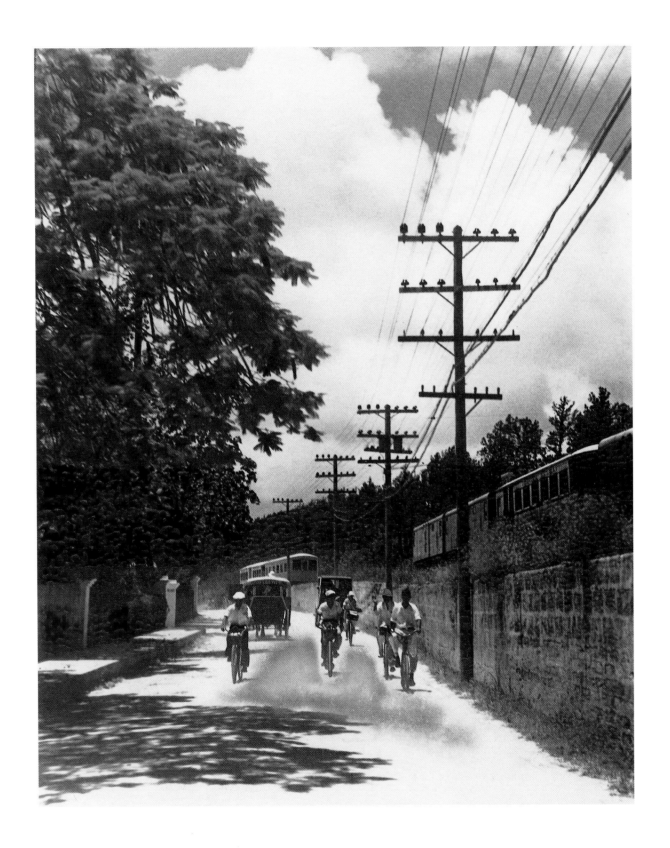

guard's van. But the train ran only for about fifteen years. By 1946 the Railway was bankrupt. Then, in the optimism of the postwar period, Bermuda's legislators finally let the motorcar in.

Today, the railway track has been turned into an elongated public park, the Railway Trail. It is used by runners, cyclists, and nervous rollerbladers, by people letting the steam out of their children and their dogs, by friends who haven't seen one another for months and want to talk in the sun. If you get tired, you can lie in the rough grass beside the pathway and look into the dense blue eyes of a Bermudiana, or listen to the catbirds fussing in the undergrowth. Travel the length of the Trail and you pass through the heart of Bermuda. It's easy to imagine an idyllic past still there, in the clusters of white-roofed cottages, the azure sea dotted with sailboats, the sturdy, olive-tinted cedar trees, the watchful lizards. You can read the island's history quietly spread out on either side of you as you walk through present-day Bermuda.

~

Bermuda is not a single island, although it is usually referred to in the singular, but a cluster of more than three hundred, one for every day of the year, they say. Some are quite large, some little more than rocks. Some you could almost carry away in your pocket! A while back, a government committee thoughtfully made sure that all had official names, but they had always had popular ones anyway—Duck Island, One Tree Island, Spectacle Island, Gibbets Island, Sin Island—all charged with meaning. Together, Bermuda's islands form an upended fish hook. They occupy less than twenty-one square miles, about the same area as Manhattan or Hong Kong. The comparison ends there, though, for Bermuda is startlingly pretty, and it sits in sparkling blue waters to the east of the Atlantic gulf stream, six hundred miles off the U.S. coast of the Carolinas. Bermuda is not in the Caribbean. It is all by itself. It is unique.

From the earliest days of seafaring, Bermuda and its surrounding reefs have been a well-known shipping hazard—The Isles of Devils, said the sixteenth-century Spaniards, warily. At that time, the islands stood as a marine signpost to the flotas returning to Europe in the westerly winds, laden with the riches of Empire. On several occasions sailors were blown ashore in the unpredictable storms of the area; few lived to tell the tale. But despite its strategic location, within easy distance of Hispaniola, Cuba, and Florida, Bermuda had never been claimed. At various times Spain half-

First-class passengers enjoyed the comforts of the Bermuda Railway's wicker chairs.

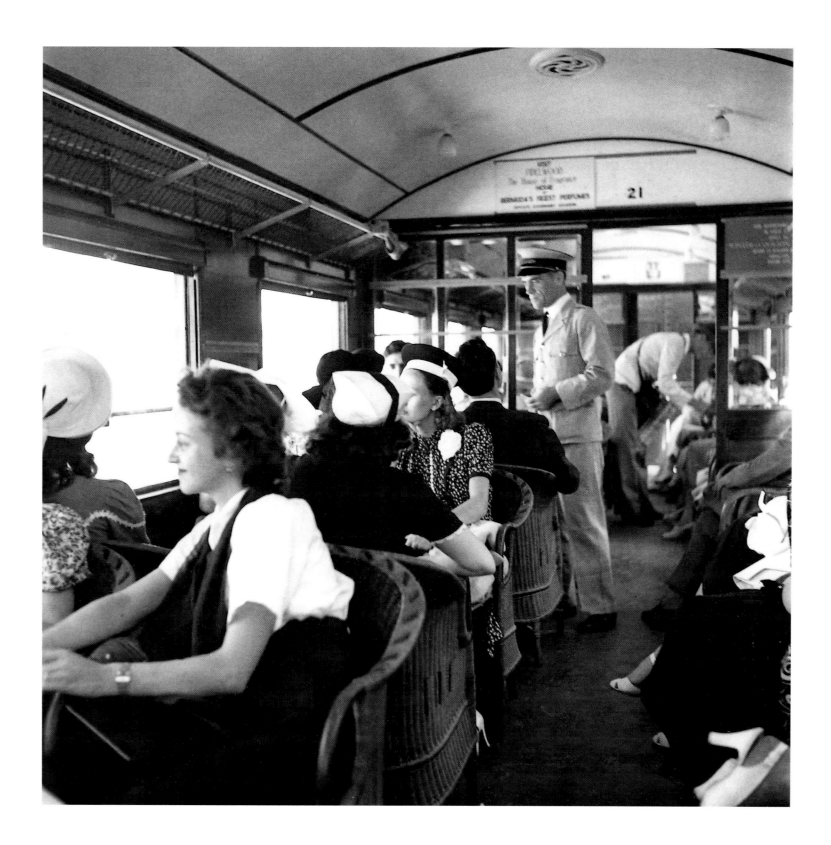

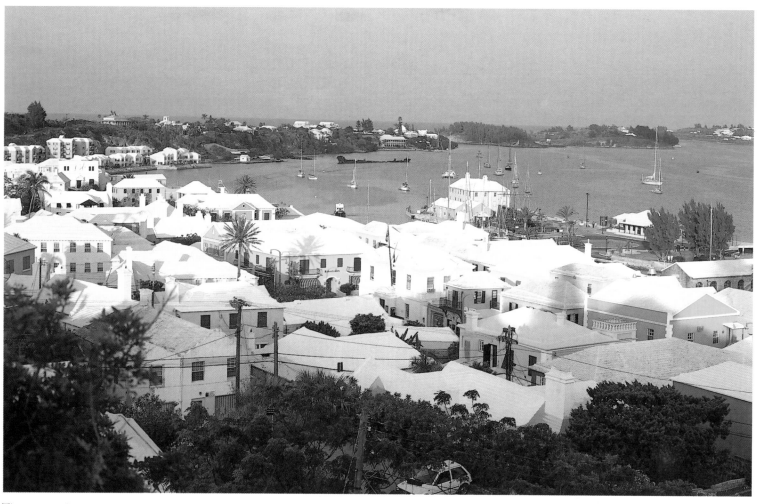

The present-day town of
St. George's.

heartedly planned settlement, but land without an indigenous population or any promise of gold offered little motivation. It was only after the *Sea Venture*, the straggling flagship of Admiral Sir George Somers's fleet, was driven onto the reefs off St. George's Island in 1609 that England realized the possible advantages of a presence in Bermuda. The first Bermudians had been bound for the fledgling Jamestown colony in Virginia when they found themselves stranded, their ship damaged beyond repair. Provisions, rigging, and fittings were salvaged from the wreck, and two new pinnaces of cedar were built from the island's dense evergreen forests over the next nine months by the stranded settlers. Leaving three men behind to guard a claim for England, Admiral Somers sailed his people bravely on to deliver the starving Jamestown colony.

Contemporary descriptions of the island by shipwrecked mariners read like a prospectus for a Bermudian bank today. The principals of the Virginia Company, sitting safely by their hearths in London, were told of a place as close to paradise as any on earth: peaceful, when the wind was not blowing, with a mild climate and few of the dangers that the poor Americans were suffering. Earlier sailors had set hogs ashore to breed. Fish were abundant, and Bermuda's sea birds were so docile you could catch them with your hands. These would provide ample food for the new breed of Adam should he decide to move to this Eden. Fertile Bermuda was seen—and sold to the investors— as a potential larder of exotic produce, a place in which to experiment with crops and perhaps obviate having to deal with that tiresome Mediterranean rival, Spain, for the supply of grapes, olives, and Seville oranges. Tantalizing descriptions, together with the lucky, if unusual, find of a large, rare, and valuable piece of ambergris on the shore, encouraged the Virginia Company. In May 1612 they launched the *Plough* with sixty men and women on board under Governor Richard Moore, a carpenter, to begin formal settlement. Bermuda became England's second New World colony. Within three years, a Bermuda Company had been formed, and Moore's small community had swelled to over six hundred people, more than Virginia had at the time. The investment promised to be a great success, and an early minister, Lewis Hughes, interpreted this as evidence of God's goodness, for He had surely kept Bermuda in reserve "ever since the beginning of the world for the English Nation" to live in.

The town of St. George's, later the railway's terminus, was the site of Governor Moore's first settlement. It was the principal port and, until 1815, was the capital of Bermuda. Founded on a safe harbor, its narrow streets were laid out in medieval fashion following the natural contours of the land. Today it is a quietly beautiful little town, resonant with history. It has a central square for parades and public meetings, a graceful church for baptisms and funerals, some interesting museums, and a fanciful replica of the first parliament building. Twice a year it is invaded by garrulous yachtsmen, sailing north in the spring when the hurricanes begin to spawn down south, or south when the hurricane season ends, or across the Atlantic via the Azores. They seem to come to roost here, torn between sitting at their moorings telling tales and sailing on. Twice a week, St. George's is invaded by two enormous cruise ships that the local people and the yachtsmen do their best to avoid.

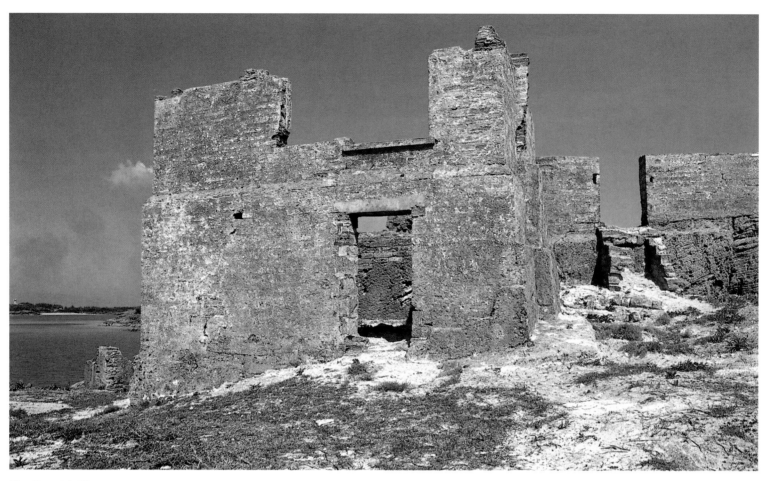

The Captain's House,
Castle Island.

Bermuda's first houses were built on St. George's Island. None stands today, however. On nearby Castle Island there is an isolated stone house, built in 1620 for Thomas Stokes, Lieutenant of the Castle, as part of the fortifications of Castle Harbor. The earliest house in the town of St. George's dates from the late seventeenth century.

The first houses embodied the expectations of settlers who struggled to adapt to unfamiliar building materials. It was a process of trial and error. At first, houses blew over, and the carpentry remembered from journeyman days in London had to be modified for the windy climate. The settlers soon discovered the virtues of indigenous cedar, "verie fine to work upon"; and the leafy palmetto, which William Strachey praised in his narrative: ". . . so broad are the leaves as an Italian Vmbrello, a man may well defend his whole body vnder one of them from the greatest storme rain that falls."

Makeshift huts were replaced with cedar-framed and plastered houses with palmetto-thatched roofs. But it was not until the century came to a close and people began to feel really established, to feel as if Bermuda were home, that stone houses were built in any number. It was then, in 1684, that the Bermuda Company turned over control of the island to the Crown, and Bermuda became a self-governing colony. It keeps the same status today.

If shelter had been a priority, producing a cash crop was equally important. "First of all they shall build themselves howses," instructed a shareholder in London, "and then proceed to ther cleringe of ther ground, and then to plant and sett such thinges as bee most vendable." This was, after all, a commercial adventure. Bermuda is an abundant place, with rich soil, "the richest ground to bear forth fruit that is in

Bermuda's endemic cedar tree.

the world, and verie easie and light for the digginge." Although there were no native models to copy in agriculture, the land was so fertile that newly introduced crops were soon established and thriving—potatoes, corn, and cassava from the New World; mulberries, figs, and pomegranates from the Old. Unfortunately, tobacco, the cash crop upon which the Company had pinned much hope, quickly rotted in the salty, humid weather, frequently reaching England as compost in the cumbersome cedar chests that were built to transport it. Tobacco was a legal tender in Bermuda in the seventeenth century, and the disappointments of the Company can be read in its gradual fall in value.

When their cash crops failed, Bermudians turned more and more to the sea for their livelihood, to venture trading and fishing. They built ships in boat yards in St. George's, Bailey's Bay, and Ely's Harbor, swift little cedar sloops that they used to transport cargoes between ports all

over the Western Atlantic. They became renowned for scurrying about the seas. Back in London in 1723, Bishop Berkeley, still caught up in the mythology of opulent Bermuda as Eden, decided it would be the perfect place to build a clergymen's college. He wrote a book with a long-winded title: *A proposal for the better supplying of churches in our foreign plantations and for the converting of the savage Americans to Christianity, by a college to be erected in the Summer Islands.* In it he noted how Bermudians had been "obliged to become carriers for America as are the Dutch for Europe" and how they were "the only people of all the British plantation who hold general correspondence with the rest." The college was never built, but this was a true description of the Bermudians, who were certainly intrepid. In addition to venture trading, they established a colony of their own in the Turks Islands, one thousand miles to the south, where they raked salt in the drier air to sell to the American colonies. During the many wars of the eighteenth century Bermudians also took to supplementing their incomes by privateering, a polite word for legal piracy. They were singularly well equipped to do this in their swift little boats, and the sideline continued profitably into the early nineteenth century, when the Congress of Vienna put a stop to the practice.

Through the early eighteenth century Bermuda gradually built up economic stability and, by mid-century, a measure of prosperity as well. The population of the island consisted mainly of the descendants of English immigrants and their slaves, of African and Native American origin, brought here from the second decade of settlement as laborers, sometimes from the West Indies. Bermuda's domestic slavery is sometimes said to have been kinder than that on a sugar plantation, but this is a meaningless distinction. Slaves were robbed not only of their freedom, but of their identity and human value too. In inventories there are sad references to people now forgotten: Kate, a little Indian girl, was valued at nine pounds sterling; Joseph, an old Negro man, superannuated, had no value at all. Slaves were often listed among the farm implements or, worse still, the livestock.

When the living got too easy and the population passed a certain number, Bermudians depended heavily on their mainland neighbors to supplement their food supplies. With the first rumblings of the American War of Independence, the Continental Congress placed an embargo on exports to all those who remained loyal to England. With their patterns of trade destroyed, the Bermudians faced starvation. But, then as now, Bermudians are people whose respect for authority is limited to the extent that authority is sensible. To effect a solution, a group rather

more practical than the rest and not so loyal to the Crown, and with close family ties in Virginia, took matters into their own hands. To renew their trading connections, they helped with the theft of a large quantity of English gunpowder that was quietly loaded onto waiting ships and sent to aid George Washington.

After American independence, Bermuda entered a long era of poverty. The fortunes of St. George's waned in particular. A new, central town, Hamilton, took away much of its lifeblood. In 1806, André Michaux, a French botanist who was a prisoner of war, described a rather sad place with "...only 250 or 300 houses...divided by a dozen very narrow roads, unpaved and allowing only a single passage for carriages.... One encounters very little life in the streets; and the inhabitants appear to be extremely indolent. In the town there are only five or six shops, which sell some very dear groceries, some remedies, some drapery."

The widespread use of steamships had meant an end to the Bermudian carrying trade. But there was money to be made for a brief time during the American Civil War. Bermuda had abolished slavery early, in 1834, but some sympathy and many family ties were still with the Southern states. St. George's came to life again for four years as sly Confederate runners crept in to the port from Charleston and Savannah with loads of cotton and slunk away with much-needed coal and munitions, often mixed with a large percentage of luxury goods for the Southern gentry as well. A mysterious Englishman, Edward James, made his living painting detailed watercolors of St. George's in Civil War days. James had arrived in 1861 on a steamer in distress, bound for New York—a voyage so frightful that he never dared to sail away. He ended his days in the town.

Life in St. George's today continues at a leisurely pace, with the mundane and the eccentric side by side. A green parrot, escaped from captivity, is one of the newest residents. He lives in the churchyard, where, anticipating married life, he has built himself a very impressive nest in a palm tree. He shouts at the starlings and they mimic his cries, but there is no one to move in with him.

~

Today, energetic groups of people sometimes walk for charity from one end of the island to the other. They take the hard road over the Causeway, which from 1872 has linked St. George's to the main island. The Railway Trail runs parallel, through a spit of parkland known as Ferry Reach.

It is a good place to search for the iron spikes that once held the sleepers down and are now discarded in the soft earth beside the pathway. My father spent hours mounting these spikes on mahogany plaques to award to the more stoic members of his walking group. Dogs who went on the walks got crossed spikes.

Ferry Reach is also the name of a country house, built for Vincent Astor in about 1930. What a house! It is a cluster of every possible kind of Bermudian roof—hipped roofs, fancy Dutch-influenced gable ends, raised parapets, shed roofs, and steep, smooth butteries. It looks like a small village. Astor furnished the house lavishly and entertained his friends there on a similar scale. He had a large saltwater aquarium in the private taproom. He even had a private railway. This was an enlarged version of a Toy Town train, custom-built for the estate. It carried guests around the multiacre property and collected or deposited them at the nearest main-line station. After the Second World War, Astor returned to Bermuda to find that an airport had been built on reclaimed land smack in the middle of the view from his living room window, and not much further than a stone's throw away. He sold the house and life was never the same at Ferry Reach. Today, what remains of his little train sits rusting in its shed beside the Railway Trail.

Past the Astor estate, at the far end of the Ferry Reach parkland, a swing bridge was built to take the train from St. George's Island to Coney Island. It followed the route that ferrymen had rowed for two hundred years to the main island. Today, there is nothing left of the bridge but the concrete pilings. They make a good place to tie up your boat and go fishing in the shade. Coney Island is named for a tasty fish, best served panfried with bananas. It now has a motorcycle track and a cricket field.

Cricket is central to Bermudian culture. The national holiday, Cup Match, is a two-day game between teams representing opposite ends of the island, St. George's and Somerset. The game is played on the anniversary of emancipation on August 1, 1834. This is not staid cricket like the kind played at Lords or the Oval, or simple, village-green cricket. It's noisy, participatory cricket, watched by a huge crowd in a holiday spirit. When a player performs well, spectators run onto the pitch and stuff his trouser pockets full of money! The match is surrounded by side shows, gambling tents, stalls selling fried fish and peas and rice.

The gable end at Somerset
Cricket Club.

If, as many visitors used to do, you ride a bicycle around Bermuda, you will quickly realize

that it is far from flat. The rolling hills are steep. The land is a sedimentary limestone deposit formed

of wind-drifted shells and fragments of coral, perched atop a volcanic mountain that rises four

thousand meters above the floor of the Atlantic Ocean. The stone has built up over millennia and,

where the rocky dunes have disintegrated, a rich, red soil has formed. In the late 1920s, railway

cuttings exposed strata of soil beneath rock, which showed the process in action. The reddest soil,

and the most interesting area in which to explore Bermuda's geology, is between Coney Island and

Paynter's Vale, at the eastern end of the main island. This area is full of magical caves. Crystal Cave

was discovered in 1907 by boys searching for a lost cricket ball, much to the delight of the landowner,

who rigged up an electric light system and a series of catwalks and promptly charged admission to

see this mysterious crystal netherworld. Many of Bermuda's caves are now rocky pools, for their roofs

have fallen in. The Victorians were fascinated by geology and wanted to record it. Thomas Driver,

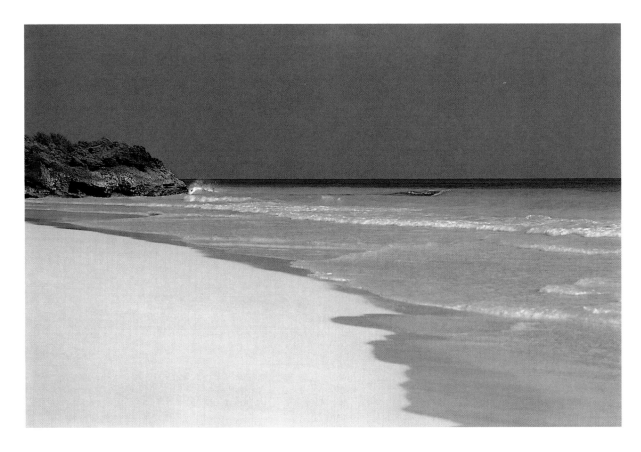

A South Shore beach on a calm afternoon.

a topographical painter in the early nineteenth century, obliged with romantic scenes. The cave at Walsingham, with its icy pool where people still go to bathe, was captured in the form of a cautious figure, the painter himself perhaps, standing among the stalactites and looking into the scene.

In 1924, when plans for the Bermuda Railway were being hatched, it was suggested that a narrow-gauge branch track might run into Tucker's Town. Tucker's Town, they say, was discovered twice. The first time was in 1616, when Daniel Tucker, Bermuda's second governor, a harsh man with an eye to the main chance, laid out a small settlement there and built huts on the common land. But the settlement really never came to much. It was useful only for access to the fortifications at Castle Point via a military road. The land around Tucker's Town was very exposed and could be farmed only in patches. Over time, Tucker's Town became a fishing hamlet, removed from Bermuda's cultural mainstream. Like isolated St. David's Island nearby, here people lived a life of quiet subsistence. Fish were purchased with potatoes, and vice versa. Whaling boats put in

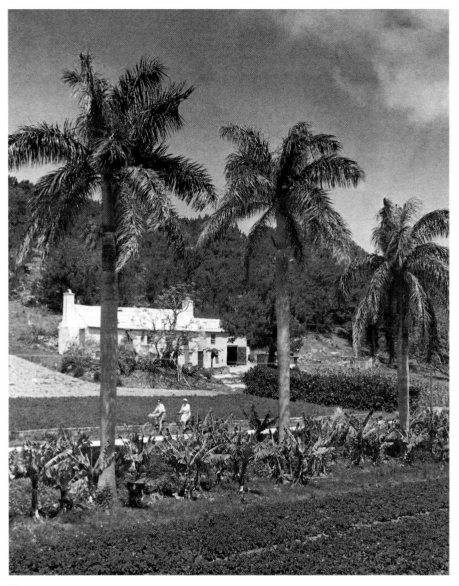

Tourists cycling on the
South Shore Road.

to Tucker's Town Bay, cotton was grown for local use, and the wonderful, useful palmetto was plaited into rope and made into hats, fans, and slippers for export to England. It was also turned into a potent palm wine for local consumption.

After the First World War, with the help of the Bermuda Government, the Furness Withy Steamship Company purchased 645 acres, most of Tucker's Town, in return for providing a regular service for visitors between New York and Bermuda. The Furness liners, precursors of today's cruise ships, brought visitors for stays measured in months, not days as now. Many came for the whole season, which was winter, when the weather is mild. They were wealthy, the sons of the American Renaissance and their brides, and Furness Withy furnished what they expected to find—an exclusive country club with two eighteen-hole golf courses and a fancy hotel nearby. They left their Packards at home and rented rickety pedal bikes. They lazed on the windswept pink beaches of Tucker's Town, perhaps the area of greatest natural beauty in Bermuda. Now, the area has become a manicured version of paradise, a sort of settled botanical garden.

Some visitors rented a house for the season. Others built their own houses in revival styles, sympathetically scaled and sited. The houses in Tucker's Town epitomize luxury in the local idiom. In the 1920s and 1930s, Bermuda had no department of planning to restrict building design. However, there is such a strong streak of patriotic conservatism in the Bermudian character that the Bermuda style of architecture began to propagate all by itself, an offshoot of the colonial

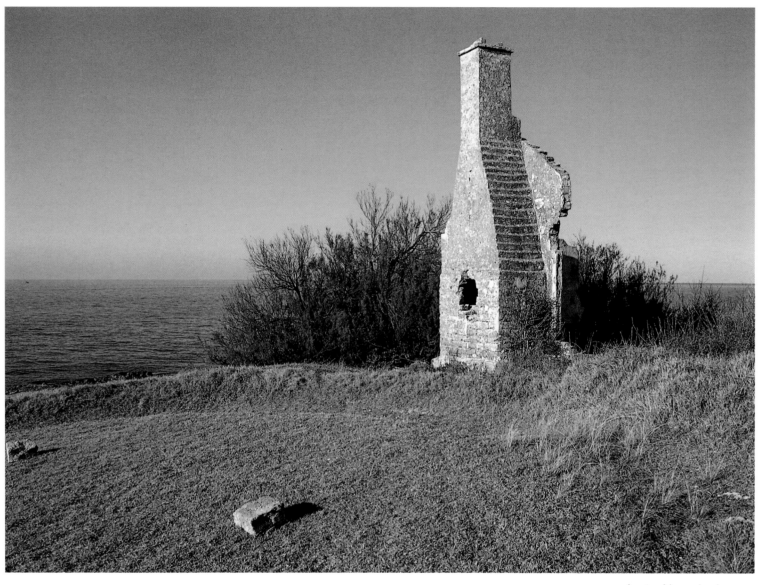

A ruined house by the railway on Crawl Hill.

revival in America. While this isolated Eden, this "colony of contentment," refused to bow to "the modern gods of speed and noise," a few modernist architects did sneak in and leave a remarkable, if subtle, trail. Round House was built by Wallace Harrison in 1936 for David Milton, who had married a daughter of the Rockefeller clan. The house, round in plan as its name suggests, managed to capture the flavor of the local vernacular while adhering to the streamline moderne as well—no mean feat. It was exquisitely sited on the very edge of a lagoon. Its owners could almost

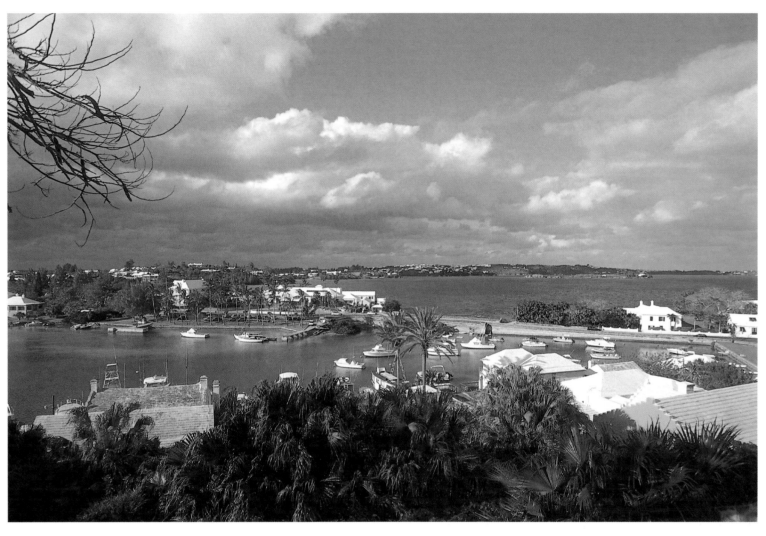

A view of Flatts Village and
Harrington Sound.

reach out the window and feed the fish. Houses of great luxury and architectural interest continue
to be built in Tucker's Town.

Since the railway closed down and the little trains were sold to the Guyanese, there have
been many changes along the side of the tracks. In some places clusters of new buildings encroach
on the land, in others you pass the ruins of old buildings; but you can still walk right the way along
the North Shore from Coney Island until you reach Flatts Village. The Bermuda Aquarium opened
in Flatts in 1926, replacing an earlier aquarium less conveniently located. Both a research and a
tourist facility, it contains a variety of local fish. Angelfish were a popular favorite then, while

moray eels seem to attract more attention now. Some marine animals were imported. Patrons like Vincent Astor donated Galapagos penguins and giant tortoises as well as fish surplus to his collection. Today there are macaws and flamingos and ring-tailed lemurs, who perhaps find it safer here than in Madagascar. There are also friendly harbor seals. When one of these was expecting young recently the Aquarium had a baby seal-naming contest. Miranda, I thought, if it's a girl. But the winner was Calico, a unisex name inspired by a delicious but endangered local clam with a mottled shell.

~

The city of Hamilton was named for a former governor and was built of necessity as a central commercial port. It was the prime destination for most of the train's passengers. Throughout its history St. George's had been disadvantaged by its isolated position in the East End. It had always faced unofficial competition from deepwater docks at Heron Bay, Salt Kettle, Crow Lane, and others widely dispersed across the island. Much to the

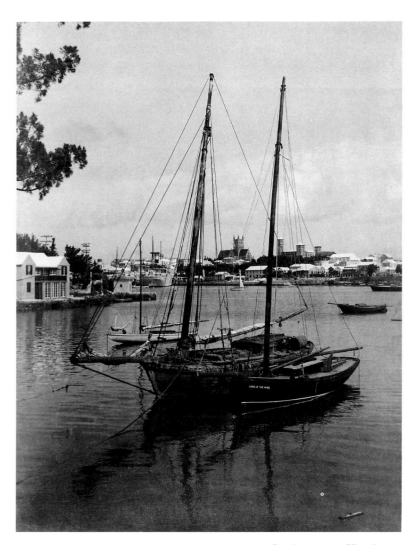

Looking across Hamilton Harbor toward the cathedral, built at the end of the nineteenth century.

annoyance of the H.M. Customs, ships often put in at night and unloaded surreptitiously. The founding of a central town had been under discussion since the middle of the eighteenth century. Land for the town, 144 acres, was purchased and surveyed, and the town laid out in a grid system in 1790. Square parcels of land were sold, with public lots reserved for a market, a parade ground, and public buildings. A mayor was elected by the freeholders, and the town was open for business. By 1815, the legislature had also removed themselves there from St. George's. The smart, strong new Public Building with a classicized facade was built from 1838, a new cathedral begun in 1889. Front Street, facing the harbor, still retains something of its character today, thanks to a nineteenth-

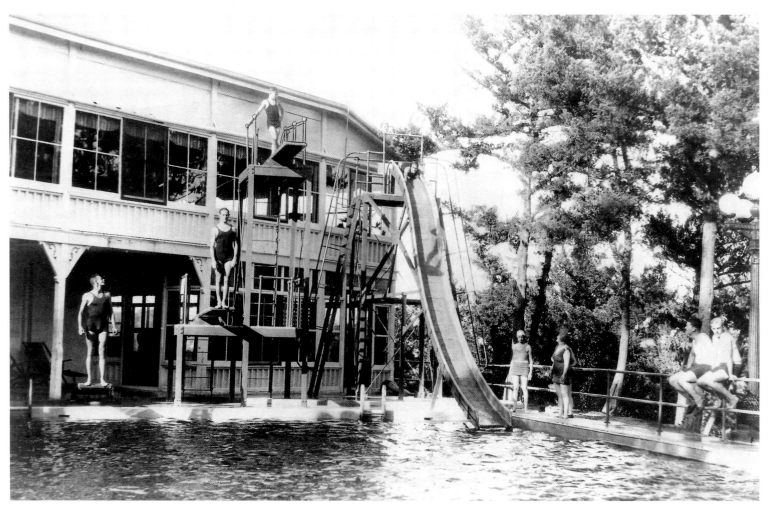

Bathers at the Hamilton
Hotel in the 1930s.

century ordinance obliging owners to maintain a twenty-five-foot-wide covered walkway for the convenience of shoppers in the sun or rain.

Bermuda's economy in the later part of the nineteenth century was bolstered by the development of tourism. People had come in the eighteenth century for the beneficial climate; in the 1740s, Alured Popple was "one of many strangers who resorted thither for their health." Later in the century it was ominously recorded in an American woman's journal that "Aunt Hannah hath gone to Bermuda for her health. It is not thought that she will survive." Though the fancy Hamilton Hotel had been built in 1852, and though there were a number of other places where one might lodge quietly, such as the Globe Hotel in St. George's (once the home of Major Norman Walker,

Confederate Agent), it took a royal visitor to give Bermudian tourism the cachet to begin in earnest. In the winter of 1883, Princess Louise, Marchioness of Lorne, a daughter of Queen Victoria and wife of the then Governor-General of Canada, stayed at a private house, Inglewood, in Paget. The very next year a large, wooden-verandaed hotel was built near Hamilton and called the Princess, in her honor. Suddenly, Bermuda was in the affluent business of attracting affluent visitors.

In the early days of tourism the steamship journey was often a difficult one, prompting Mark Twain's comment that Bermuda was heaven but you had to go through hell to get there. Twain himself was a frequent visitor. He stayed first at Mrs. Kirkham's Boarding House in 1867 under an assumed name, and wrote about the island in *Innocents Abroad*: "Bermuda is free at present from the triple curse of railways, telegraphs and newspapers, but this will not last the year." His timing was wrong, and he had somehow overlooked the *Bermuda Gazette*, founded in 1783 by Joseph Stockdale, but one cannot help feeling that he would have enjoyed riding in Bermuda's version of a train. Twain returned several times as an old man, to rest from his old troubles and to create more complex new ones. He stayed at the Princess, close to friends, the Allan family of Bay House. In 1908 he formed a club, the Angel Fish, consisting of himself and a number of little girls, surrogate granddaughters, with whom he explored the island's beauty spots in a donkey cart.

Twain was just the first of a number of writers to find solace in Bermuda. The subject of Bermuda's discovery, a very romantic one, had attracted writers from the earliest days of the island's history.

> "Seven months among mermaids and devils and sprites
> And voices that howl in the cedars o'nights...."

wrote Rudyard Kipling in a farcical story, "The Naval Mutiny," shortly after his own ship put unexpectedly into Bermuda in 1930. Kipling, who visited Bermuda twice, became curious about how Shakespeare had come to write *The Tempest*, which contains a direct reference to the island's stormy seas and is generally believed to have been inspired by accounts of the wreck of the *Sea Venture*. He imagined that Shakespeare overheard the story from a drunken sailor who wandered into his theater and who revealed more information with each succeeding glass of sack. "What was the land like?" asked the theater manager. "It was green, with yellow in it; a tawny-coloured

country . . . and the air made one sleepy, and the place was full of strange noises," answered the sailor, taking full advantage of the fact that he had recently narrowly escaped with his life. The theater manager quietly noted the conversation on his frilly cuff, and Bermuda was woven into mythology.

The myth, of course, is that a place like paradise can exist after mortal men have discovered it. Bermuda has borne the brunt of this expectation ever since its discovery. In 1611, Shakespeare's kind character Gonzalez was the first to describe the steps he would take to keep it that way:

> Had I plantation of the isle, my lord . . . no kind of traffic would I admit; no name of magistrate; letters should not be known; riches, poverty and use of service, none; . . . all things in common nature should produce without sweat or endeavour . . . but nature should bring forth of its own kind . . . all abundance to feed my innocent people . . . I would with such perfection govern, sir, t'excel the golden age.

"The literati are now swarming to Bermuda like salmon to the sea," trumpeted *The Bermudian* in 1931, apparently oblivious of the ways of foreign fish. This new magazine promoted both tourism and local society life. Apparently you couldn't walk a hundred yards in Hamilton without stubbing your toe on a full-fledged poet, dramatist, or novelist. Writers did indeed come here. Some of them are well remembered. Eugene O'Neill wrote three of his major plays in as many different houses in the mid-1920s. Others, like Ursula Parrott, a writer of steamy romances that made the censors frankly nervous (as if O'Neill didn't), have sadly faded from memory. The topic of literary visitors fascinated the editorial staff of the magazine, and they did a survey. Why did the writers come? There were two responses. One man had few expectations. He said he chose Bermuda because the place had no distinct personality, leaving the artist free from any distracting or coercive influences. Most of the others said, a little more graciously, that they found it inspiring. However, few, if any, described Bermuda in their work. Perhaps it was the social life, after all, that drew them here.

Sophisticated winter visitors with a modern eye did not always find Bermuda totally sympathetic. The painter Marsden Hartley, who arrived at Christmastime in 1916, first wrote to his friend and agent Alfred Stieglitz in New York of the "material warmth and caressing southerly

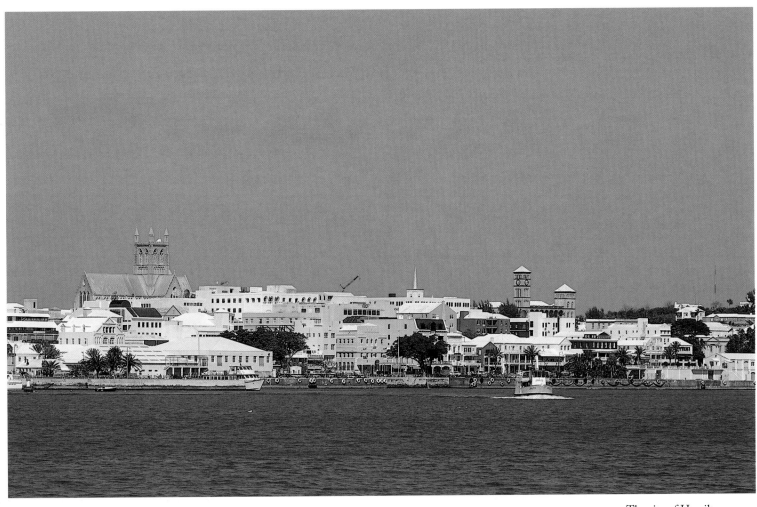

air" and the "voluptuousness of vegetation—the large red hibiscus, full, beautiful, bell-like." He hoped Bermuda would soothe his irritated nerves, would be the remedy he felt he needed for the curse of American materialism. "I feel as if a good long season here would be productive, as the proper kind of quiet is to be had here, and it is really a very decent place...." His mood became fractious as he tried to gear down to Bermuda's quiet pace. "After ten days in this place I find it singular as a resort—incredibly little to do and an incredible sparsity of populace. I find the most attractive feature the roads—so fine they as any I ever walked on." But Hartley walked alone: "Few seem to walk, everyone cycles." At the end of six weeks, Bermuda had completely lost its charm. "I should perish of ennui if I remained here a year," he complained.

In February 1917, Hartley was joined by Charles Demuth, and the two men moved from Hamilton to St. George's, where they stayed in the hilltop St. George's Hotel, working together in a large room on the hotel's top floor. It was here, in early March, that Demuth's painting crystallized into the cubist forms that would have such an influence on twentieth-century American painting. Like painters today, Demuth had never used as much black as when he worked in Bermuda: the dazzling effect of the light makes for very dark shadows. Both men enjoyed St. George's, Demuth in particular for its colonial resonance. Hartley, still battling his nerves, admitted there was "a fine old legend in every glance of the eye," but concluded that it was really just "a place for [Childe] Hassam, or for the lady painters." He made oil sketches, and at the end of March, when Demuth was leaving, Hartley wrote to Stieglitz to say that he would stay on a while to finish some writing after all. He was referring to *Ironies out of St. George's,* a series of poems on the senselessness of the war, suggested to him by wounded soldiers he had seen in the army hospital.

I am an island –
My mother was a mountain once
My father is the sea –
Somedays I hear my mother groan
And see my father froth
And frighten me somewhat
They have so many other children now
I do not count –
Some are ships and some are men
Of no account
We lose them every day—
They say!
I have no doubt
'Tis so!
I can not grow
Because my father hates
My mother so.

~

Although the little railway dogged the shoreline all the way from St. George's to Hamilton and ran along the Front Street docks to the end of the harbor, it then took an inland turn, passing under a long cut in the limestone rock at Rural Hill. Schoolchildren would stand up and shout at the tops of their voices each time the train went through a tunnel. Today, when you walk this shady stretch of the route, you can look back across at the city and admire it from a distance. Hamilton is now a small metropolis in Technicolor, struggling to keep its identity in the face of the heavy demands of international business. Its early-nineteenth-century character has been slowly sacrificed to purpose-built modern buildings since the 1960s, although no building over five stories is permitted yet. The architectural character of Hamilton is confused. One office block, the headquarters of Bacardi International, is in the International Style, yet its Cuban architect, flying in the face of reason, calls it "the most Bermudian of all Bermudian buildings." Bermuda's banks cannot seem to make up their minds how to build. As agents of the most conservative of influences, they cannot quite bring themselves to espouse modern design yet do not completely let go of the traditional in Bermudian architecture. Ill-advised attempts to graft elements of cottage design onto office buildings produce bizarre effects, as if a shrunken Seagram Building had been painted pastel pink and given a thatched roof.

The fact that Bermuda had no hostile indigenous population had an effect on the development of the built environment. There was no need to huddle defensively. Building spread quickly and evenly all over the island, reaching Somerset, the western extreme, by 1616. Many of Bermuda's finest houses are built within easy access of Hamilton Harbor, and you can glimpse them on the stretch of the Railway Trail that runs through Paget and Warwick. Some are below you on deep waters of the opposite shore. Many more are inland in sheltered valleys, the farms or small holdings of factors sent out from England. As times and fashions changed, others commanded expansive views from all facades over the sea or the countryside. Some were built on the beach.

Bermudian houses are vernacular hybrids. Their builders took the English tradition as their starting point and then worked out a unique series of solutions to suit the practicalities of a small place with limited yet singular resources. Many of the features that have come to be associated

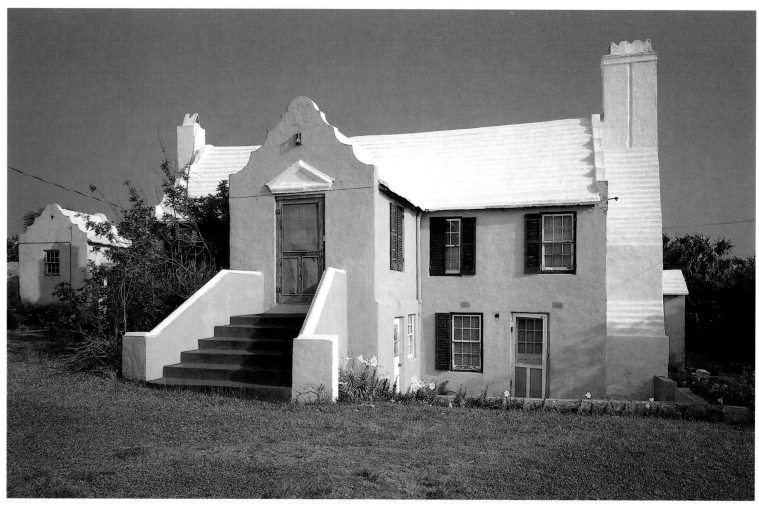

Oleander Circle, an early-eighteenth-century hall-and-chamber house with a projecting porch.

with the Bermudian tradition can be explained in terms of function, yet, as with all vernaculars, they transcended their practical origins and evolved as objects of spontaneous beauty. Plans of Bermudian houses grew from the late medieval hall-and-chamber nucleus. Wings and additional rooms were added in a sometimes haphazard manner to form X, L, H, T, or flattened U-shapes. The houses were almost always a single room deep, for ventilation in the warmer months, perhaps, or because of the limitations of the indigenous cedar tree, which, at its most vigorous, seldom yielded timbers more than twenty feet in length.

From the early eighteenth century, stone was the predominant building material for houses. Bermuda's white stone is soft and easily worked, but it is porous and needs to be sealed. When it

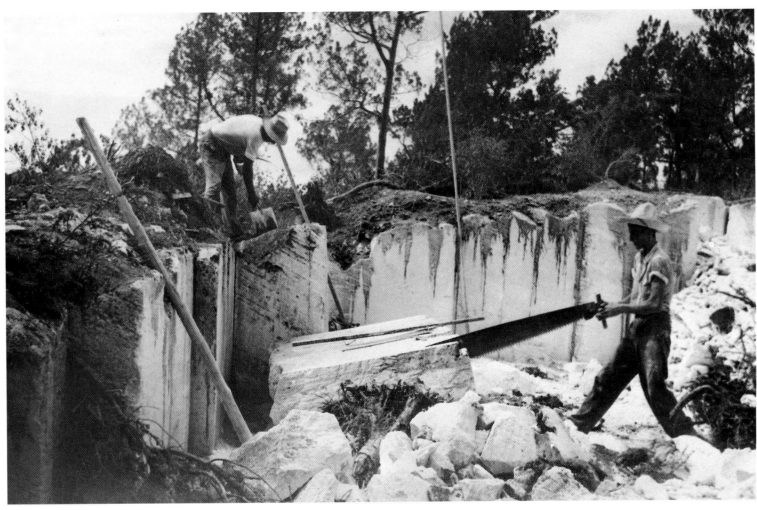

Early laborers sawing Bermuda's soft stone into building blocks.

is cut and exposed to the air it hardens, becoming gray and somber. The soft stone is quarried with handsaws into blocks of varying thickness, with larger blocks used for lower stories. You can sometimes see this expressed on the outside walls. Some early stone houses were built into partially quarried hillsides, the stone cut from the face of the hill and a house of one-and-one-half or more stories neatly inserted in its place.

At the beginning of the eighteenth century several stone houses were built with a towerlike entry porch and a centrally planned wing at the rear, resulting in the cruciform house. Tankfield and Inwood, both near Hamilton, are good examples. They were modeled on earlier half-timbered houses. Their entry porch functioned as a waiting room, an office, and perhaps, as inventories

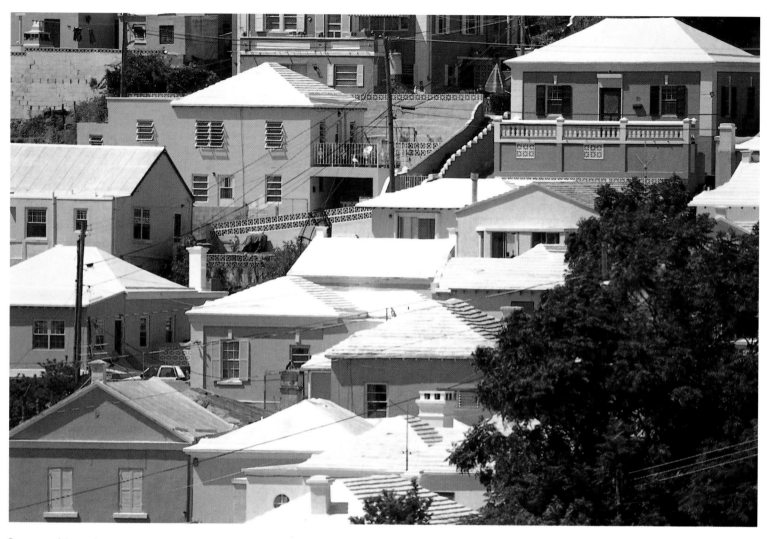

Latex emulsion paints are used today to give Bermuda's houses their eye-catching colors. Here, houses in Hamilton.

hint, a place to keep things that wives would not allow in the principal room, the hall. A porch was commonly furnished with a table and chairs. Small houses emulated its welcoming function by setting simple wooden benches into the walls at the top of a broad, flaring "welcoming arms" staircase that gave access to the upper story of the house, where the main rooms commonly were. In the case of a single-story cottage, an open stone enclosure outside the front door often would have a sitting area with the same function. Later in the eighteenth century, entry porches became less common as the square-faced Georgian house came into fashion, but in Bermuda this plan was commonly U-shaped and not two rooms deep. Perhaps the reason was tradition, for by that

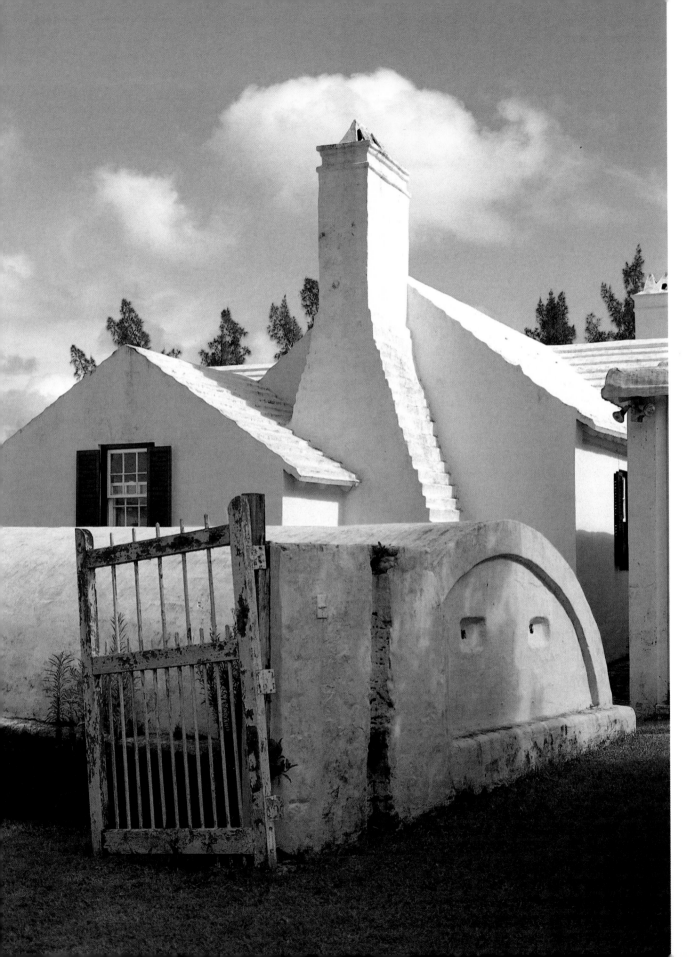

A vaulted water tank at
Maria's Hill.

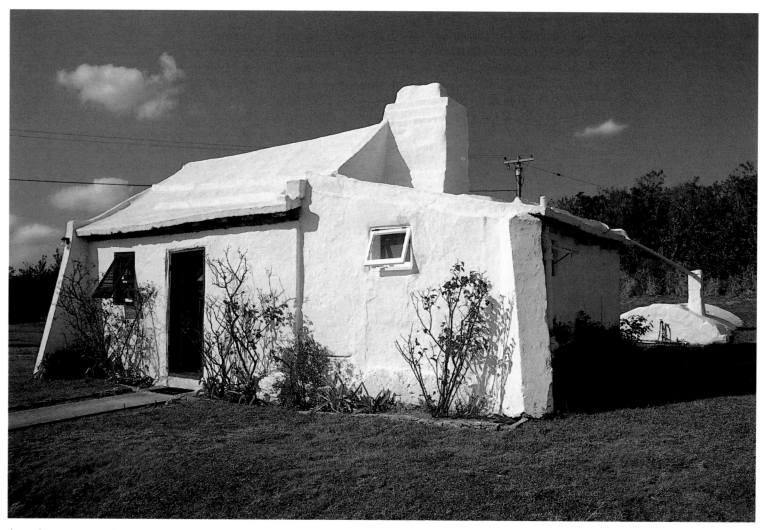

An early one-room cottage with lean-to addition in Sandys's Parish.

time sufficiently large timbers could be imported from North America to build two rooms deep. Verandas, which became popular in the nineteenth century, were in many cases added to older houses, part of a slow adaptation and not of the original vernacular.

Lime for building was obtained by burning pieces of hard stone in kilns. The resulting material was then slaked in water and mixed with whale oil and clay to make plaster to seal the porous stone. Walls would then be covered with lime wash, sometimes tinted with earth-colored pigments. Today, latex emulsion paints give Bermudian houses a much more uniform color in a far wider range of hues than could have been imagined previously.

The stone slate roofs that are so typical of Bermudian houses replaced earlier roofs of palmetto thatch or wooden shingles. The function of the distinctive Bermuda roof is to catch rain water, for there are no rivers and easy access to well water is rare. Bermuda's roofs are made from blocks of the same limestone cut into one-and-one-half-inch slates and laid one overlapping the other on a frame of sawn or hewn cedar rafters. These are framed into a ridgepole at the summit and fastened to a cedar wall plate that tops the stone wall. Roof slates bond together over time and, after repeated brushings to clean away accumulated mildew and coats of lime wash, an old roof will come to have the soft appearance of a single undulating slab of stone. Rainwater is channeled by raised gutters at the bottom of the stepped roofs into a dark, lime-washed tank below. Traditional tanks were above ground and had a vaulted top, allowing free circulation of air over the water. Today, a tank is more likely to be under the house. People sometimes put a guppy or two in the water to stop mosquitoes from breeding.

Traditional Bermuda roofs were hipped or gabled, sometimes both in the same building. Their eaves were always shallow to protect against high winds. They were always painted white.

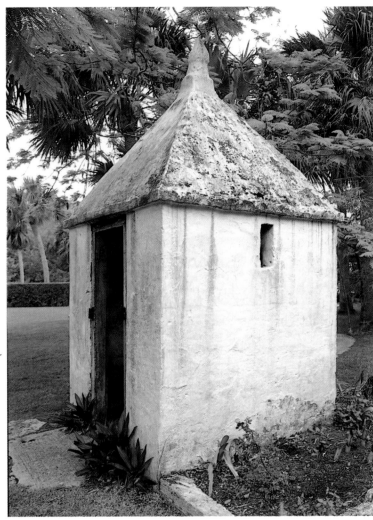

Captain Cox's convenience, built in the eighteenth century.

Snow is not prevalent in Bermuda, but the first look . . . gives one the idea of a snow storm. Every house is white, up from the ground to the very point of the roof. Nothing is in so great a demand as whitewash. They whitewash their houses incessantly. . . .

wrote a Victorian visitor. Of course it never snows, but at Christmastime in Bermuda you have only to narrow your eyes a little to see snow on the rooftops. The white roofs glisten in the cool night air, like frosting on a cake. The glare could sometimes trouble travelers. The botanist Michaux

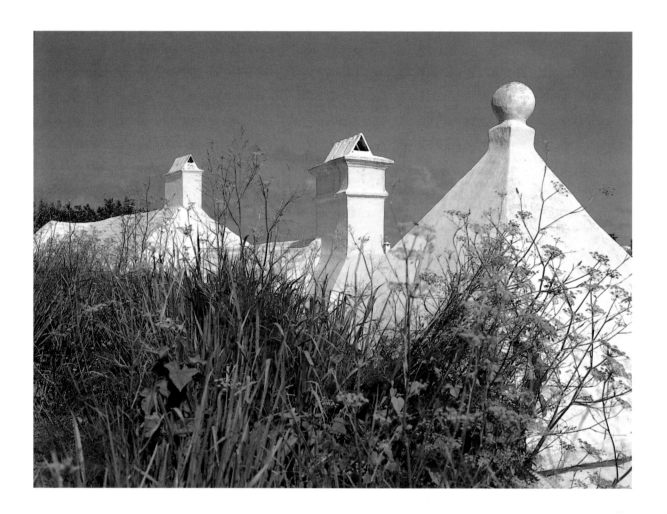

Limewashed roofs of smooth and lapped stone at School Lands cottages in Pembroke.

complained: "the roofs, painted white, reflect the sunlight; which is very fatiguing to the sight." Despite the occasional discomfort to a European eye used to terra-cotta tiles, white stone roofs are central to the Bermudian way of building. Today, precast synthetic materials sometimes replace stone, but the aesthetic is the same.

The distinctive square outbuilding, the Bermuda buttery, has a steep, gravity-defying roof of flat or lapped slates laid without any supporting wooden frame at all. Butteries were used for storage, for food preparation such as salting and pickling, for dairy-related activities, and for making rose water. Fragrant Old World rose species are still common in Bermudian gardens, and in earlier times rose water was an important factor in keeping the environment sweet. The buttery form was sometimes built as an outdoor convenience. It continues to be built today, incorporated into

cottage extensions as guest wings, or sometimes as a boathouse or a postmodern garage.

Broad, stone-stepped chimneys, their tops ringed with simple stringcourses, seem to buttress Bermudian houses in the wind. They, too, are part of the Bermuda style. Their disproportionate size caused Mark Twain to write that there was nowhere else in the world that had chimneys to be gloated over, to be worshipped. Inside, their thick, soft walls were lined with brick. The height of a hearth indicates its original function. Ankle- or hip-high fireplaces, embellished in gentry houses with ample cedar bolection moldings and sometimes with panels of wainscoting as well, provided warmth in the winter months. Integral closets built around the chimney made a useful dry storage space. Waist-high fireplaces were for cooking and often had a built-in oven with its own flue. Even small houses had several chimneys, serving different areas of a house. Outdoor kitchens were common in large houses in the eighteenth century to keep slaves and cooking heat at a polite remove.

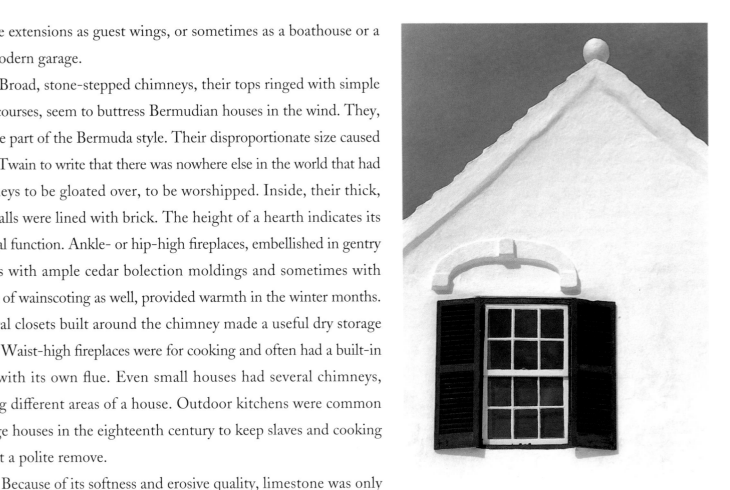

A quizzical "eyebrow" over a shuttered sash window.

Because of its softness and erosive quality, limestone was only used for bold architectural ornament. A simple ball would sometimes crown a roof. An arched "eyebrow" over a window or a pediment over a door helped channel the rain to the side. A handsome pair of gateposts with molded tops announced an important house, but there was little other decoration. Bermuda houses relied instead on their simple massing and rootedness in the bedrock, from which they almost seemed to grow.

The traditional Bermuda house is a comfortable place in which to live. It is well ventilated in summer and warm with a cheerful fire in winter, sheltered from windstorms by its siting and by stout louvered shutters at the windows, protected from drafts by pelmets over the doors. The rooms on the upper floor take advantage of the pitched roof construction. Their "tray" ceilings conform to the line of the rafters to give additional height and air circulation. Walls are sometimes braced with tie beams at wall plate level, strengthened at the join with an angled cedar brace or

"elbow," a shipwrighting technique. On the lower floors, structural timbers also are often exposed, making for snug, safe rooms. Bermuda-made furniture fits perfectly into these distinctive interiors. Those necessities of modern living, swimming pools and patios for outdoor entertaining, can be tucked discreetly into the spaces between projecting wings in the garden. People who live in an old Bermuda house can enjoy the best of two worlds.

~

In Southampton, the Railway Trail passes Gibb's Hill Lighthouse. The lighthouse was designed and prefabricated in Britain in 1844. That organ of Empire, the *Illustrated London News*, never too accurate with fact-checking, reported that it was bound for Bermuda in the West Indies—a common mistake. The lighthouse consists of a series of cast-iron plates bolted together and capped with a platform bearing the lamp room. It is 130 feet high and 24 feet in diameter, tapering to 14 feet. Running up and down the cast-iron spiral stairs is a local way of displaying strength and virility, but it is better to climb slowly up to the top and enjoy the carpet of local color spread at your feet.

The railway crossed the rich farmland of Southampton West. The island had first been surveyed in 1617, by Richard Norwood. Norwood's survey is probably the best-documented seventeenth-century example of the partitioning of Company lands. He divided Bermuda in two. The main part, comprising three-quarters of the land, was partitioned into eight "tribes," now known as parishes, named for the principal investors in England—Sandys's, Warwick, Paget. The remaining quarter, including St. George's, was common land. Each tribe was further divided into four hundred equal shares of twenty-five acres, the lots sliced across the land regardless of terrain and allotted according to investment. Because of the procedure that Norwood adopted, beginning at the eastern end and then changing direction, there was a segment of land left over in Southampton that "fell in a very fruitful valley." This was the Overplus, which Governor Tucker quickly took for himself. He fenced it with fig trees and built himself a house and garden there. The Railway Trail takes you through the Overplus.

Captain John Smith wrote of Bermuda's climate, that "no cold is there beyond an English Aprill, no heat beyond an ordinary July in France." The temperature seldom drops below fifty degrees Fahrenheit or rises above ninety, and it rains a consistent amount, about four inches, every

month. Consequently, having your own vegetable garden in Bermuda is a delight. Half the year, tropical plants will grow, and the other half, temperate. You can produce artichokes and asparagus, strawberries and bananas. The ripe tomatoes of early summer are not to be missed. Early vegetable gardens were sometimes walled in to keep the hogs off the crops.

In the eighteenth century, when attention turned to the sea, farming skills in Bermuda were neglected. Stands of cedar trees, so important to shipbuilding, were given precedence on land. Then came Governor Sir William Reid, labeled the Good Governor by Charles Dickens, who wrote of his virtues in an article in *Household Words* in 1850. When Reid arrived, shortly after emancipation, he was dismayed at the state of farming and wrote home to England of the "light but fertile soil bearing fine timber and luxuriant weeds." Then he set about to improve the situation, importing ploughs, teaching hay-

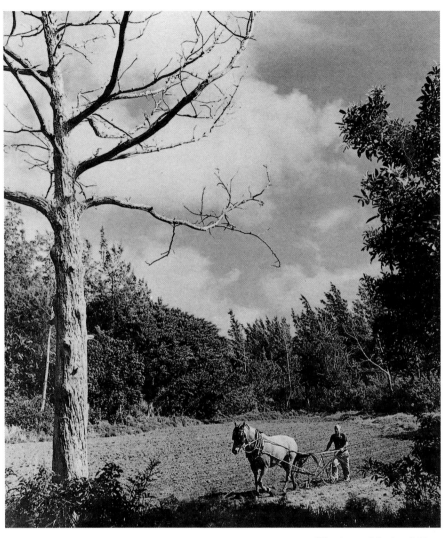

Plowing a rich clay field.

making, trying new stock, encouraging better citrus-growing. When he thought his pupils were making progress he offered the incentive of prizes, staging the first Agricultural Exhibition in 1846. This exhibition continues today. Reid also had the wit to send Bermudian crops abroad, and he promoted and developed a market for the supply of winter vegetables to the United States. Bermuda onions, potatoes, and Easter lilies became justly famous. Arrowroot was also grown for export. (Locally it was used to starch Victorian petticoats.) Today, because of the pressures of housing development, arable land is shrinking all the time. When you see a patch of farmland, a fine, red field, you stop and look long at it, fearing it will be chopped up into building lots the next time you pass by.

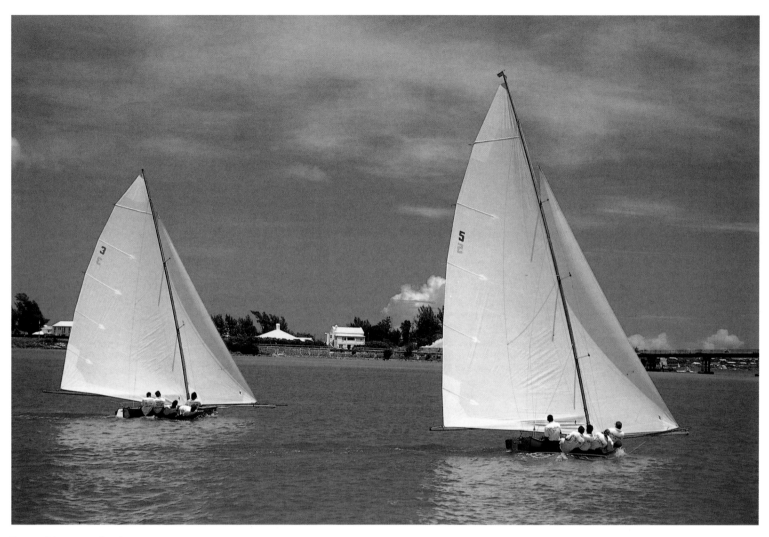

Bermuda's unique fitted
dinghies have about one
thousand square feet of sail.

Walking on toward Somerset, you travel the curving shore of the Great Sound, with its magnificent view past Spanish Point and on down the whole length of the island to St. George's Island in the east. The sea here is never still. The soft wind ruffles its surface every day till evening falls. Most Bermudians have webbed toes; swimming and sailing are second nature to them, although you won't get them into the water until May 24, once Empire Day (or Queen Victoria's Birthday) but now Bermuda Day. Every weekend there is yacht racing in the Great Sound. This began with lively informal competition between Bermudians and the Royal Navy in the nineteenth century. Yacht clubs were formed then and sailing took on a serious social function. Now,

there is an Invitational Race Week each spring, in which Bermudians excel. The long-distance Newport-Bermuda race takes place every second year, and for those who prefer a more comfortable ride, the Marian-Bermuda cruising race is held in alternate years. But most extraordinary of all is Bermuda fitted dinghy racing, held on summer weekends when the water temperature is above eighty degrees. The rules are eccentric. A crew of up to seven people sails a fourteen-foot, one-inch boat. With all that weight, the boat obviously rides pretty low in the water, and one person's job is just to bail. When the going is dull on the downwind leg, it is perfectly acceptable to throw a crew member or two from the stern of the boat to lighten the load and aid momentum, a practice that would invite loud protest in any other sailing race. Fitted dinghies have a huge volume of sail, a thousand square feet, with their spinnakers up. They look like giant white butterflies on the water. Like the bumble bee, nobody really understands how they manage to work at all.

Blue Bermudiana, one of the island's indigenous flowers.

Primeval Bermuda was covered with dense, somber woodland, and almost at once the cedars, yellowwoods, and any other species that might have benefitted the investors were cut and shipped to England, wholesale. From that time on, and especially today, there has been a growing consciousness of the fragility of the natural environment. Bermuda has several nature reserves, representing different types of terrain, including freshwater and brackish ponds and marshes. Many abut the western stretch of the Railway Trail. When you enter the Paget Marsh from a small track behind St. Paul's churchyard, you find yourself in a world of large and very ancient palmetto trees, giant ferns, sedges, and standing dead cedars. Kipling thought that this must have been the swamp that Shakespeare's characters had to deal with as they struggled inland from the beach, bewitched by Ariel's charms.

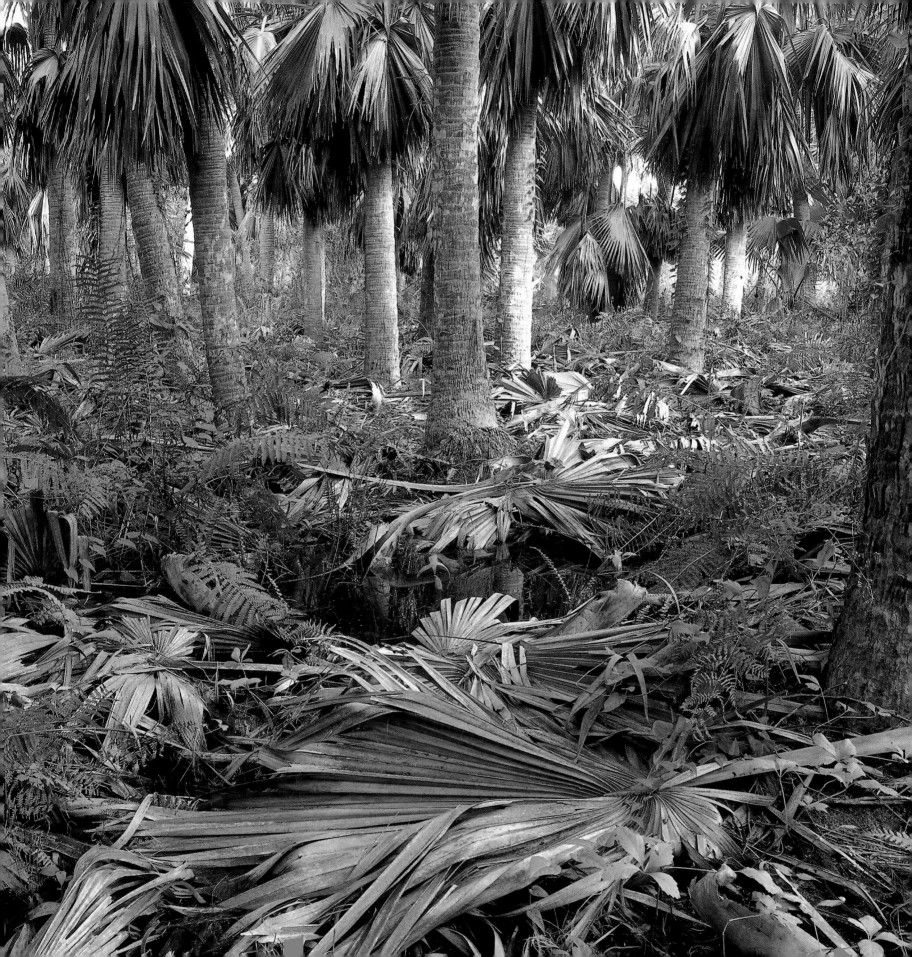

One of the largest reserves is the Springfield Nature Reserve in Somerset. It is a habitat for native plants. Of the eighty-one species that evolved naturally in Bermuda, as identified by Nathaniel Lord Britton in the early twentieth century, nearly 9 percent are endemic; they grow nowhere else. These are the true Bermudians. Of the remaining naturalized plants, the fiddlewood stands out in particular because it is deciduous in the spring, giving the Springfield woods their color contrast. In the 1940s a blight destroyed many of the cedars. Replanting was accomplished with the quick-growing Australian pine (casuarina); but this tree uproots in the wind, making it dangerous in hurricanes. Bermuda cedar, on the other hand, puts roots into the rocks and will not rot in the salty climate. It evolved here and it belongs here. Today propagation programs are encouraging its reestablishment.

Ancient palmetto trees in Paget Marsh.

Bermuda's open spaces attract another kind of visitor—migratory birds. The island is a birder's paradise. At 32 degrees latitude and 64 longitude, it is the only land mass where birds can come to rest on their long Atlantic flights. There are twenty-two nesting species in Bermuda, including the Eastern bluebird, and more than two hundred migratory species. Most of the migrant birds, including flocks of warblers, come in the fall. Bermuda's manicured golf courses are a particularly good place to watch spirited little warblers feed and rest before continuing on their journey. Spring is a time for a less spectacular migration.

Bermuda has had one major ecological success story. The docile gadfly petrel, or Bermuda cahow, was thought to be extinct for three hundred years. It had provided too easy a supper for the early settlers and the rats that they brought with them in their ships. Since a breeding pair was discovered in the 1950s, the bird has been reestablished in carefully guarded artificial nesting burrows on an isolated island, and there are now easily one hundred healthy cahows.

～

The Bermuda Railway came to its final halt in Somerset Village. Bermuda itself goes on a little further. The far West End of the island has always been a place apart. Once there were tales of bewitched hogs and buried treasure, and spells and enchantments of the kind that Prospero knew how to work. It is a more prosaic place now. In 1792, Ireland Island, the last island, was surveyed by the Royal Navy. They proposed making it a naval base for the North Atlantic fleet. The island

was sold in 1795, and a full-sized dockyard with impressive buildings developed beginning in 1809. But it was really too late to be very effective. The Napoleonic Wars were over by the time it was in operation, and soon thereafter the introduction of the steamship changed the face of the Navy completely. Nearby Boaz Island was used as a penal colony from 1848. In 1859, Anthony Trollope, wearing the hat of a British bureaucrat, came to inspect the facilities and found that the laboring convicts were faring somewhat better than the average Bermudian, at least as far as diet was concerned. The prison was closed soon afterward.

Trollope had also noted an underlying conservatism in Bermuda, without quite knowing the reasons why. He accepted a local explanation—that the south wind affects you:

> The sleepiness of the people appeared to me to be the most prevailing characteristic of the place . . . [they only want] to live and die as their fathers and mothers did before them, in the same houses, using the same furniture. . . . I must confess that during my time there I myself was overtaken by the same sort of lassitude. . . . During the period of my visit it was all south wind.

Trollope did not appreciate Bermuda. "Looking back at my fortnight's sojourn," he said, "it seems to me that there can be no place in the world as to which there can be less to be said than there is about this island." He didn't like Hamilton and he didn't like St. George's: "I spent a week in each of these towns, and I can hardly say which I found the most triste."

A man of his time might be forgiven for not appreciating Bermuda's subtlety. When it was discovered, Bermuda was a tabula rasa, if a rather small page upon which to write. With no population, the island had no culture. This was to develop after settlement through the practical adaptation of influences from abroad. Large islanders, the English, moved to a small island. It was a relatively easy transition. There was no indigenous disease, no unexplored hinterland, no frightening and unknown population against which they would have to defend themselves. The climate was temperate, even in the seventeenth century, when the weather is said to have been cooler. The culture that resulted was a mild speciation, slow to evolve and slow to change. Once established, there was little need for adaptation.

If this all sounds a little Darwinian, there is a direct connection. Darwin had developed his theory of natural selection by 1838 but he did not publish until 1859, when a perceived threat from a rival, Alfred Russell Wallace, prompted his action. A letter from Wallace, on his way back to England from the South Seas in 1858, announced results very similar to Darwin's. Shortly thereafter, Wallace's ship was wrecked off the West End of Bermuda. All lives were saved, as were the two trunks that contained Wallace's notes and specimens, but Darwin did not think it wise to delay publication any longer.

~

Bermuda today is a comfortable place to live, with one of the highest incomes per capita in the world. It is still in many ways as beautiful and bountiful a place as when it was first discovered. Yes, Bermuda is changing, but its culture still shines through despite the influence of the world outside. The island goes on proudly reflecting its own past, a little like England still does. In a world where everything seems to become more and more homogenous, this slow change preserves a precious memory of how things were.

On a bad day, Bermuda is paradise spoiled. It is grey and damp. Goods are never in the store when you need them. People are lethargic, when they aren't gossiping. Things seem to break or rot or go rusty the minute you bring them home.

But on a good day, all you can see is the light on the water and the color of the sky. It is sublime.

The walkers trudge rhythmically on, covering pitted rocks and wild fennel in the rough grass. They clamber up a little hill near the end of the railway track. Their reward: a breathtaking view of the merging sea and sky. "Heavenly blue upon blue, stretching into infinity . . . ," wrote my father. "So little toil for such a glimpse of paradise." A glimpse is really all you need.

Bermuda

Kings Point, Sandys's Parish.

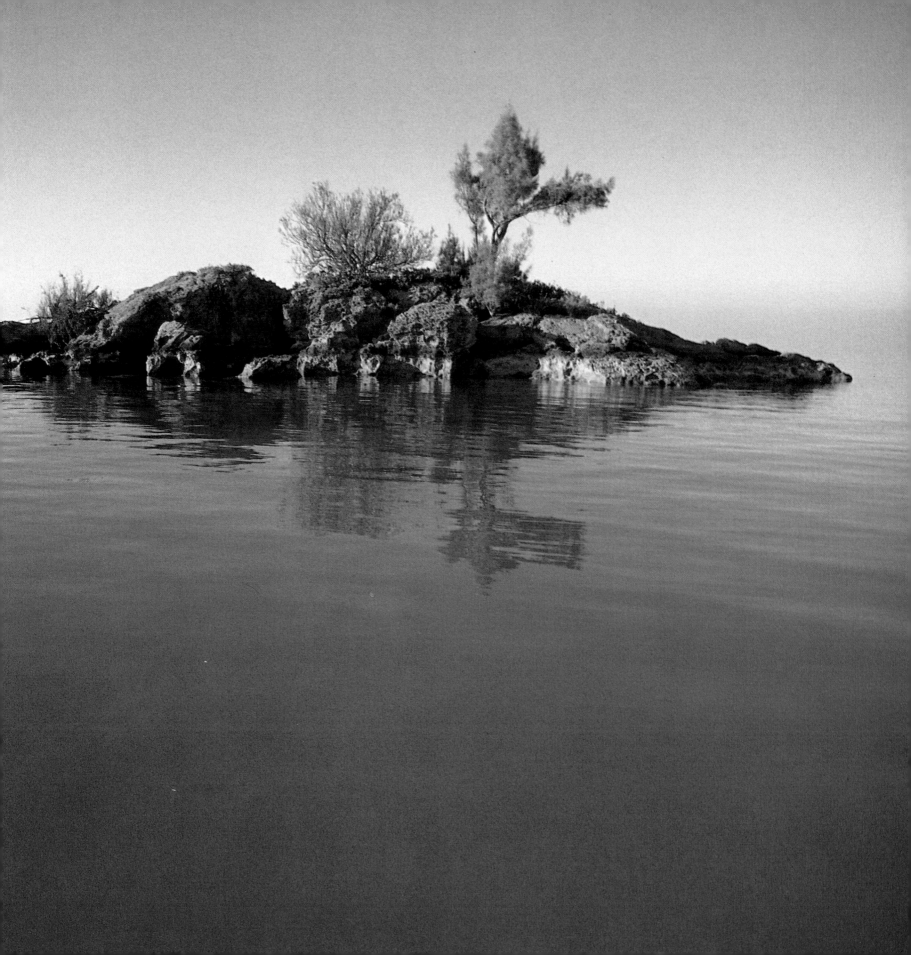

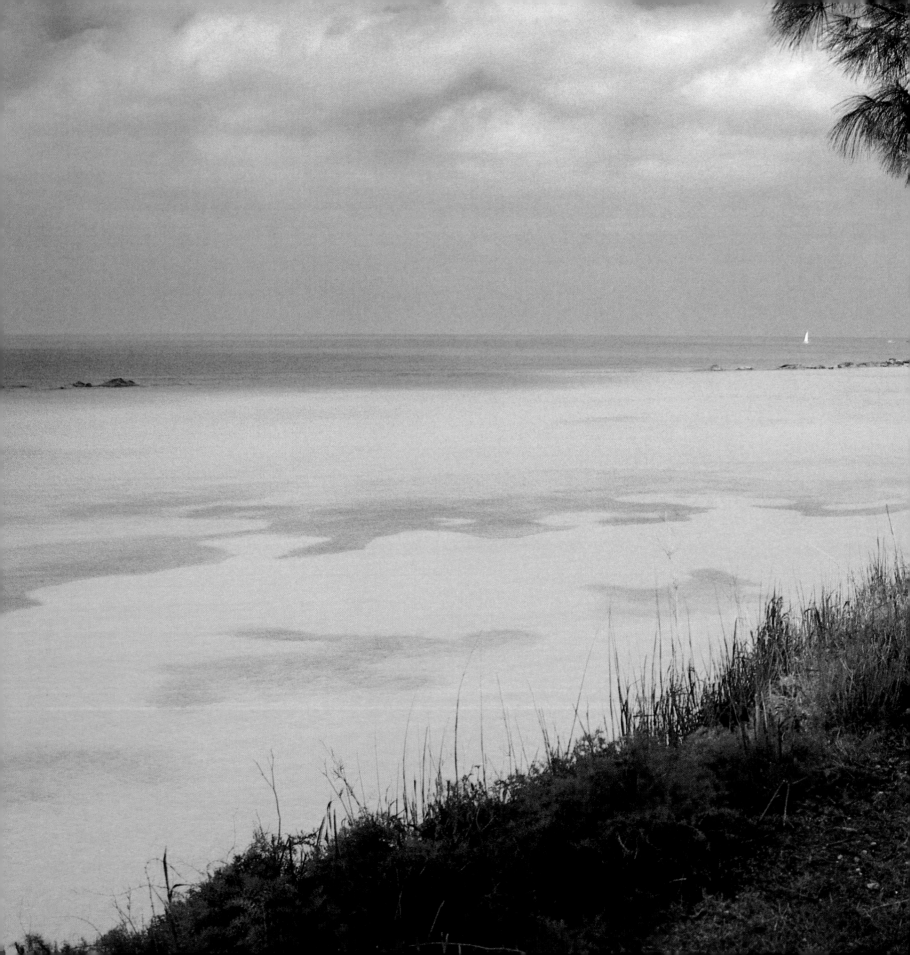

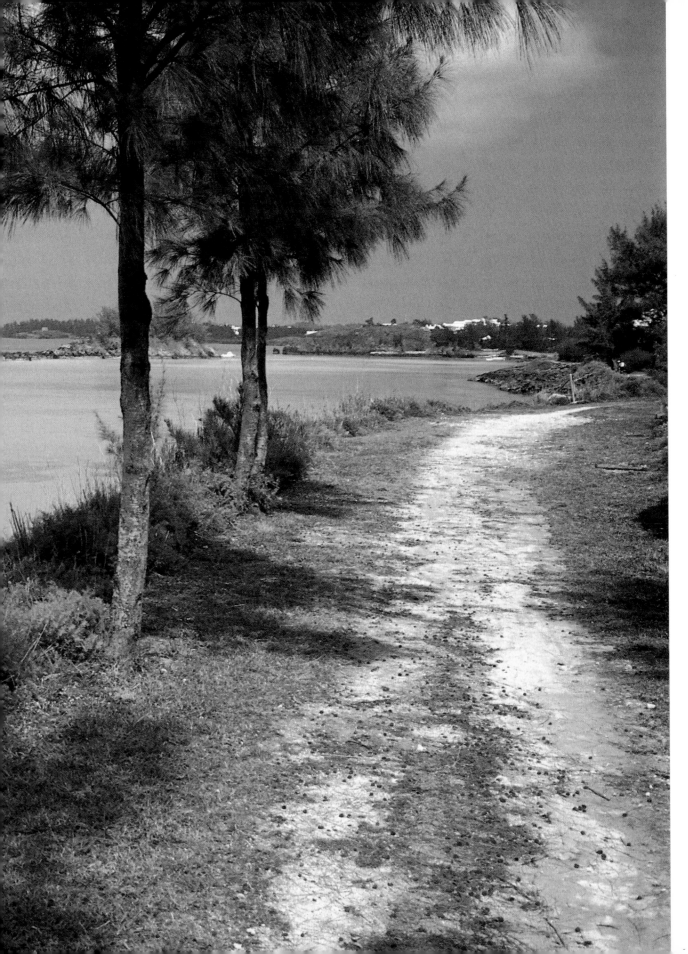

The Railway Trail near
Bailey's Bay.

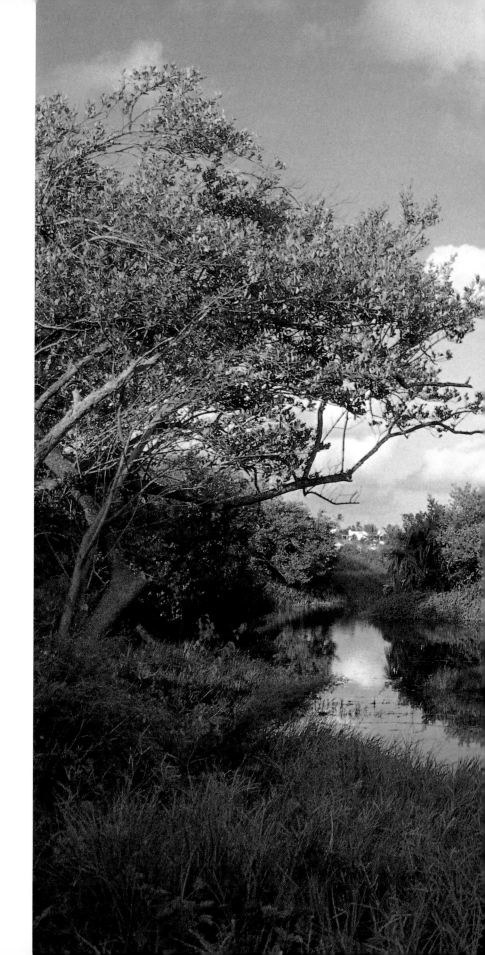

Buttonwood trees at
St. David's Head.

The Long Bay bird sanctuary.

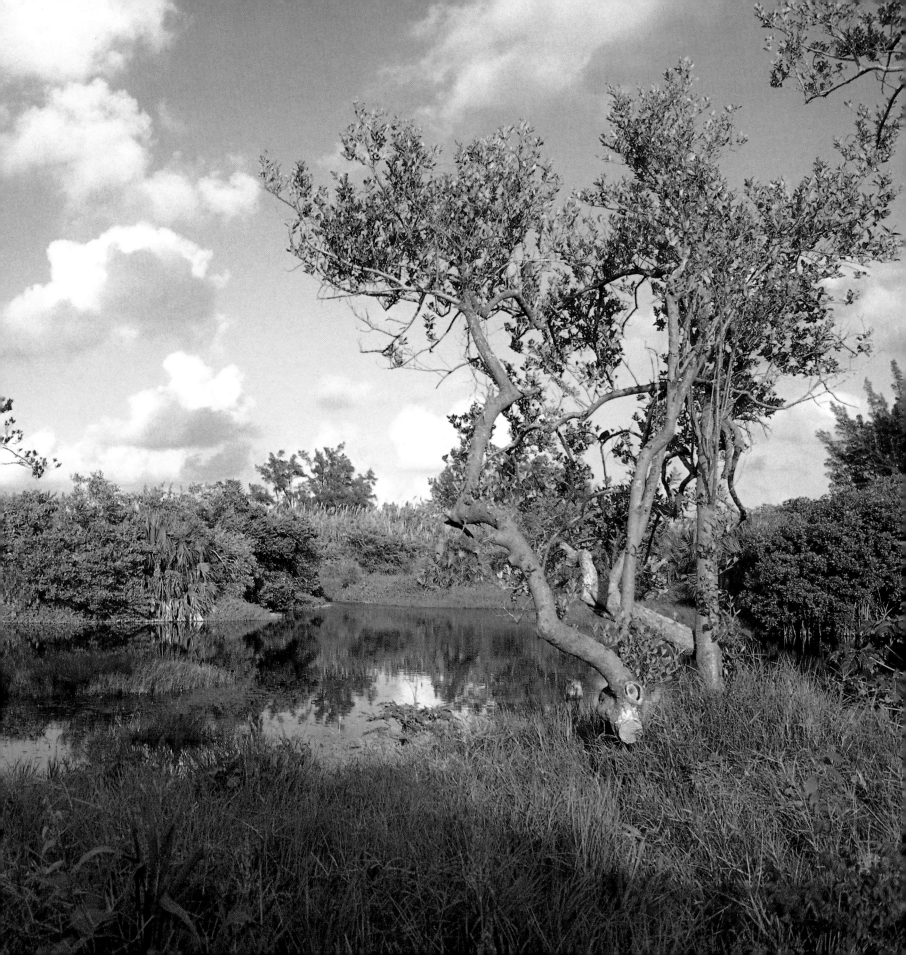

A Somerset farm track.

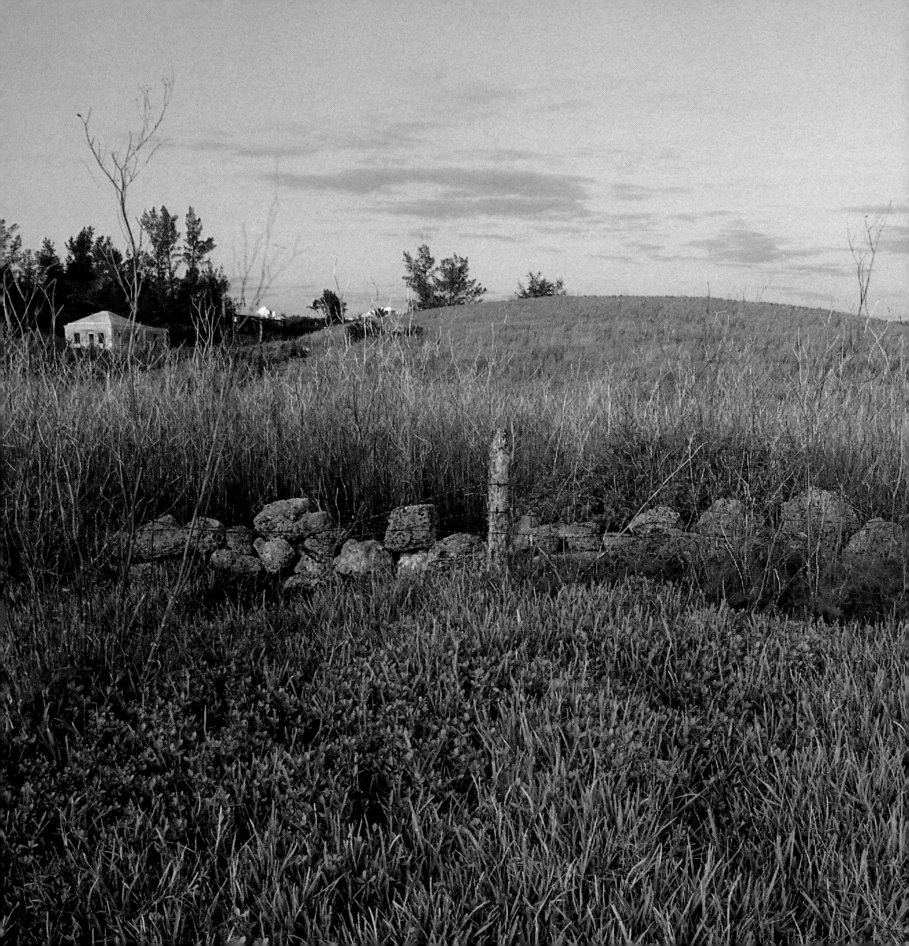

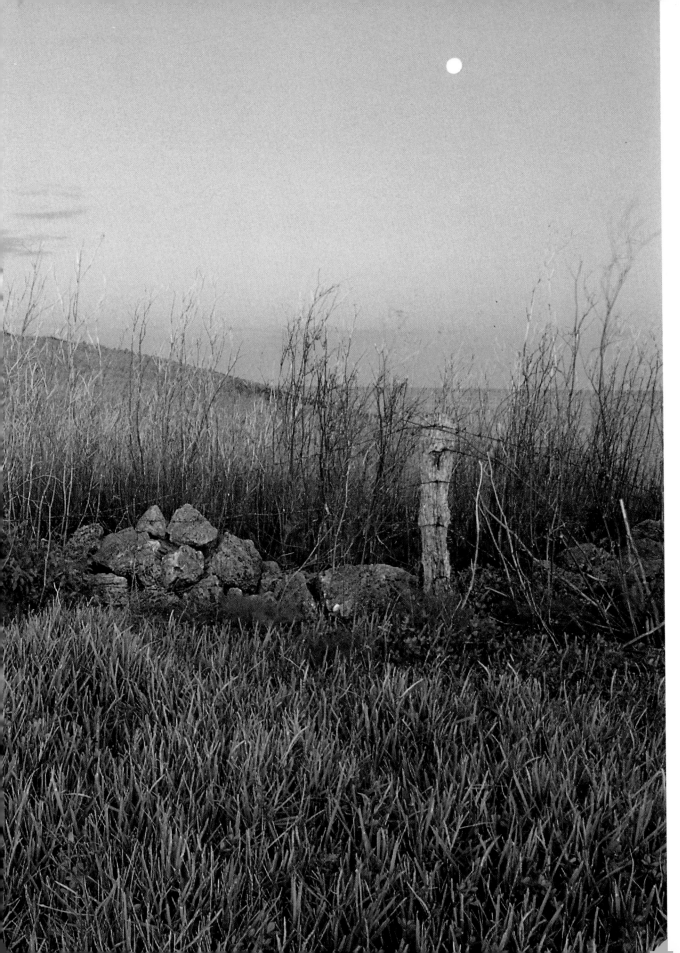

Moonrise at sunset over
Saucos Hill.

The view from
Gibb's Hill Lighthouse,
in Southampton.

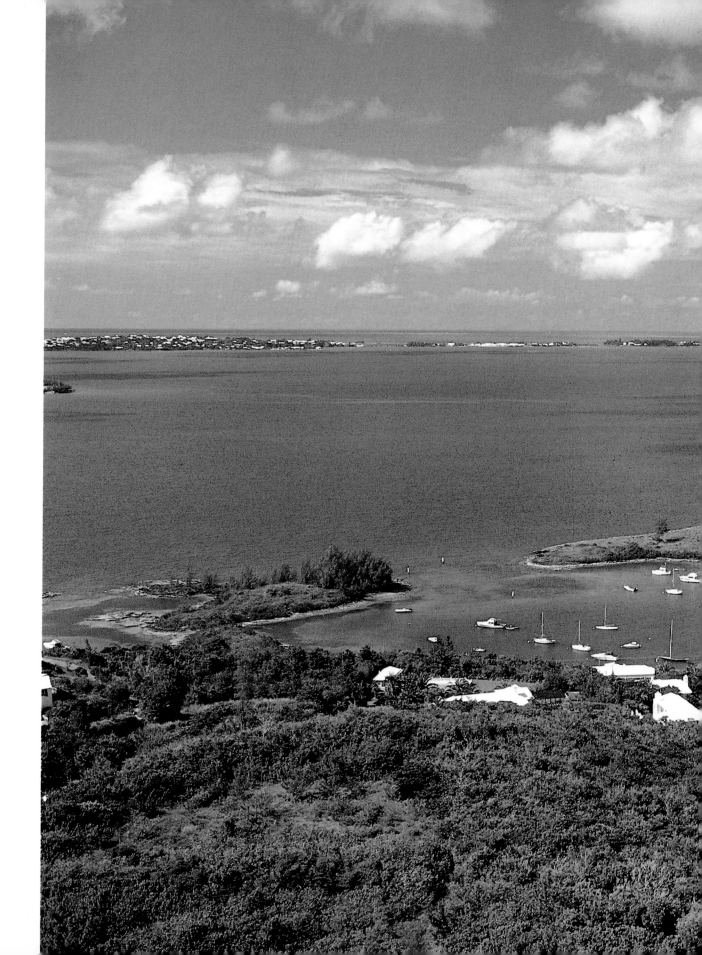

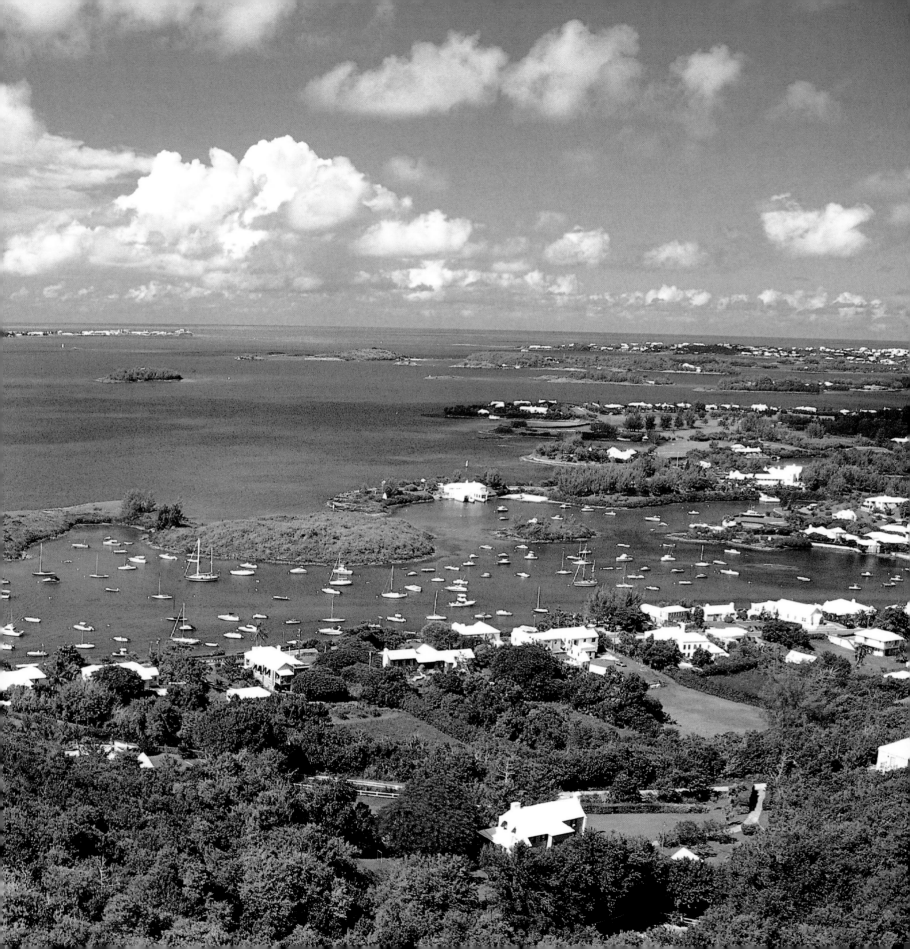

An oleander-strewn pathway.

Bermuda's fiddlewood
trees shed their leaves in
the springtime.

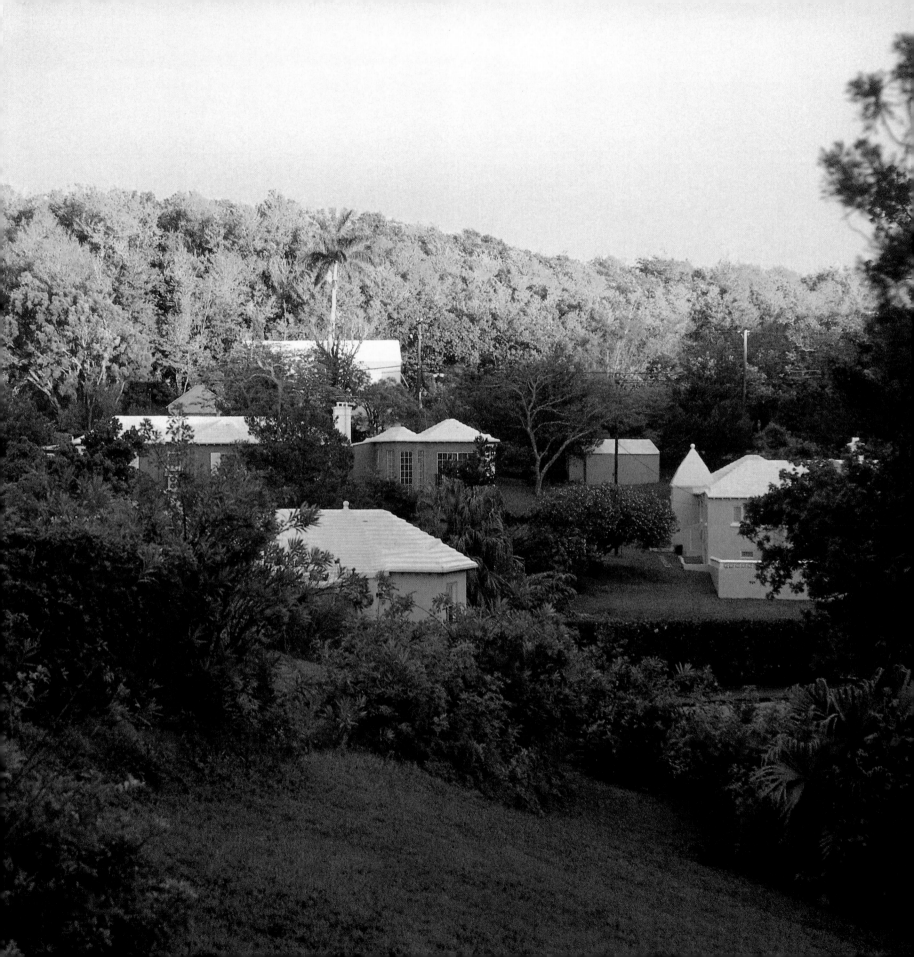

Carter House, St. David's Island. This little stone farmhouse, perhaps Bermuda's earliest, seems to grow out of the ground. The house was built in the seventeenth century of soft aeolian limestone cut from the hill. Its limewashed slate roof and stout chimney are of the same stone.

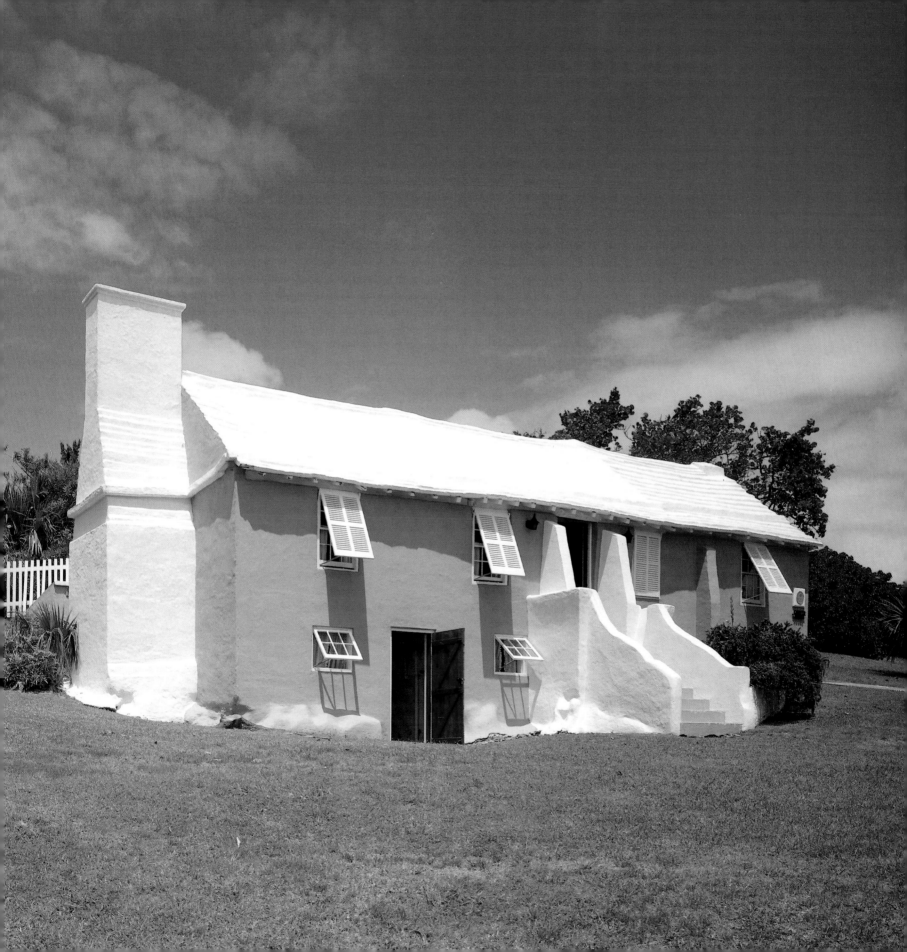

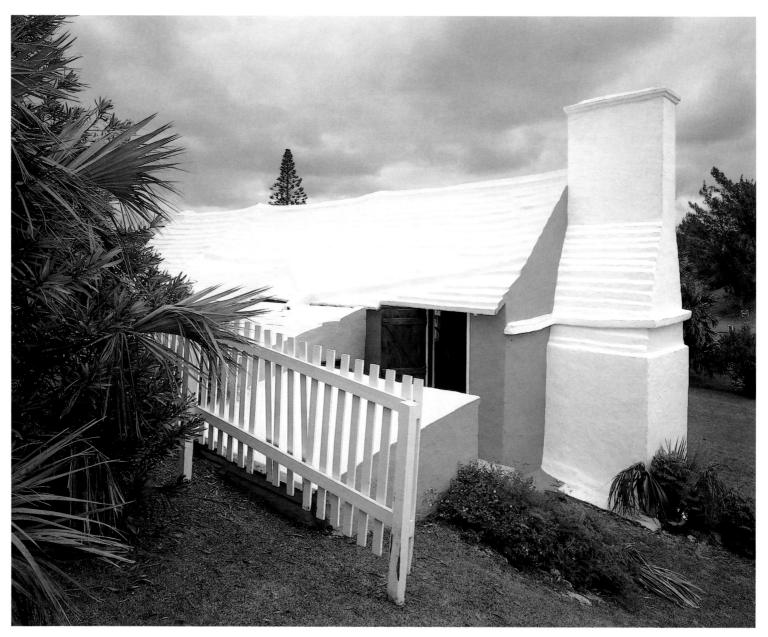

Carter House has only one
story at the back. Its roof,
smoothed by repeated wire
brushings and whitewash,
has fused into a single piece
of slate and sags gently
on old rafters. Raised gutters
direct water into the tank.

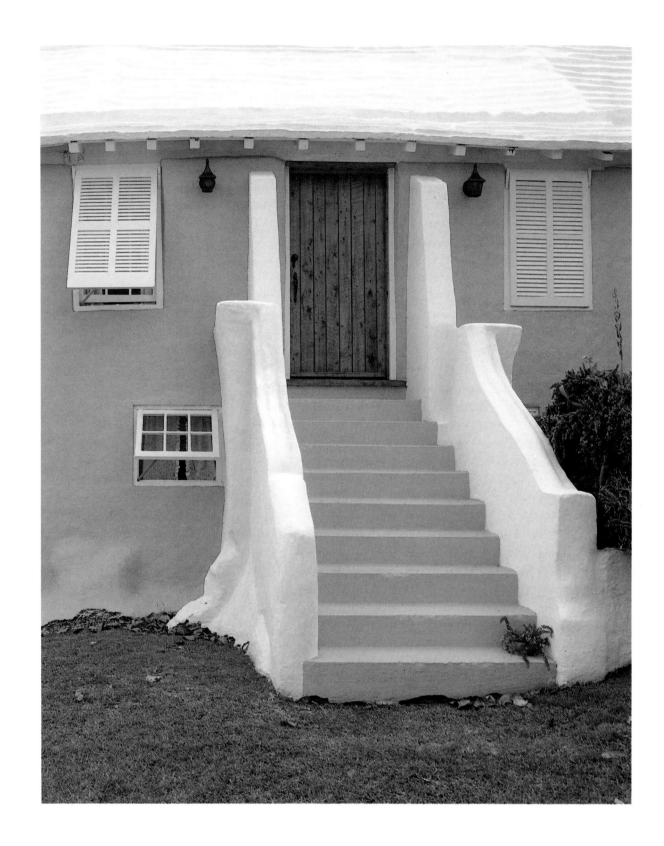

Stone steps buttress
Carter House against
the prevailing wind.

A cedar tree reflected on
the walls of Ellerslie,
a farm at Bailey's Bay that
produced onions and
Easter lilies in the nine-
teenth century.

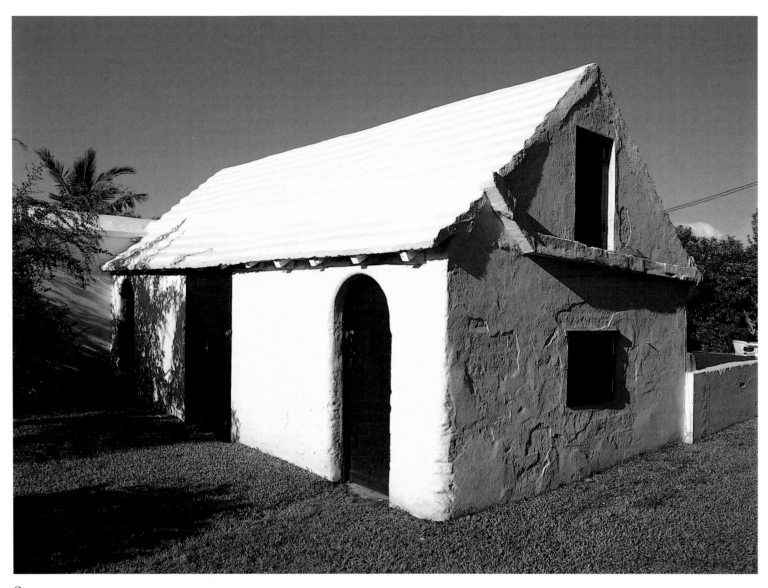

Open stone gutters once
channeled rainwater into a
tank beside Old Farm Barn,
at Bailey's Bay.

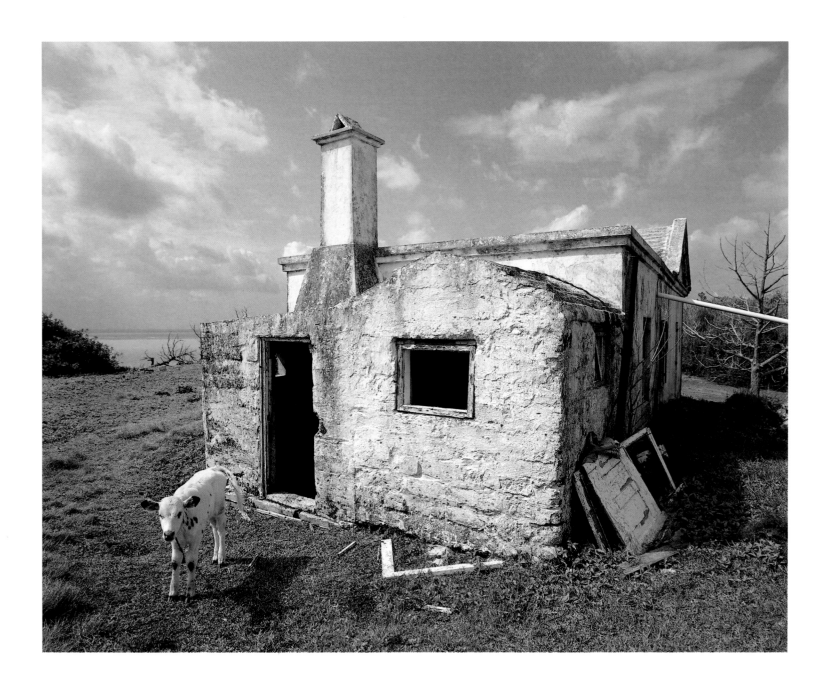

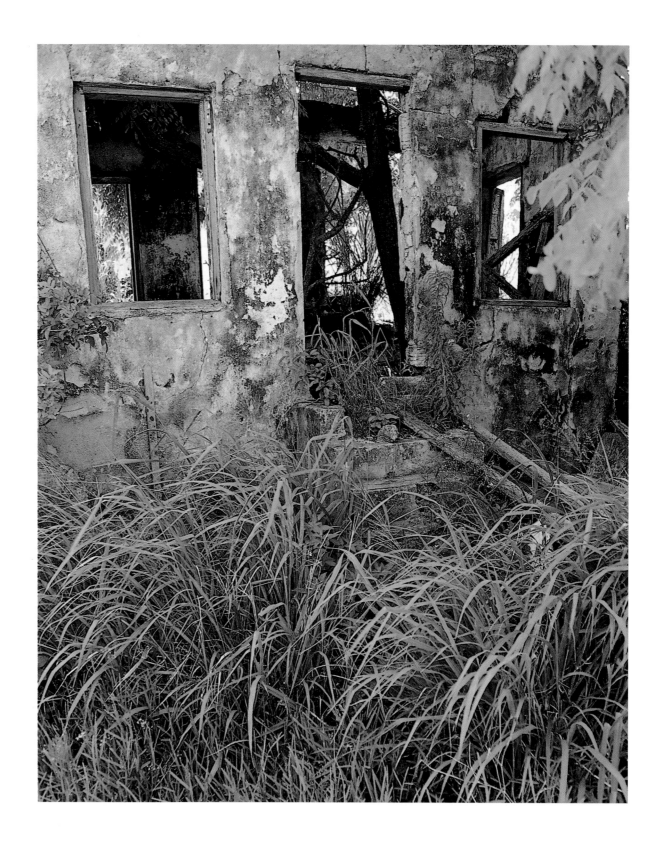

OPPOSITE AND RIGHT:
Many of Bermuda's small
farm cottages have fallen
into ruin.

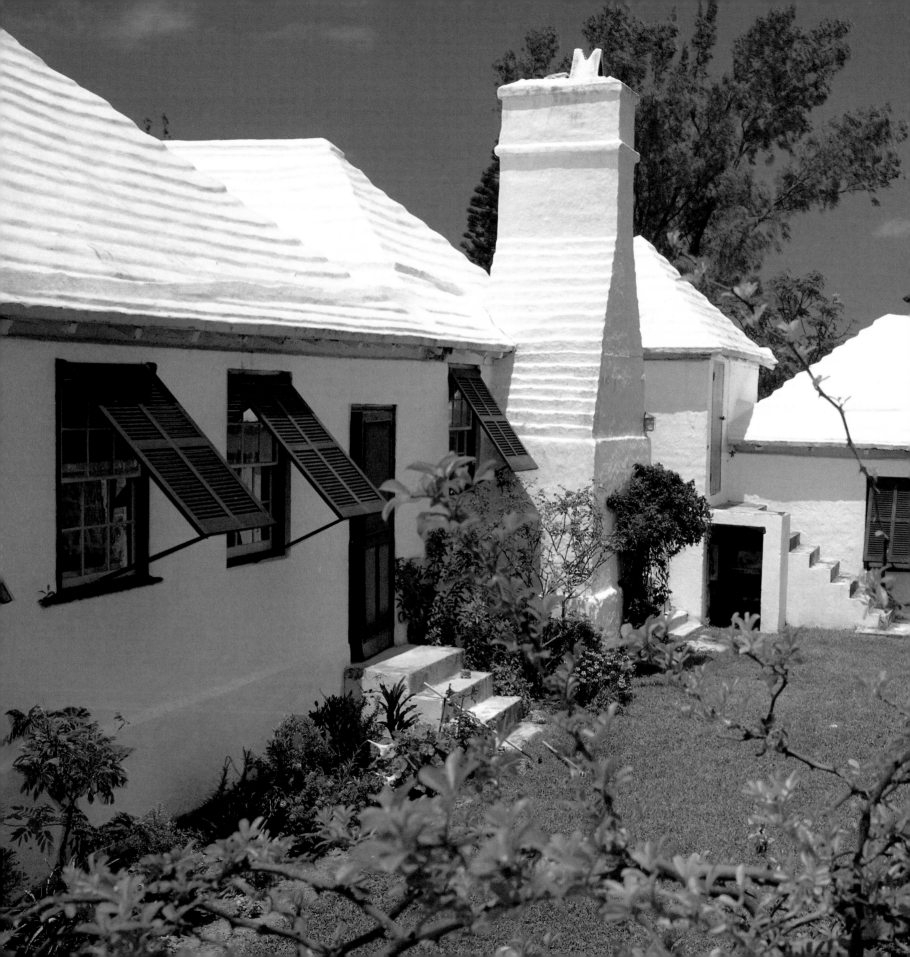

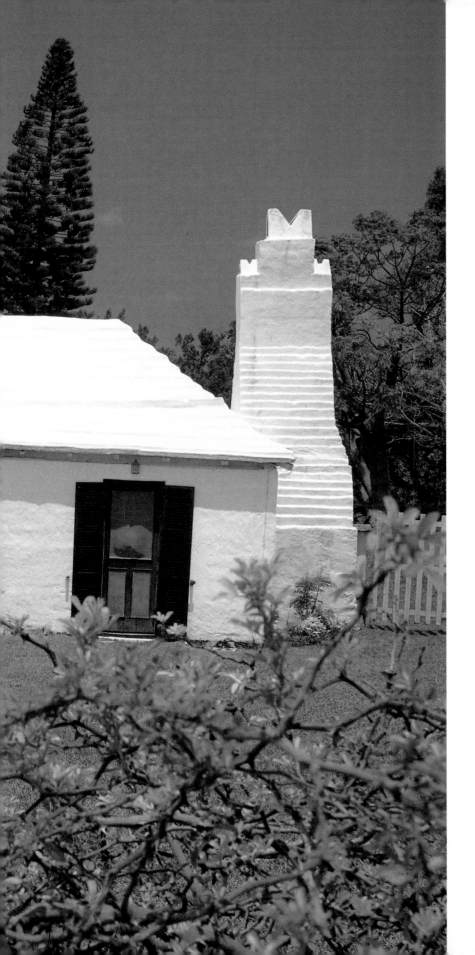

Church Hill House
in Sandys's Parish was a
prosperous farm in the
eighteenth century. Its yard
is now a sheltered garden.
Inside the house, an angled
cedar "knee" braces the
wall plate, reflecting con-
struction methods used
by shipbuilders.

Snapdragons and baby's breath at Locust Hall, a farm in Devonshire.

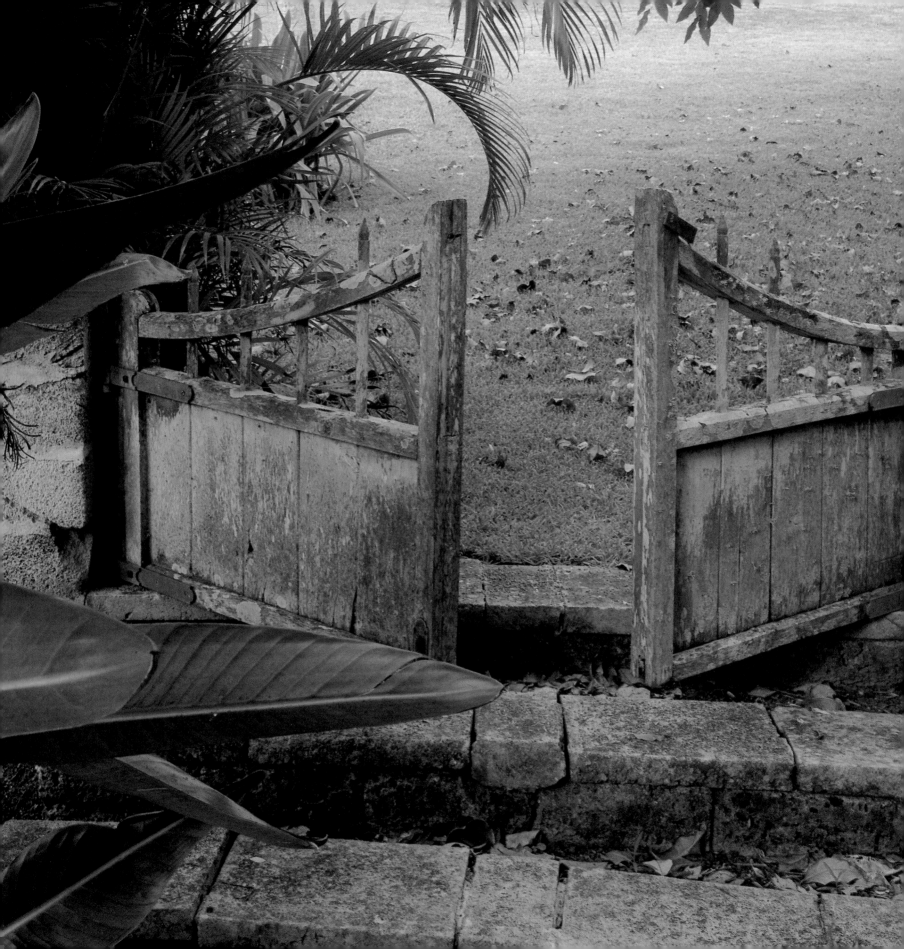

The garden gate at
Blackburn Place in Warwick.

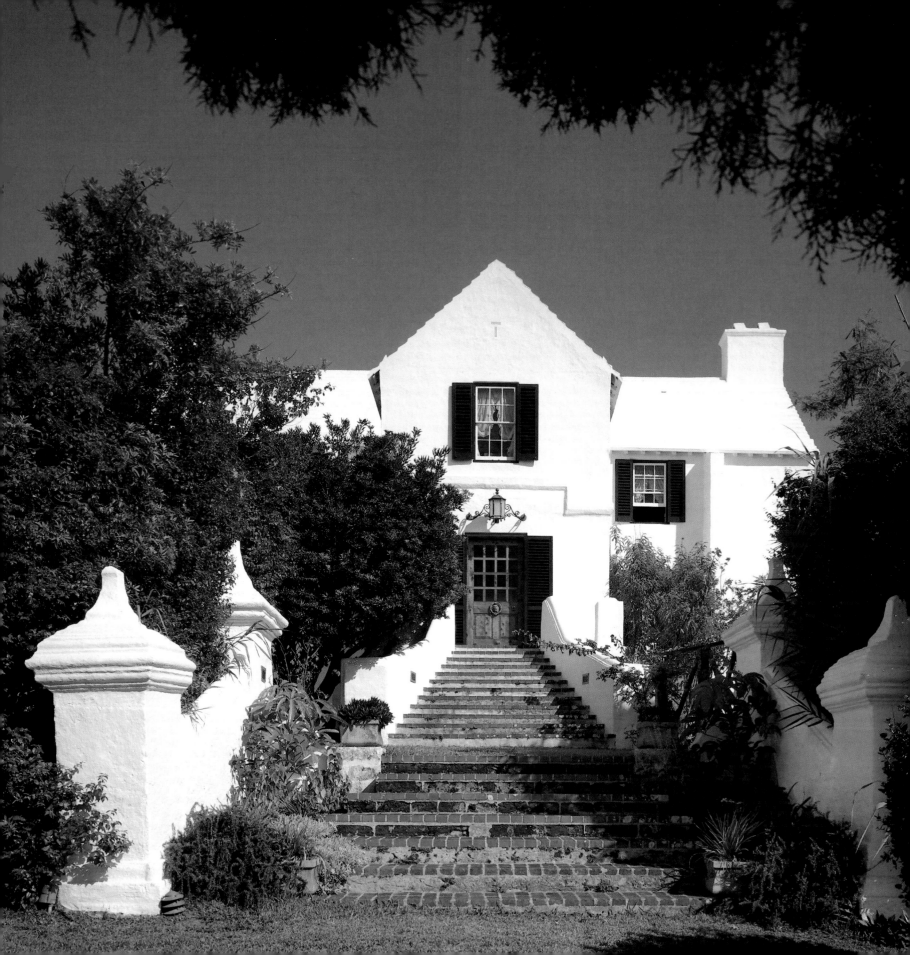

At Tankfield in Paget,
a broad "welcoming arms"
staircase faced with brick
leads visitors up to a closed,
projecting entry porch.
The porch is furnished
traditionally, as a waiting
area. A wooden pelmet
above the door excludes
drafts from the main room.

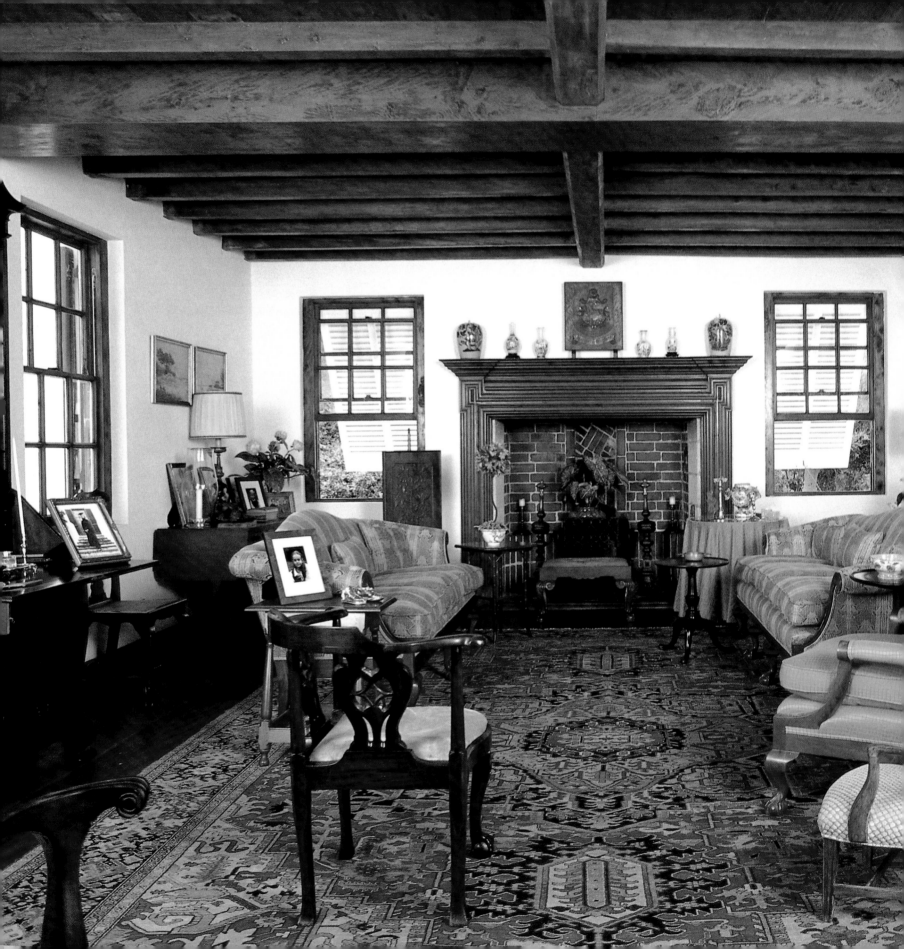

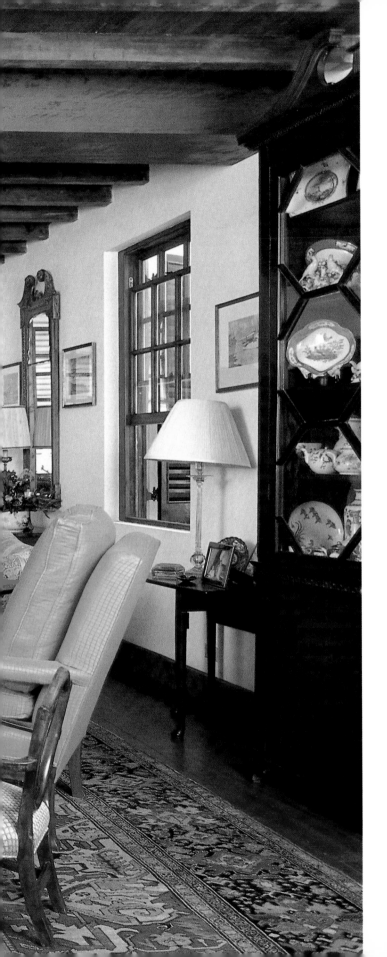

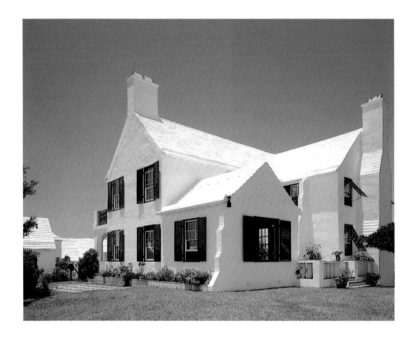

The principal room at Tankfield has exposed cedar beams and a bold bolection molding around the fireplace. Windows on three walls catch the breeze in summer; push-out louvered shutters screen the sun's rays. The collection of furniture in the house includes antique Bermudian pieces as well as American and English imports. There is also an important collection of Worcester porcelain.

The Tankfield land was originally part of the estate of Lord Paget. It eventually passed to John Trimingham, who built the present cruciform house soon after 1700. A recent single-story addition uses traditional methods and materials to blend harmoniously with the old house.

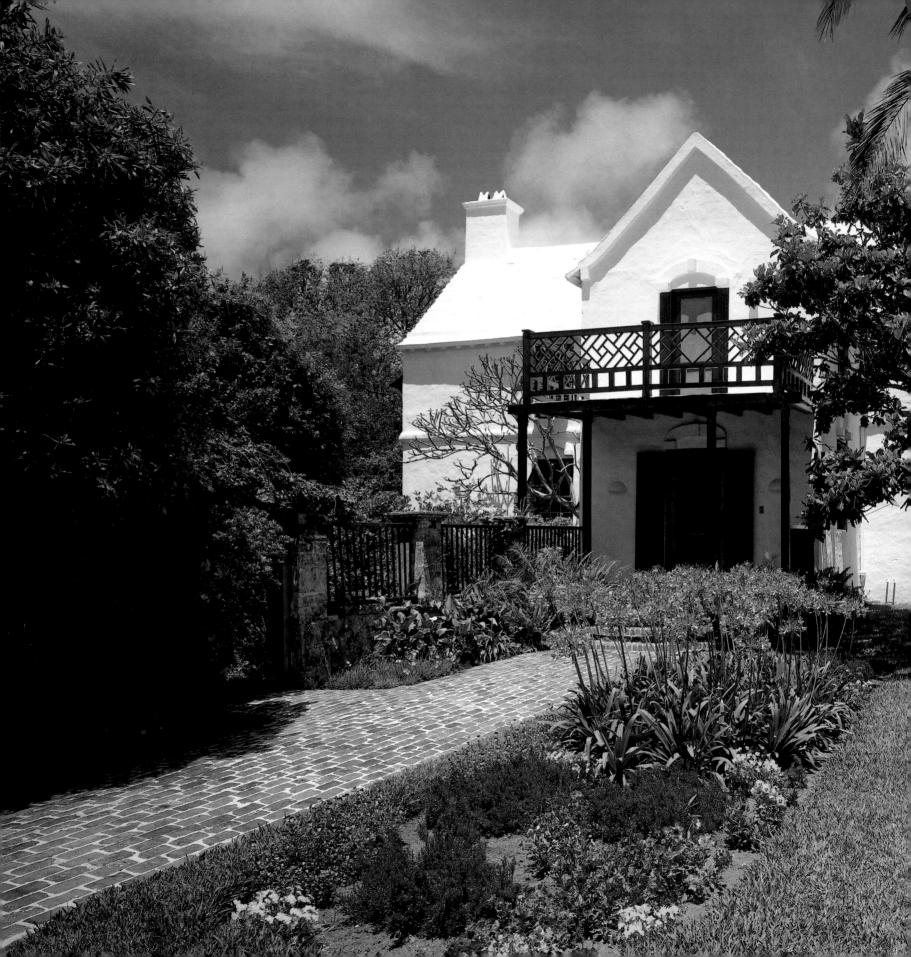

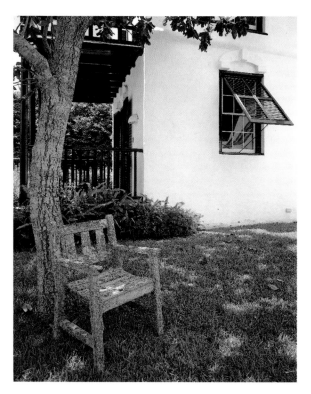

Inwood's two stories are expressed by a strong half-round stone belt course. The decorative "eyebrows" over the windows help to channel rain to the side.

Inwood, a fine cruciform house in Paget, was built by Colonel Francis Jones in 1700. Jones was sent to Bermuda by William III to act as the Bermuda Company's searcher. The wide arms of the house contained the hall and parlor; there was a front entry porch and a kitchen with fireplace behind the stair hall in the back wing. A walled kitchen garden kept the hogs off the vegetables. The wooden veranda was added later in the eighteenth century in the Chinese Chippendale style.

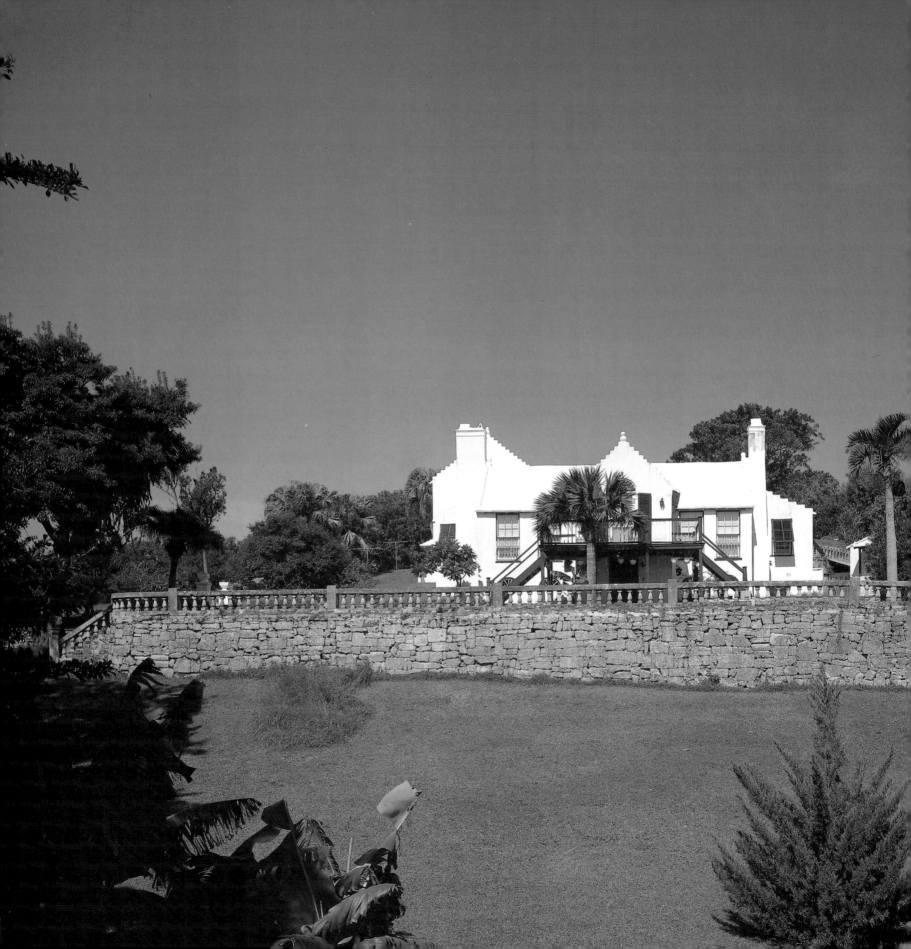

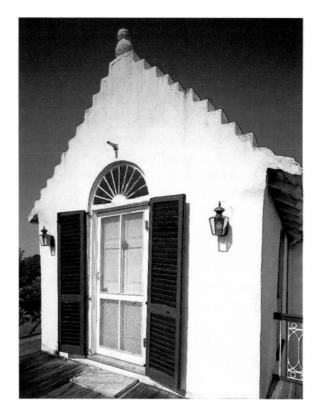

The crow-stepped gable is
an expression of the lapped
stone-slate roof.

Somerville, in Smith's Parish, was built for the widow of John Gilbert. In his will of 1699, Gilbert instructed his sons to provide a dower house with "The Hall Twenty and One foot Long the Parlor fifteen foot Long Sixteen Foot Brode Each, Two back Chambers each fourteen foot Square with Entry proportionable; and Porch Twelve foot Square with Cellar under the Hall Parlor and Porch, with Two Chimnys Suitable and hearths and one of the Cellers and Chimney most Conveniant Fitted for Kitchen."

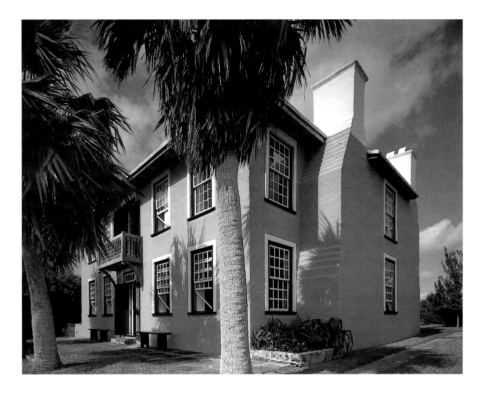

Verdmont, with an uncommon square plan, is thought to date from the very early eighteenth century. It is owned by the Bermuda National Trust, and is now a museum in Smith's Parish. Sturdy double chimneys on the side walls have spacious closets neatly inserted between them.

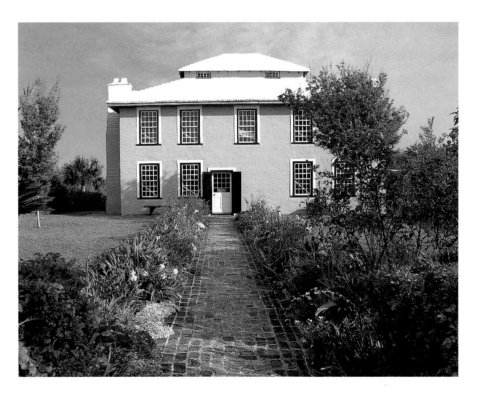

The door of the north facade sits off-center to accommodate a grand staircase. The house has interior shutters, leaving fine early-eighteenth-century sash windows visible. The broken roofline may once have incorporated a cupola or "widow's walk" from which to scan the horizon for ships returning home.

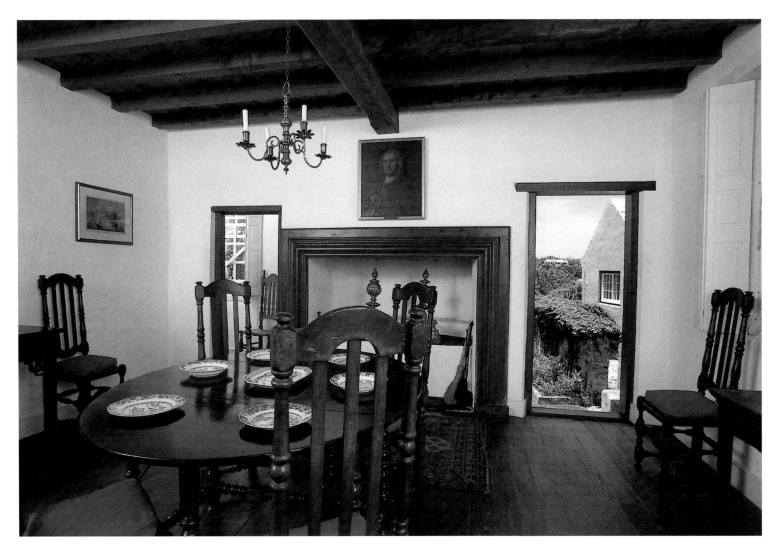

Through the open door of
the dining room is an
outdoor kitchen, built to
keep heat and smells at
a polite remove. The grace-
ful, high banister-back
chairs also date from the
early eighteenth century.

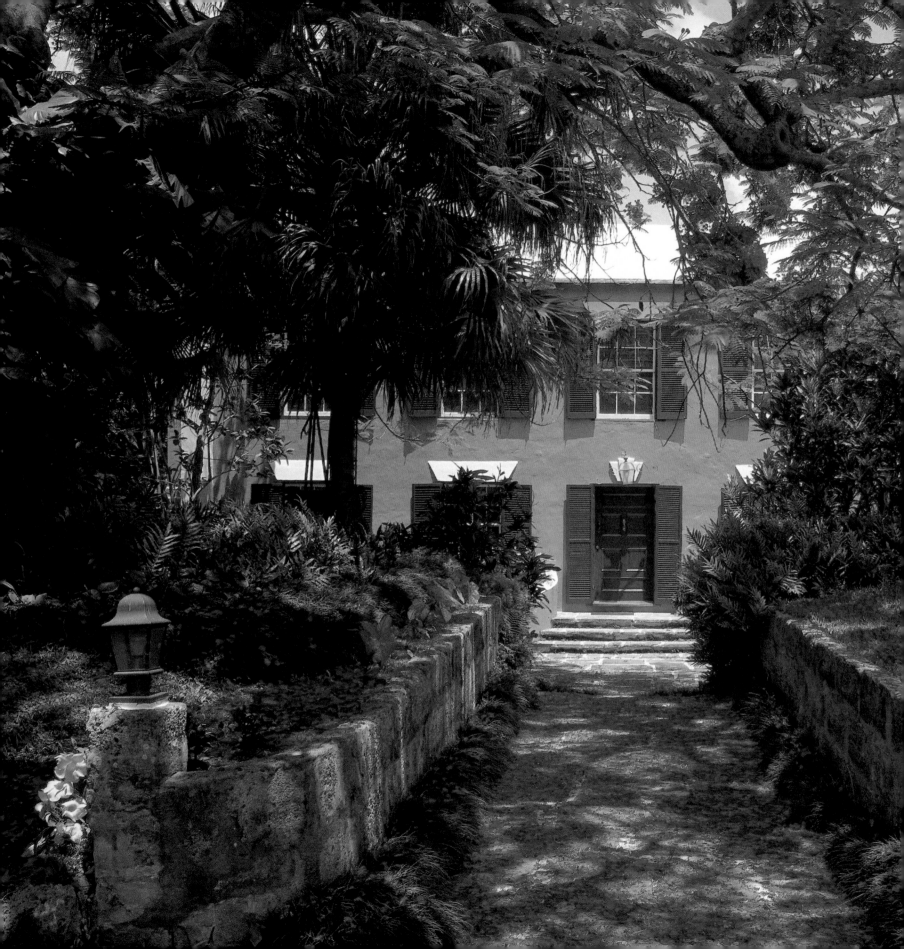

In front of Sleepy Hollow,
in Warwick, built in the
mid-eighteenth century, a
poinciana tree spreads
its branches and scatters its
red blossoms.

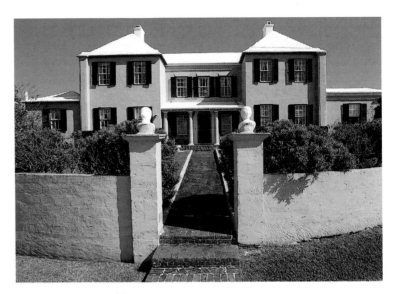

Bloomfield, in Paget. The north facade has two projecting wings that form a flattened U-shaped plan with a porch cradled in between. Classical busts acquired on a grand tour of Italy were added to the gateposts by an owner in the eighteenth century.

Like most Bermudian houses, Bloomfield was added to over time. The oldest section, once an outdoor kitchen, is now incorporated as a wing of the house. A symmetrical matching wing was added sometime after 1860. The house has been in the Gosling family since that time.

87

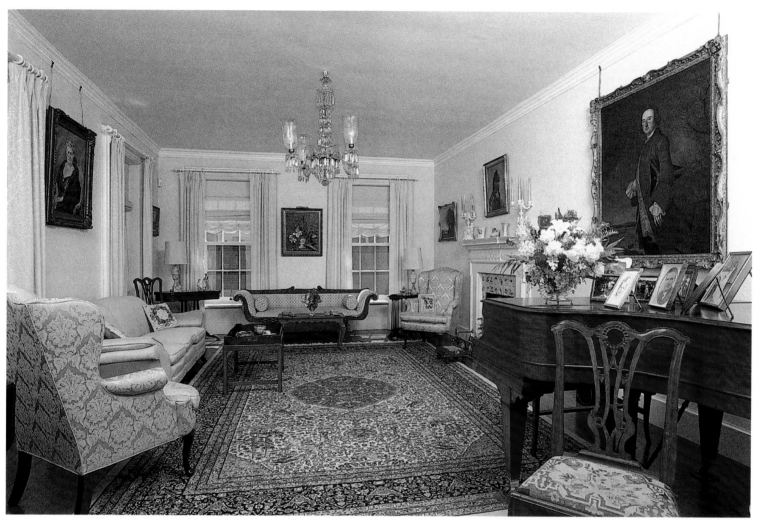

The drawing room at
Bloomfield contains
Bermuda cedar Chippendale
chairs and a fine portrait
by the American painter
Joseph Blackburn, who
visited the island in
1752–53. Blackburn's first
known work is from this
Bermuda trip.

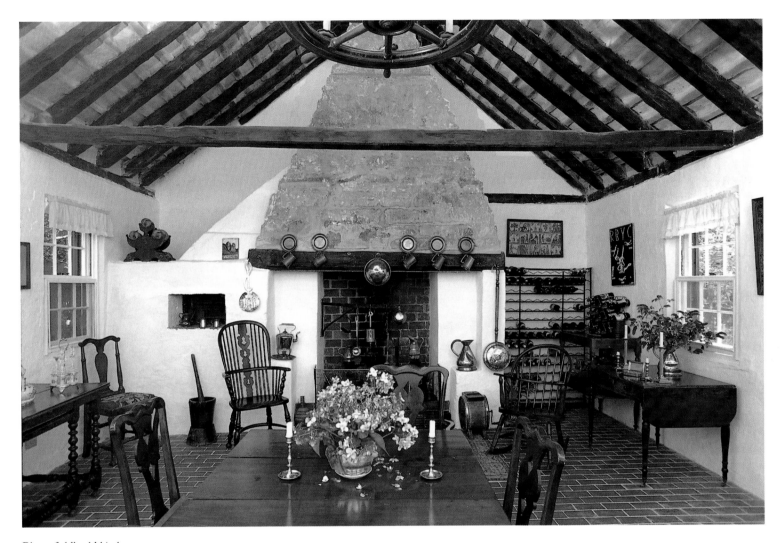

Bloomfield's old kitchen,
with exposed rafters, a
broad, brick-lined fireplace,
and an oven for baking, is
now a games room.

Milford sits high on a
hill in Paget overlooking
Hamilton Harbor.
The square-fronted, late-
Georgian house is
embellished with bold
neoclassical details.

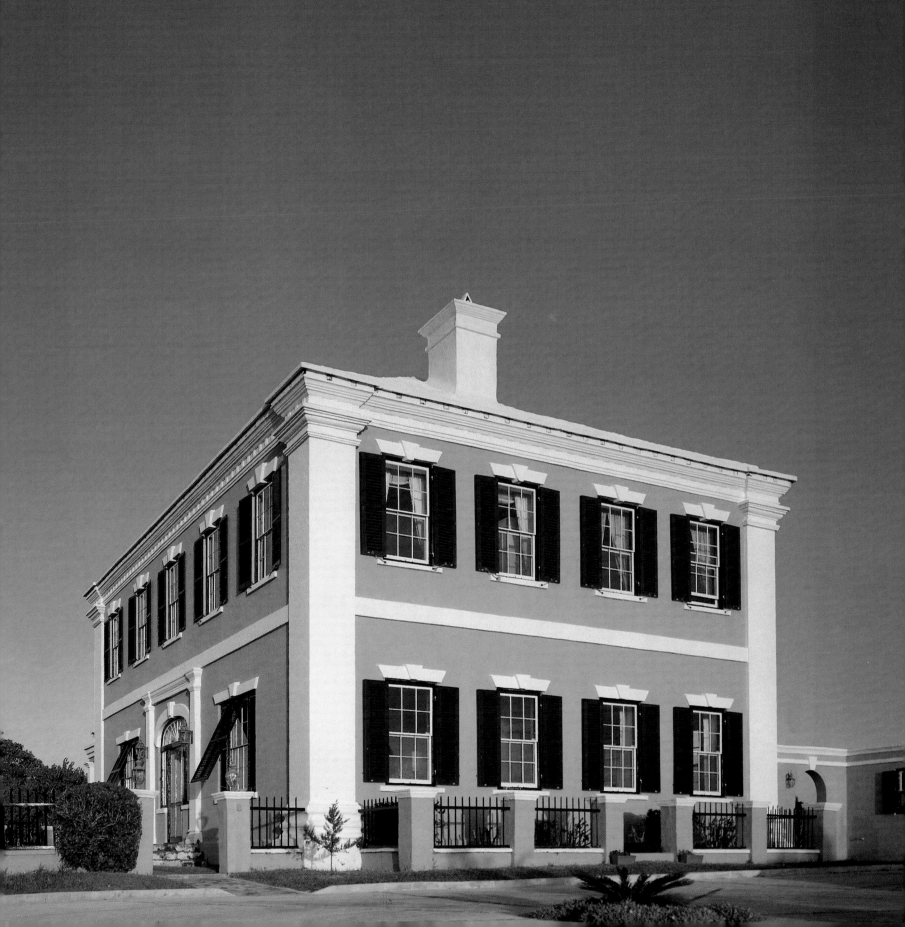

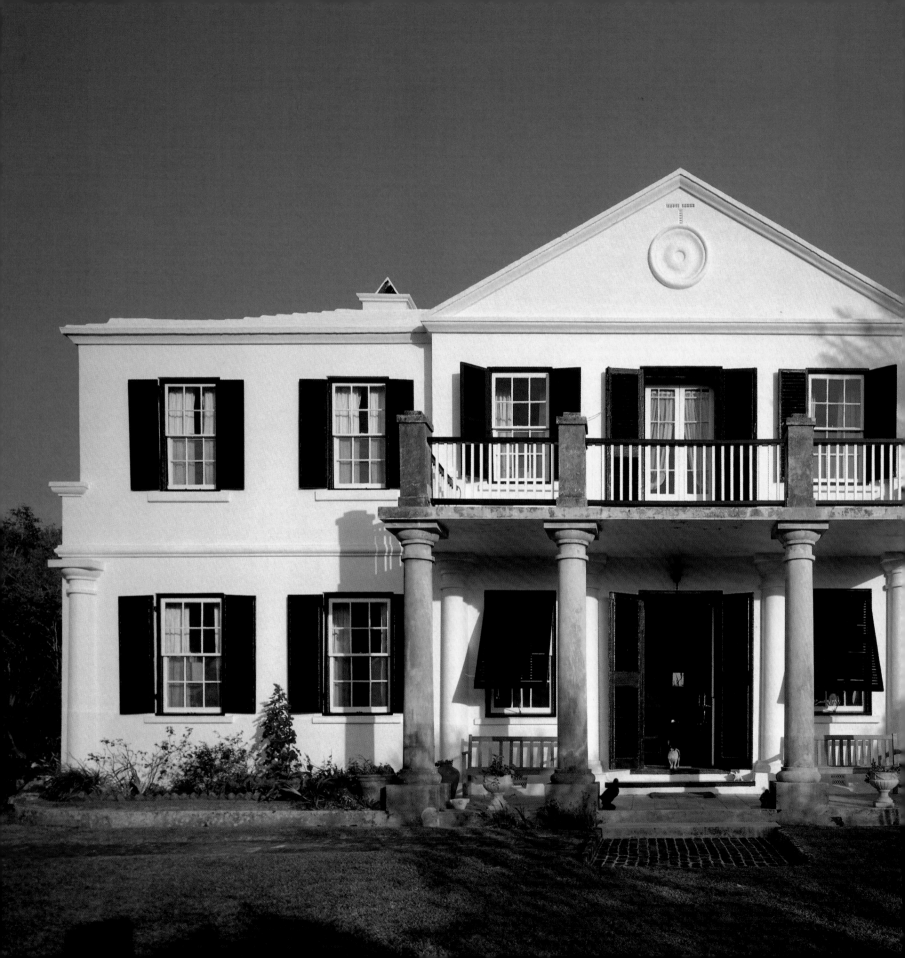

Orange Grove stands on part of the land that was owned by Sir Thomas Smith when the Bermuda Company was founded in the early 1600s. Since 1788 the house has been in the Sears and Zuill families, though it was much altered in the mid-nineteenth century.

In the Orange Grove
garden, a small stable is now
used for storing firewood.

Two rustic cedar chairs,
made in the early twentieth
century by Scott Pearman,
a local businessman with
an eccentric hobby.

Woodside, in Devonshire, was
built about 1865 as a one-story
cottage and was extended
several times. Its lush garden
provides flowers for cutting in
the spring and shrubs that flower
year-round. Salvia and
agapanthus bloom among
the chrysanthemums.

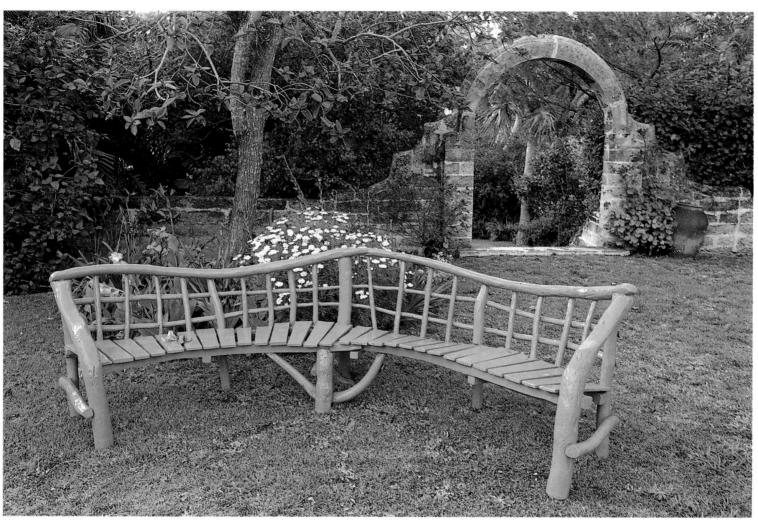

A Scott Pearman garden
bench. An amateur furniture-
maker, Pearman's great
delight was to collect oddly
shaped cedar boughs,
finding just the right piece
for each job.

Bermuda's mild, subtropical climate allows palm trees to flourish alongside temperate plants in the Woodside garden, resulting in a distinctive and vibrant floral landscape.

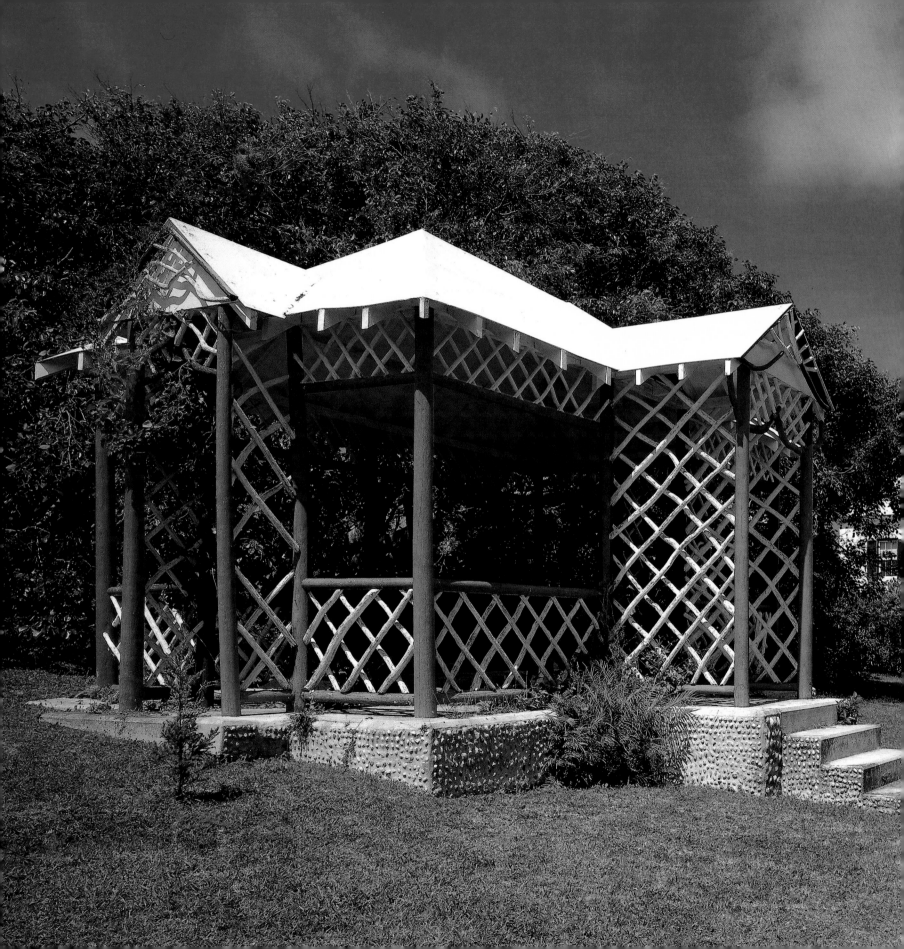

The gazebo at Rockmore
Farm, Smith's Parish.

Nineteenth-century
Rocklands, in Paget, its
standing dead cedar tree
covered with a ghostly
shroud of Spanish moss.

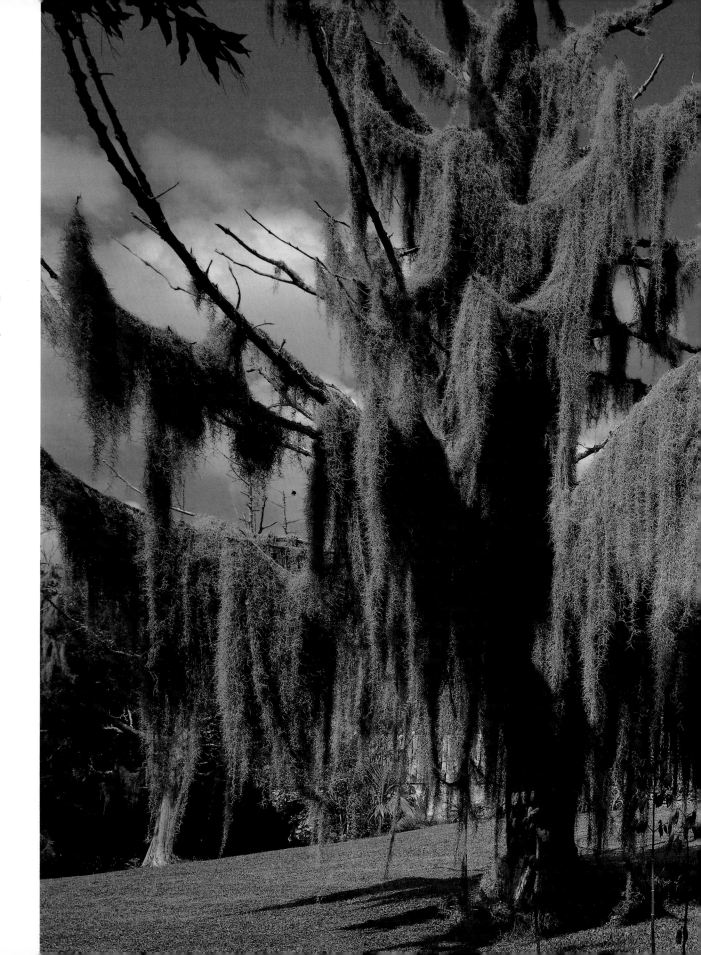

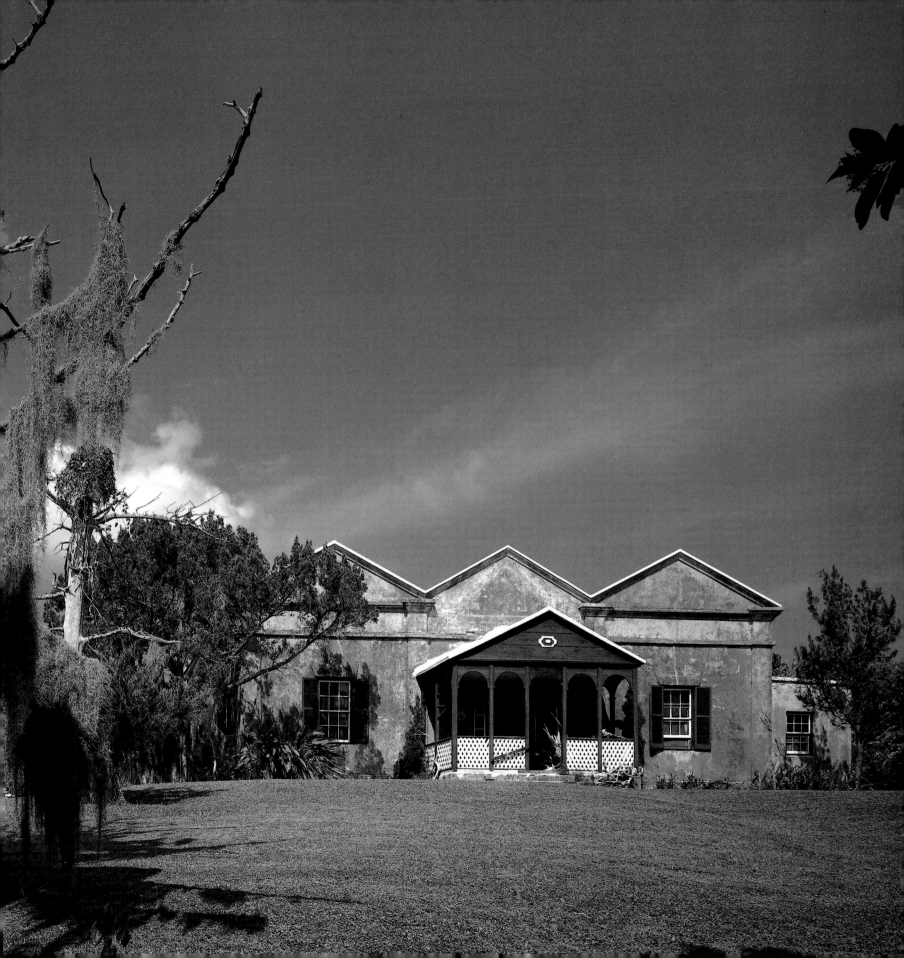

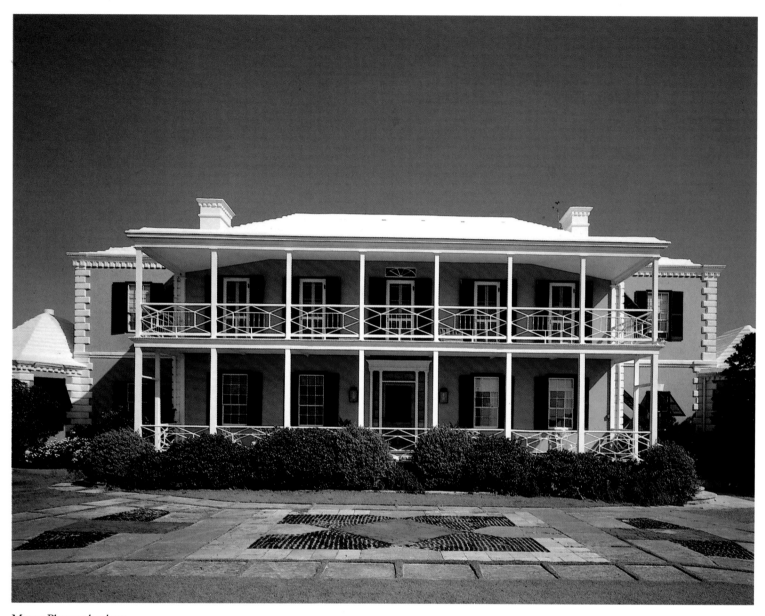

Mount Pleasant has been altered several times. First a cottage was built on the land in 1740; today's house grew around it. In the 1930s an American family made extensive changes, but the house is now under Bermudian ownership.

A cedar chest on "onion"
feet stands in the stair hall
beneath slender cedar
banisters at Mount Pleasant.
A collection of antique
maps of Bermuda dating
from as early as 1628 hangs
in the stairwell.

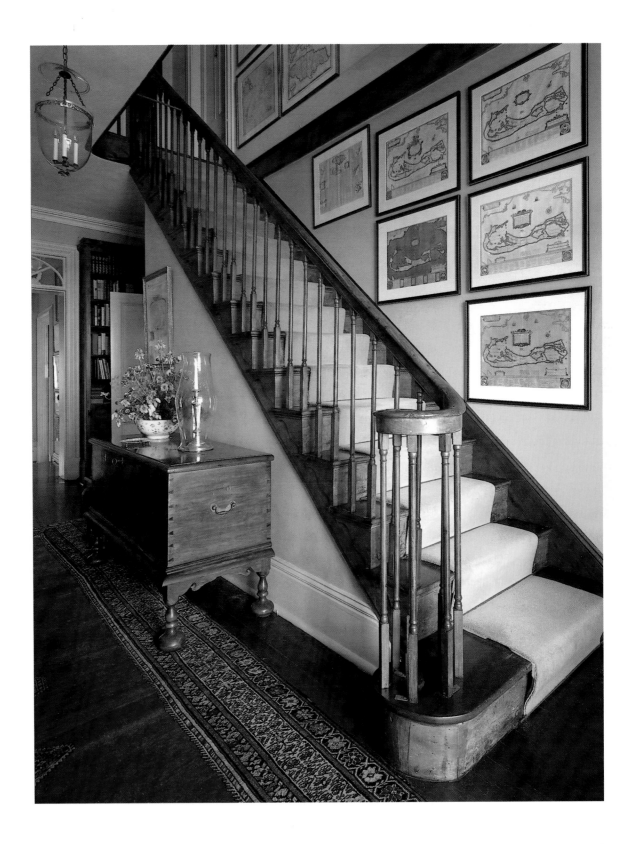

The garden facade of
Mount Pleasant in the late
spring. A large, south-
facing sitting room and the
verandas were added to
the house in 1870.

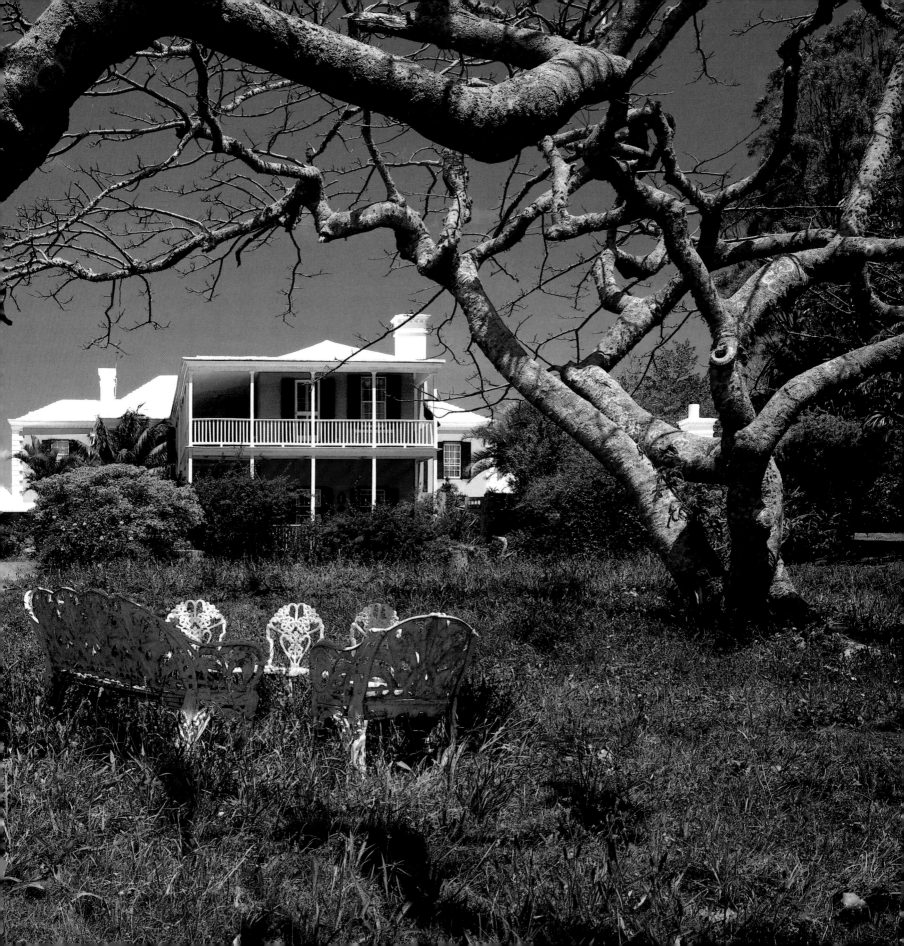

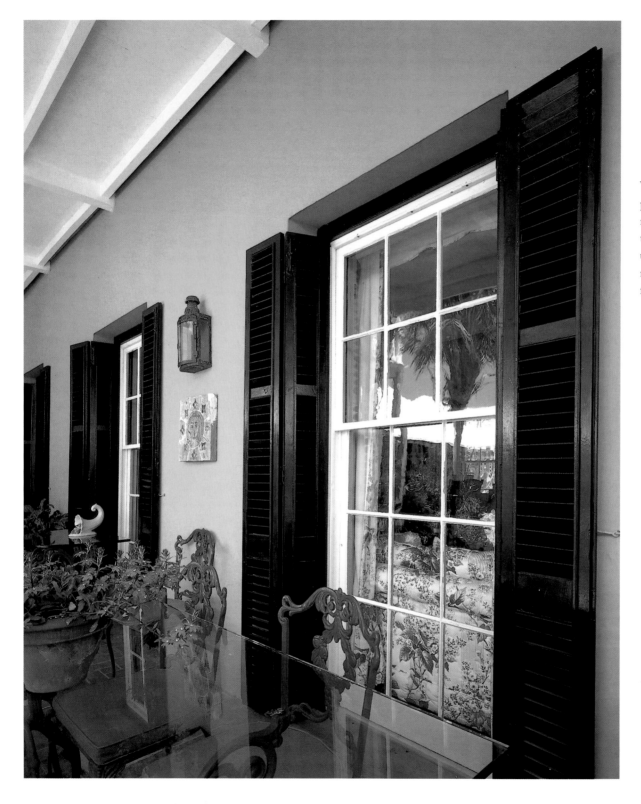

Windows on the side porch at Mount Pleasant reflect the oldest wing of the house, which was once used as a courthouse by a member of the Harvey family, the original owners.

Cutting beds in the Mount Pleasant garden.

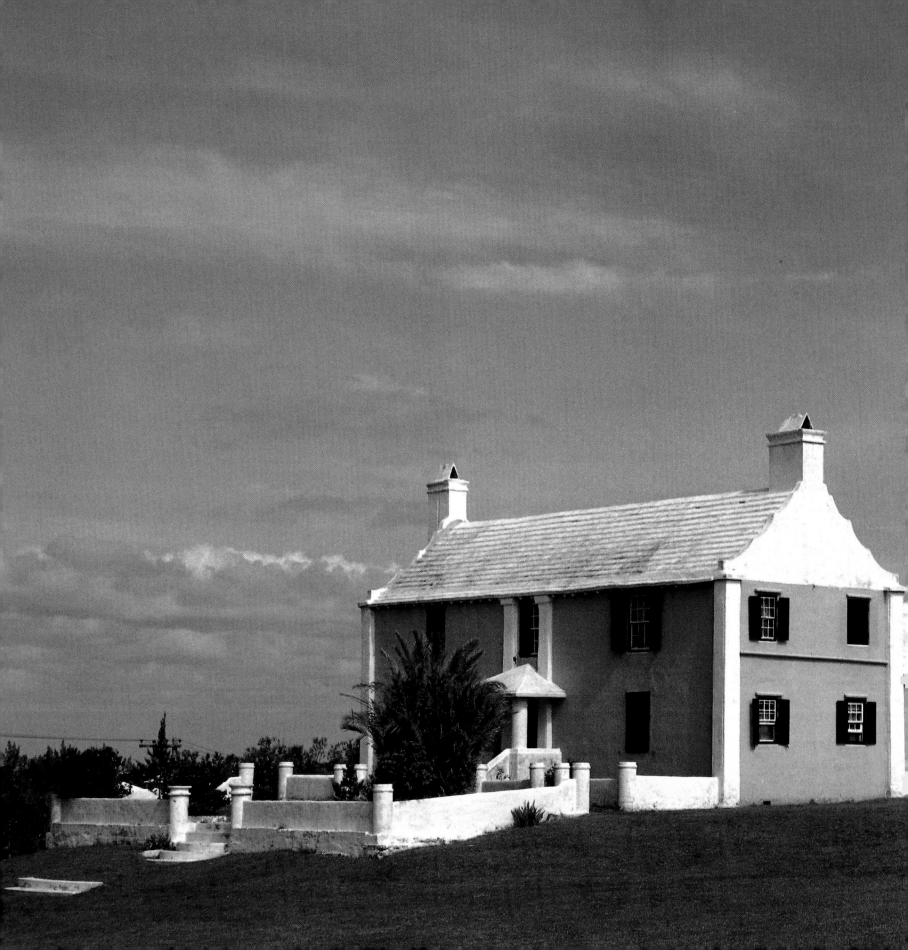

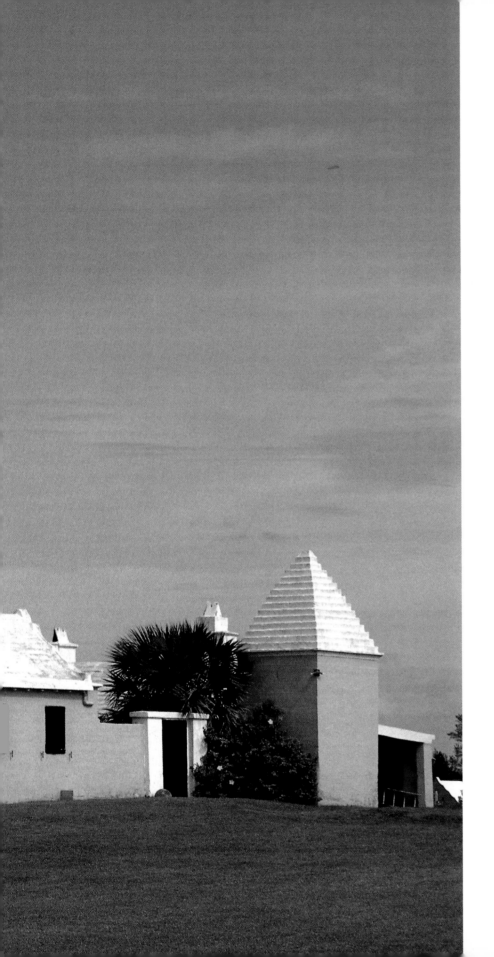

Cedar Hill, in Somerset,
dates from the mid-
eighteenth century.

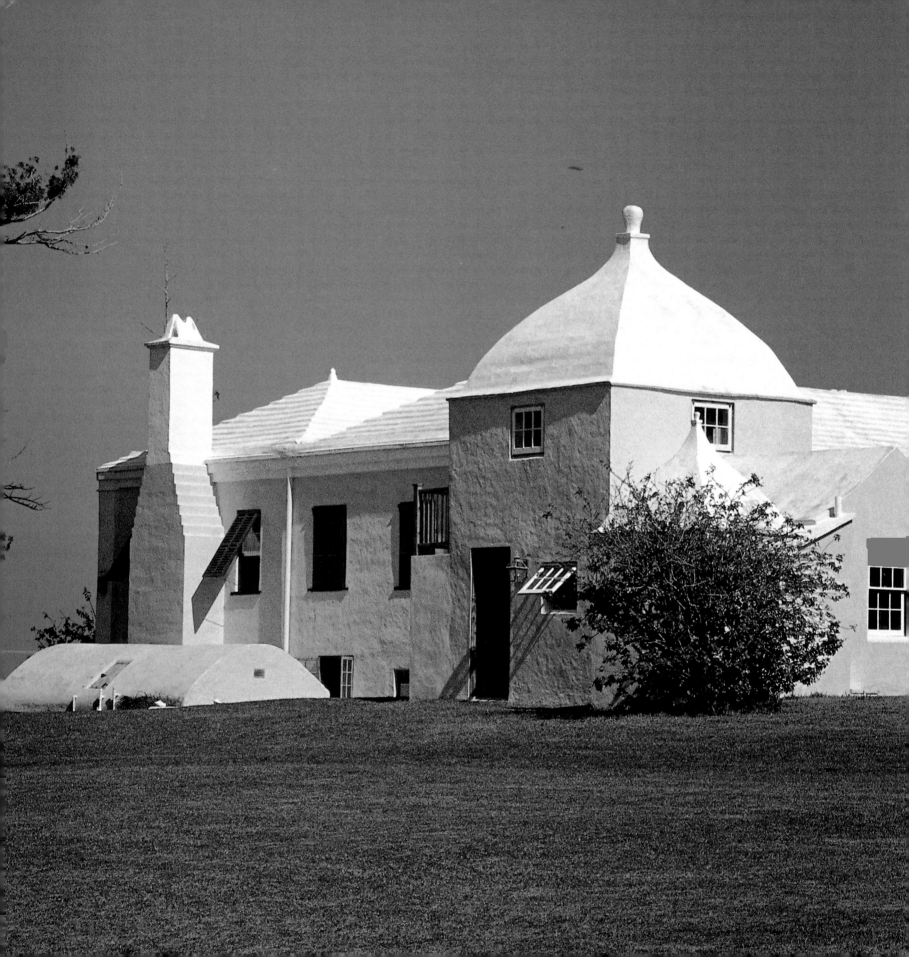

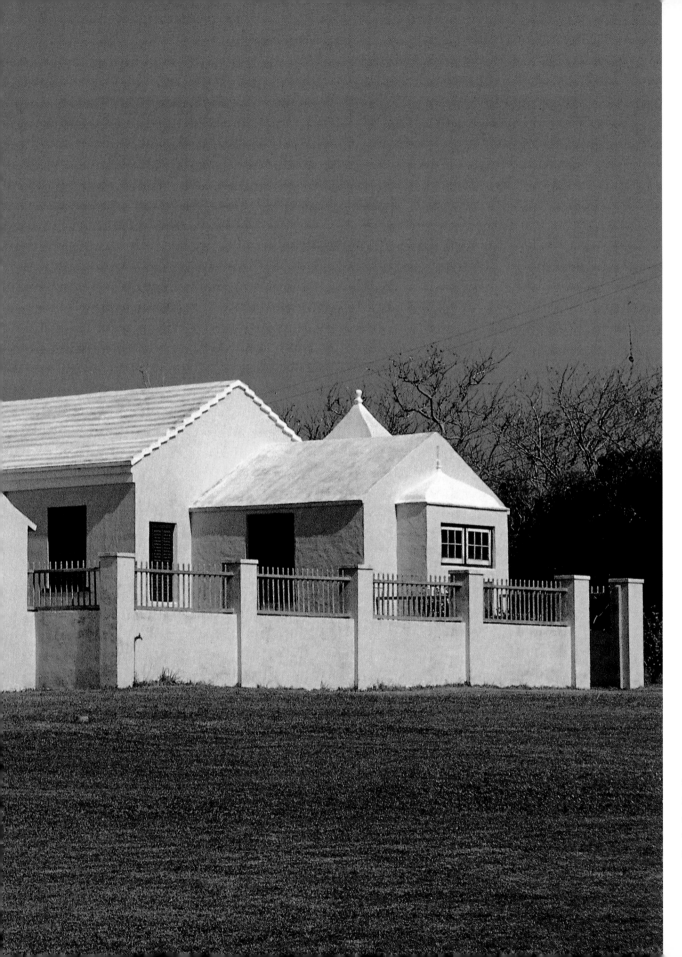

Greenmount, in
Southampton. The
eighteenth-century house
was given vernacular
additions in 1939.

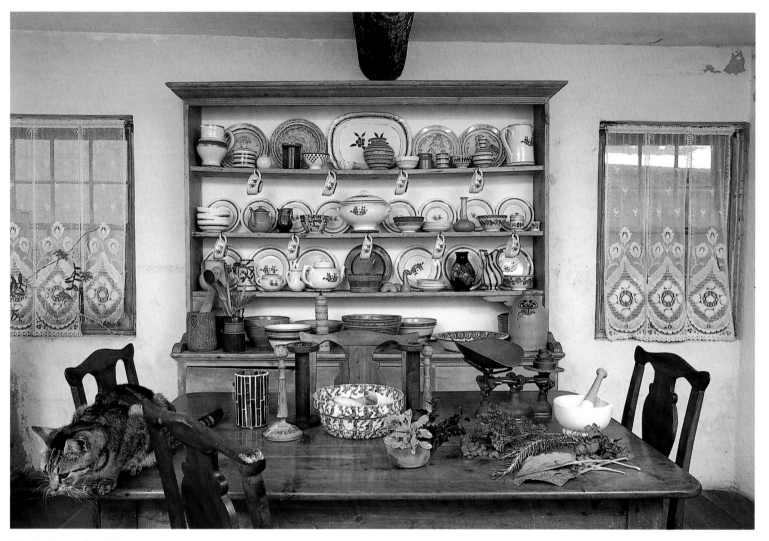

The kitchen at Stockdale,
a late-eighteenth-century
house in St. George's,
has been adapted with little
change for comfortable
modern use. The Victorian
kitchen table was made in
Bermuda; the blue earthen-
ware is from the Azores.

Bermuda cedar furniture, solid and durable, was often made in styles that mirrored those of England and the mainland colonies. The banister-back chair in the hallway at Bushy Park, in Somerset, has crisp turnings and fine Spanish feet. Cedar chests with decorative dovetails were made in Bermuda well into the nineteenth century.

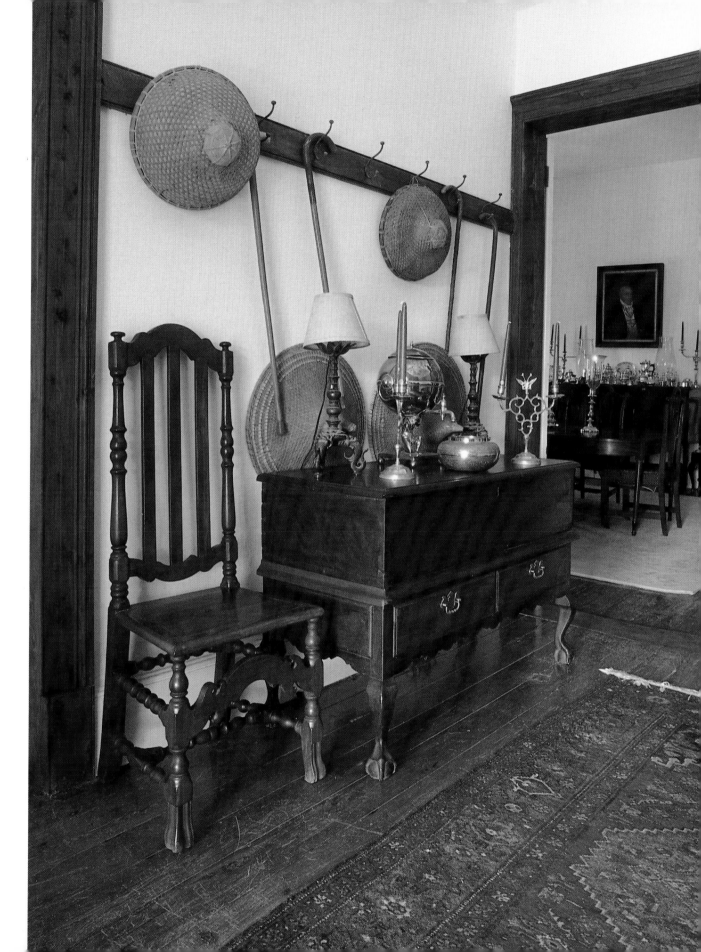

The parlor at the Tucker
House Museum in
St. George's, furnished with
Bermuda cedar, has an airy
"tray" ceiling now braced
with tie-rods. The portrait
by American painter Joseph
Blackburn shows
Mrs. Henry Tucker with
her children: Elizabeth,
and young Nathaniel in his
childhood skirts.

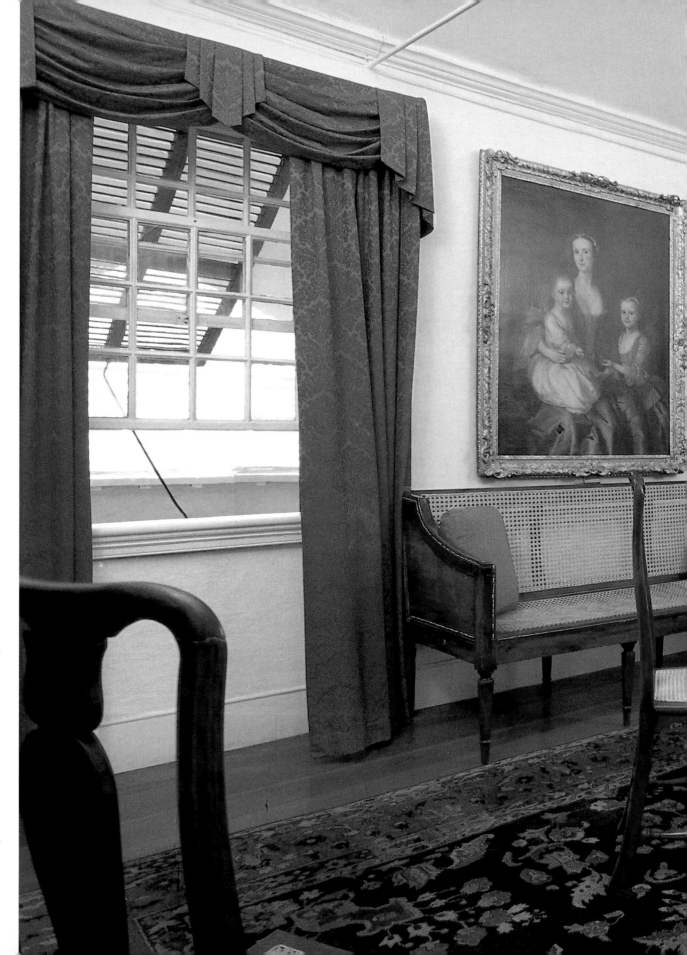

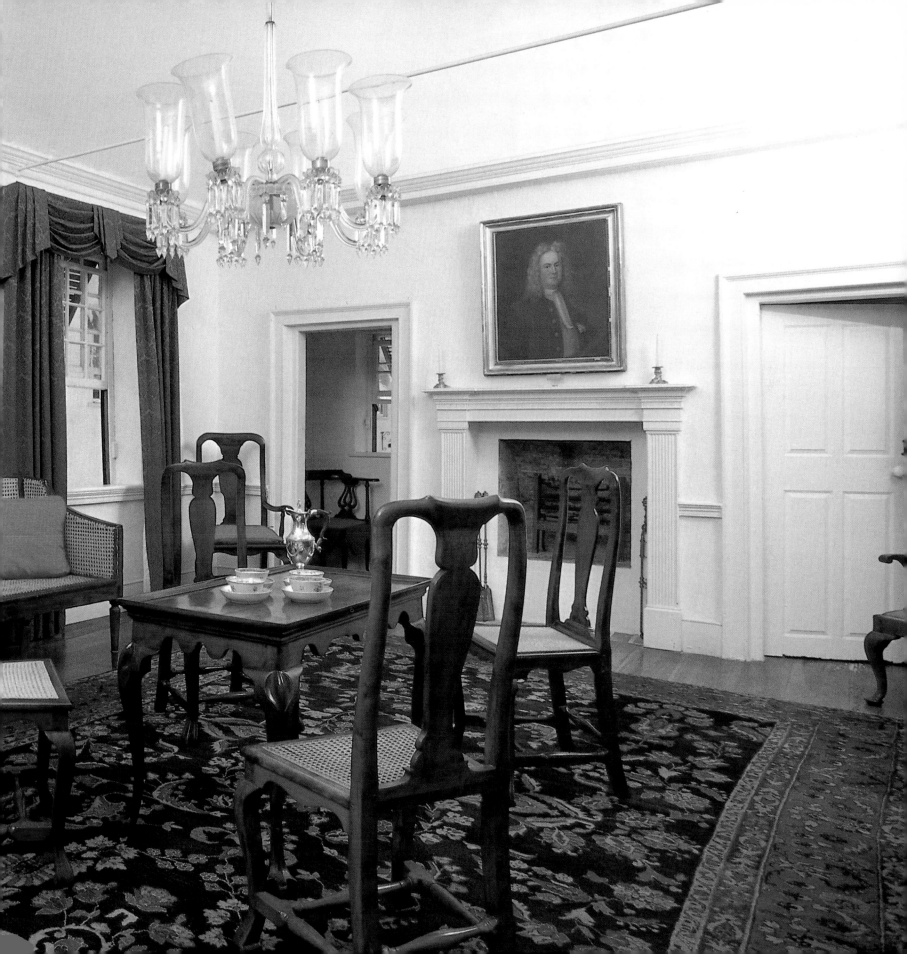

At Huntly, a nineteenth-century house in Paget, the hospitable dining room is set for a dinner party. The mahogany furniture was once owned by Henry Hunt, for whom the house was named. The Victorian silver epergne was presented to a later owner, Joseph Trounsell Gilbert, for his services as a lawyer in Demerara (a province in former British Guyana) in 1866. An open lunette over the double door reflects this West Indian connection. Portraits of Gilbert family ancestors by Joseph Blackburn and others line the walls.

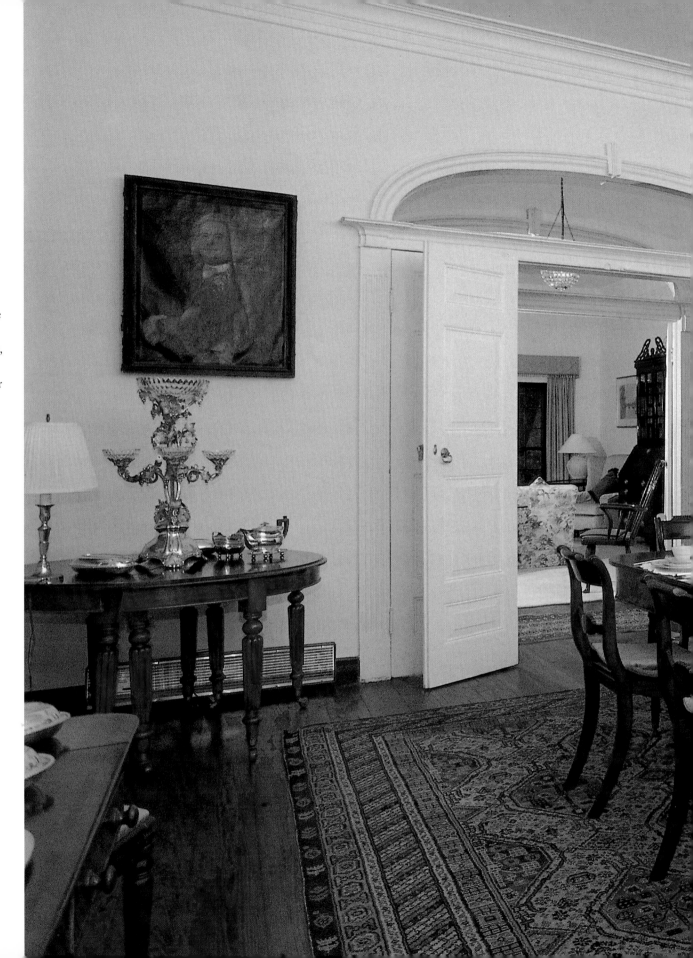

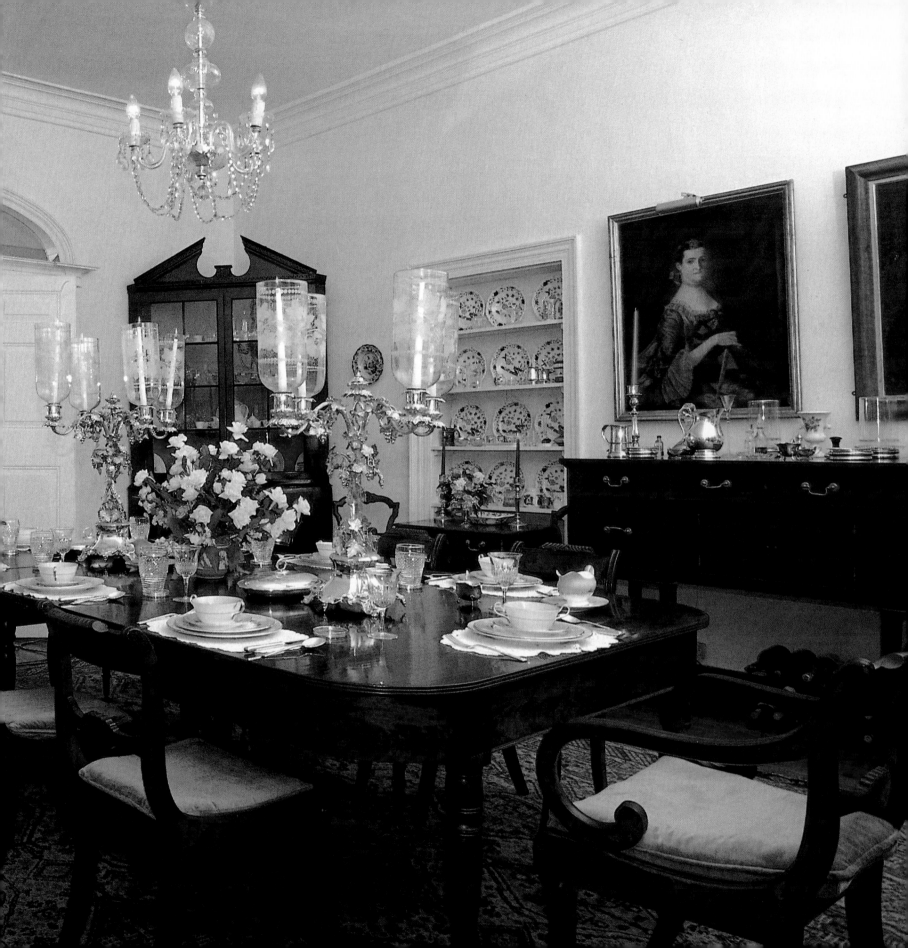

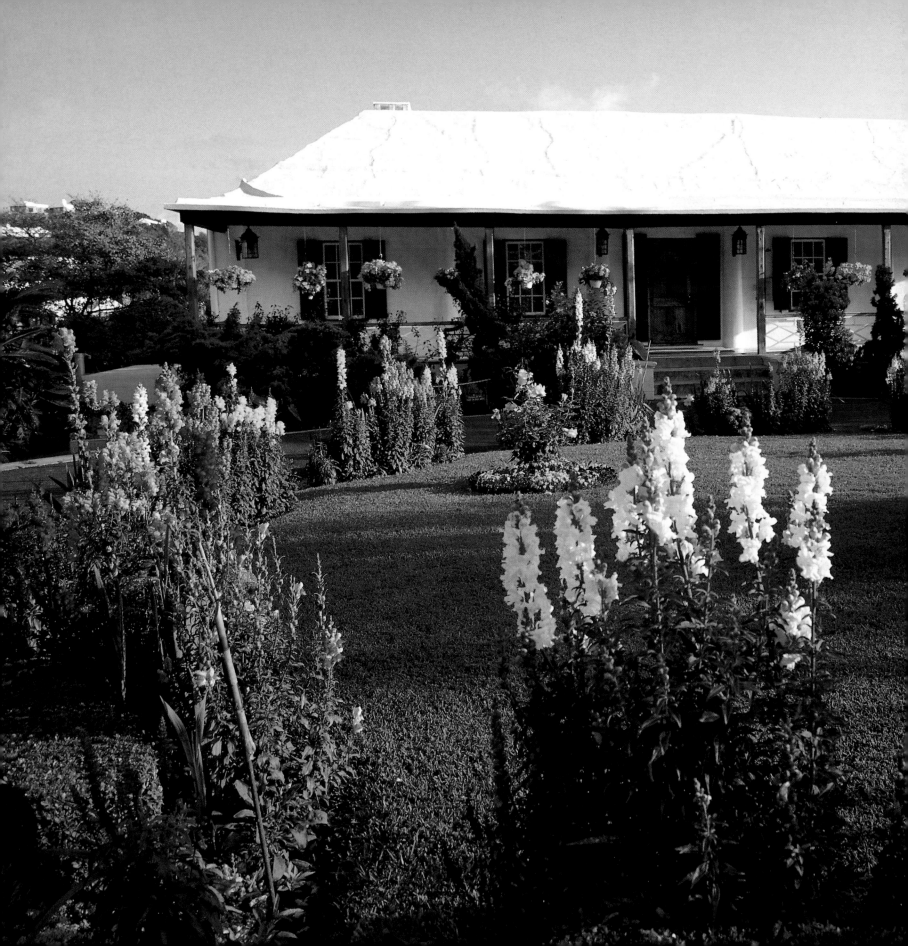

The long veranda at
Pembroke Hall, an
eighteenth-century house in
Pembroke that is now
the offices of a large inter-
national mutual fund.

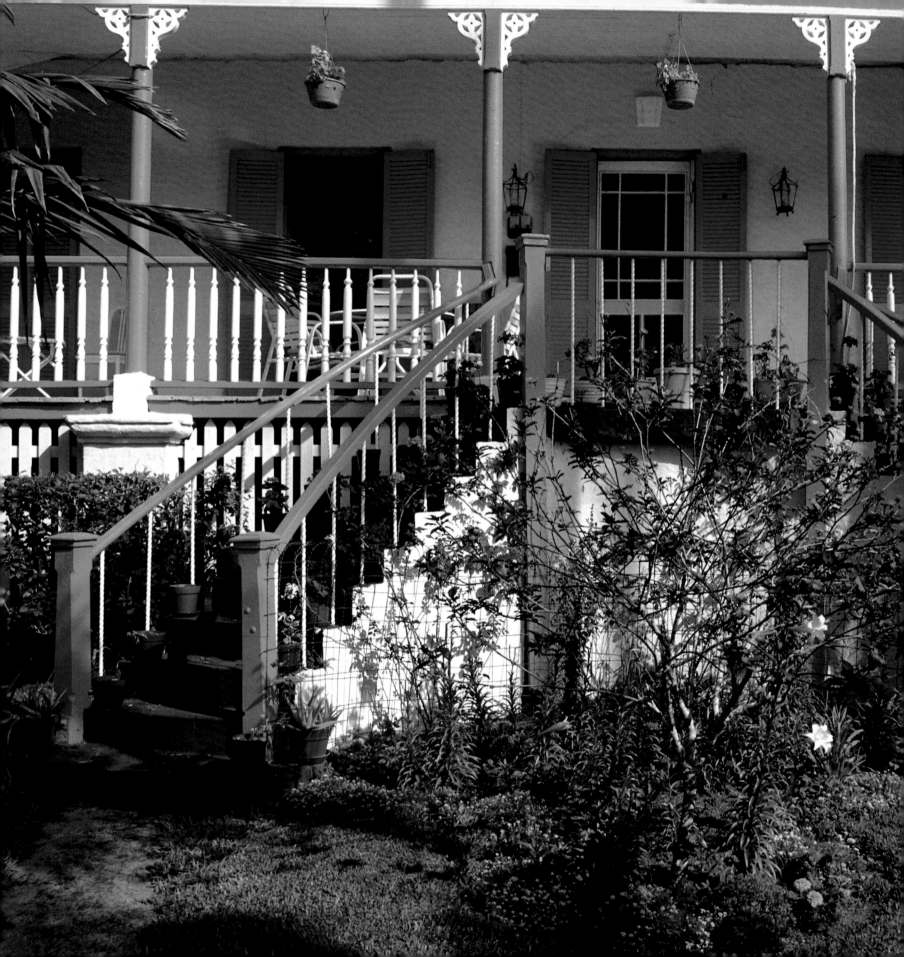

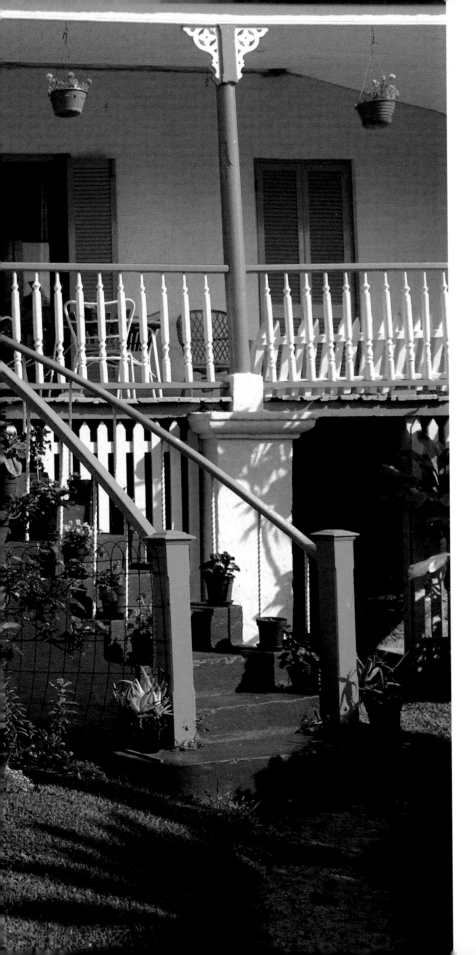

The formal garden at
Seabright, in Devonshire.

Rosebank's nineteenth-
century veranda has
gingerbread brackets and
a double flight of stairs.

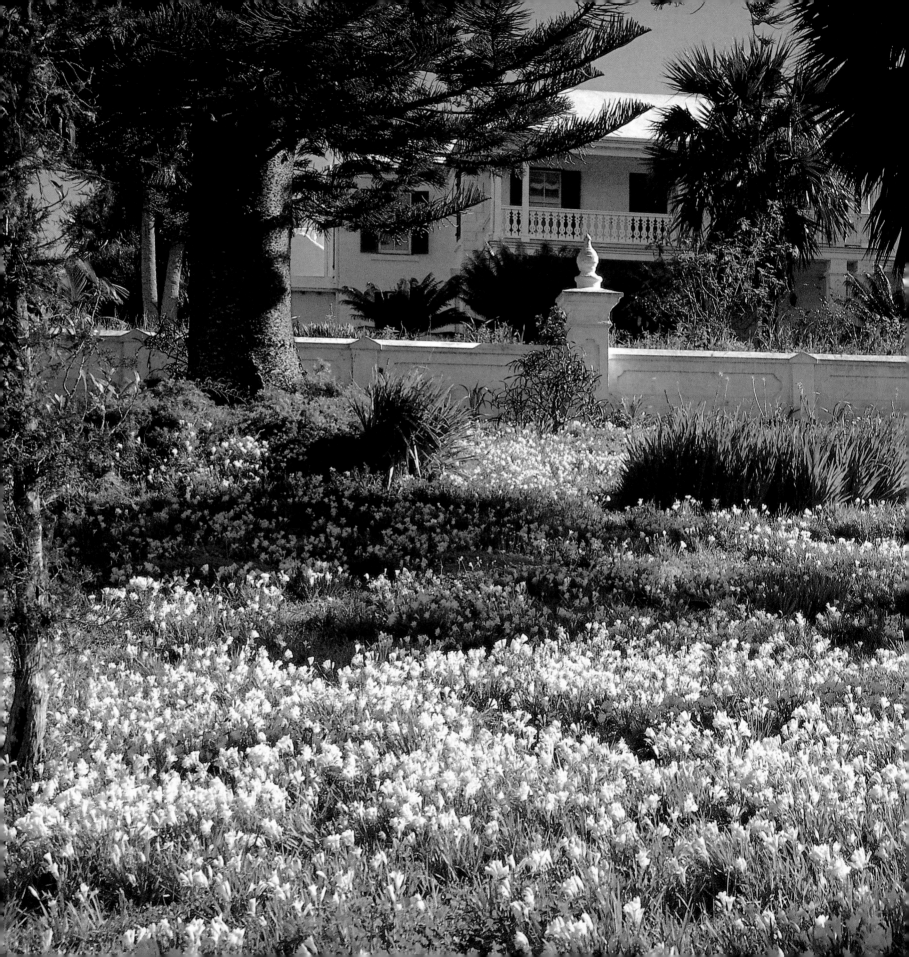

Naturalized freesias
carpet the lawns in front
of Villa MontClare,
in Hamilton Parish.

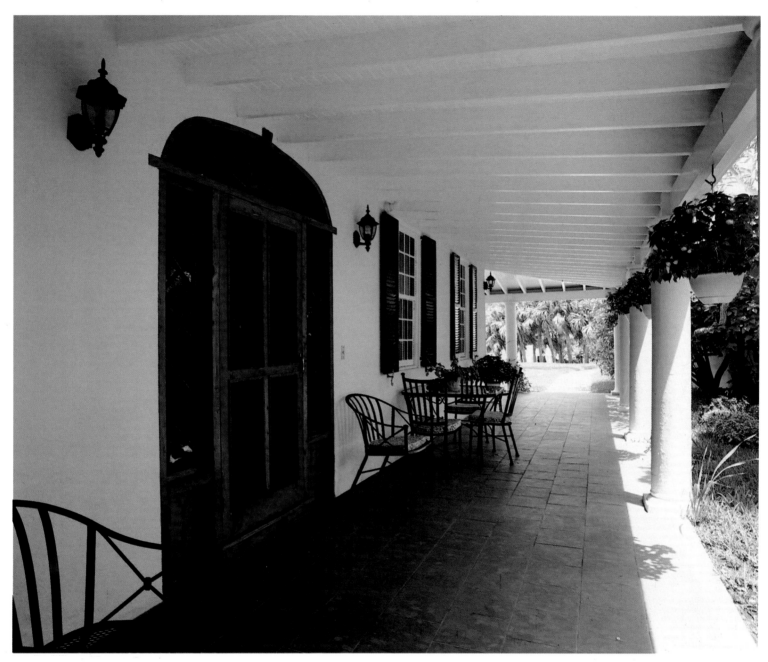

Mark Twain spent happy winters at Bay House, near Hamilton, with his friends the Allen family. He used to sit on the porch in a rocking chair, taking in the view, and once told his hosts, "You can go to heaven if you want. I'll just stay right here."

The Bay House garden.

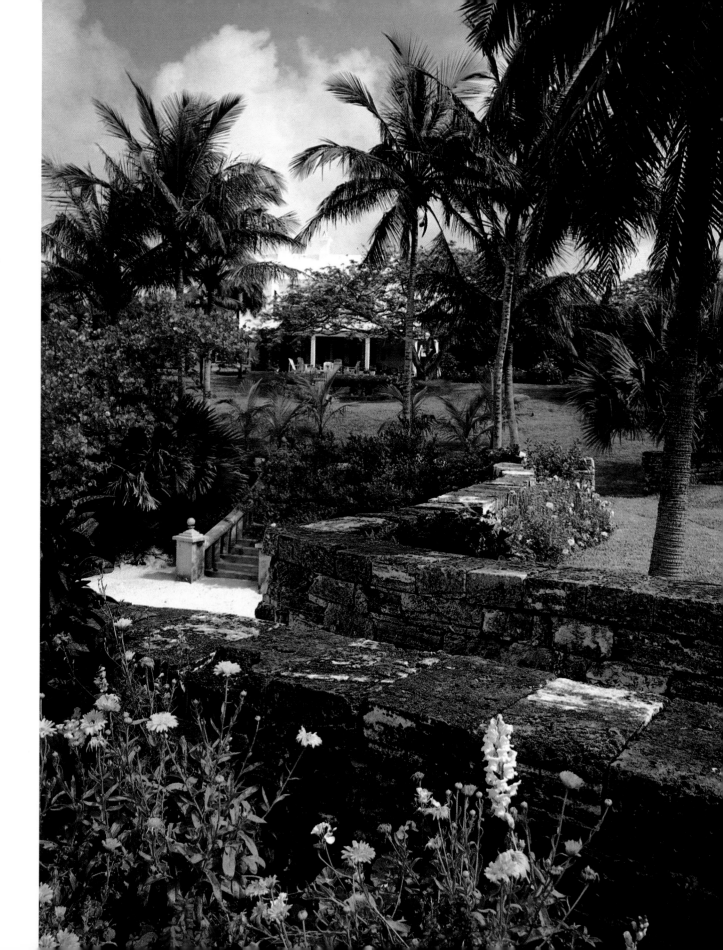

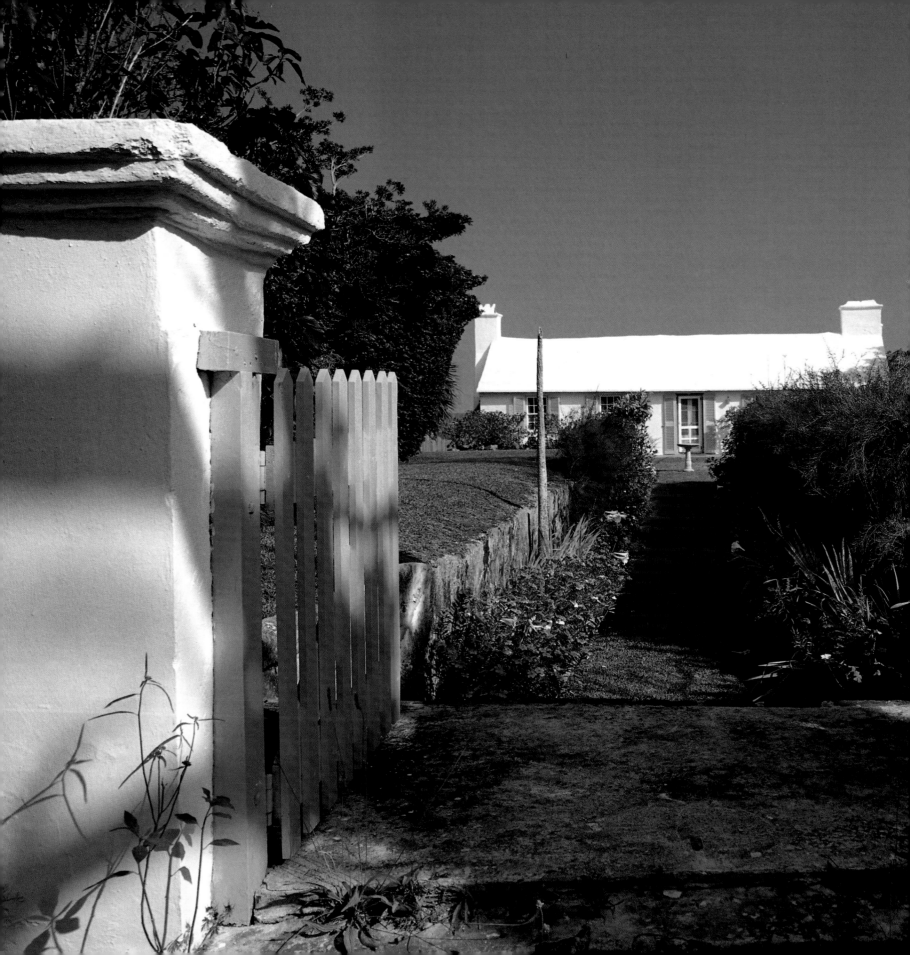

Fallen golden shower
blossoms beside a weathered
limestone wall.

Southcote, a small
eighteenth-century
house in Paget.

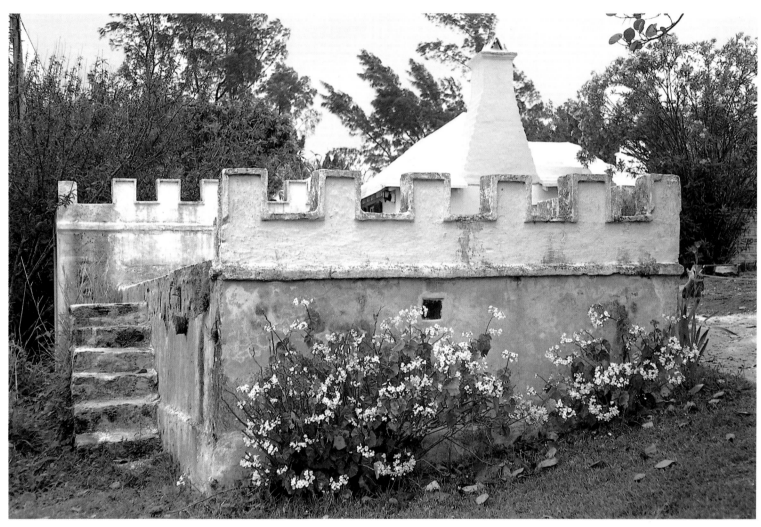

The fanciful water
tank at Shrewsbury has a
crenellated parapet.

Shrewsbury was named
for the home town of
its English builder, who
married a Bermudian
woman in 1826. The land
was given as a wedding
gift and has been farmed
since that time.

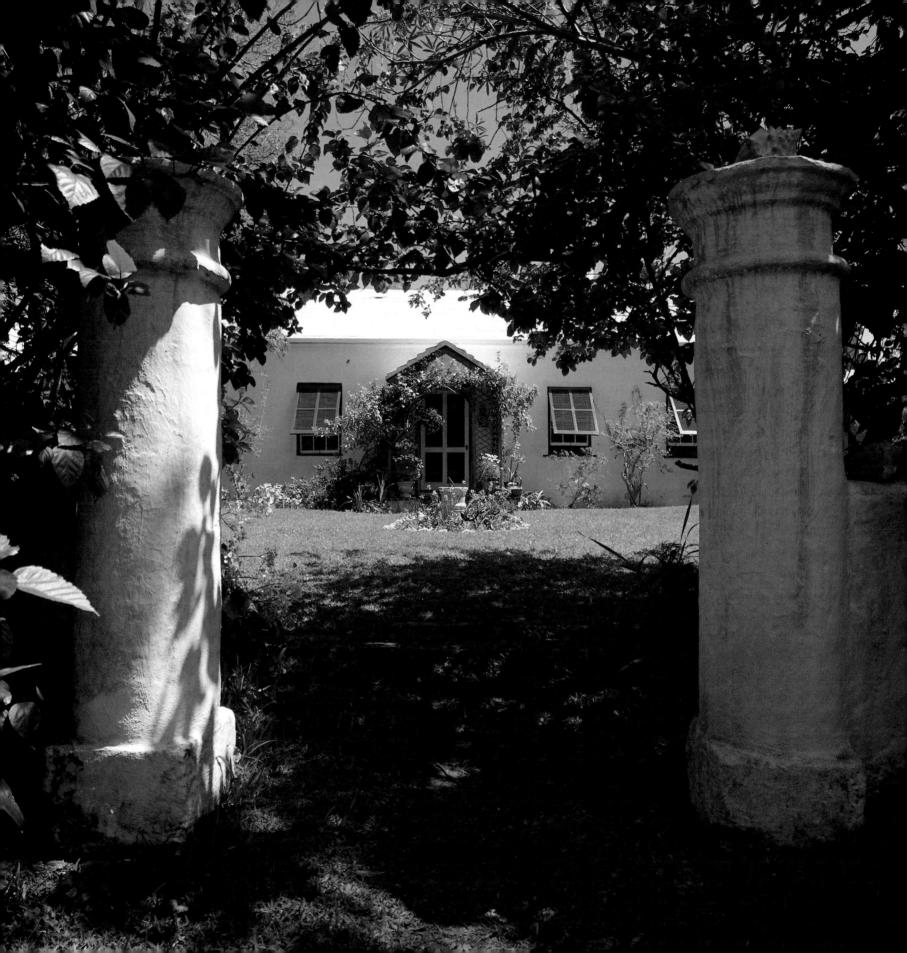

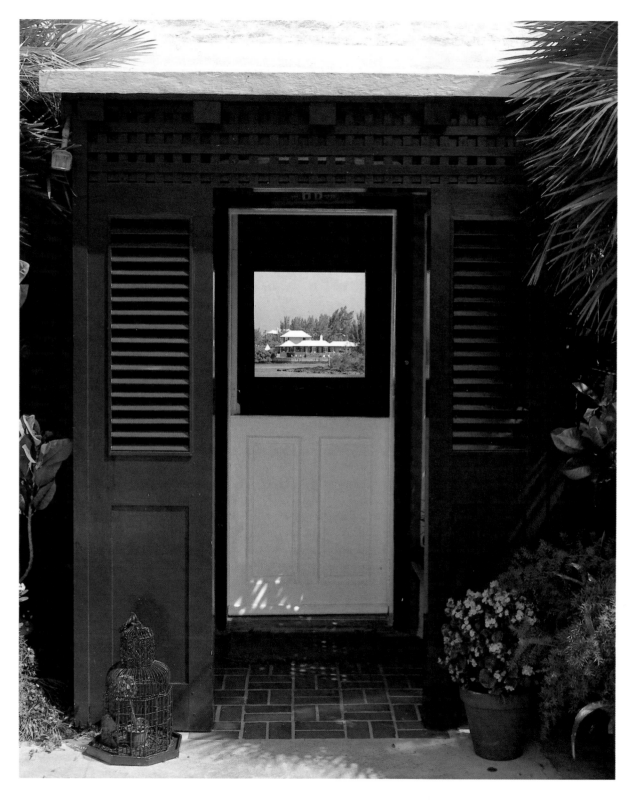

White-roofed, waterside cottages on Riddell's Bay are framed by the front door of Peppercorn, a charming cottage in Southampton begun in the eighteenth century.

The side porch of Peppercorn looks Victorian but was added as part of a 1950s renovation.

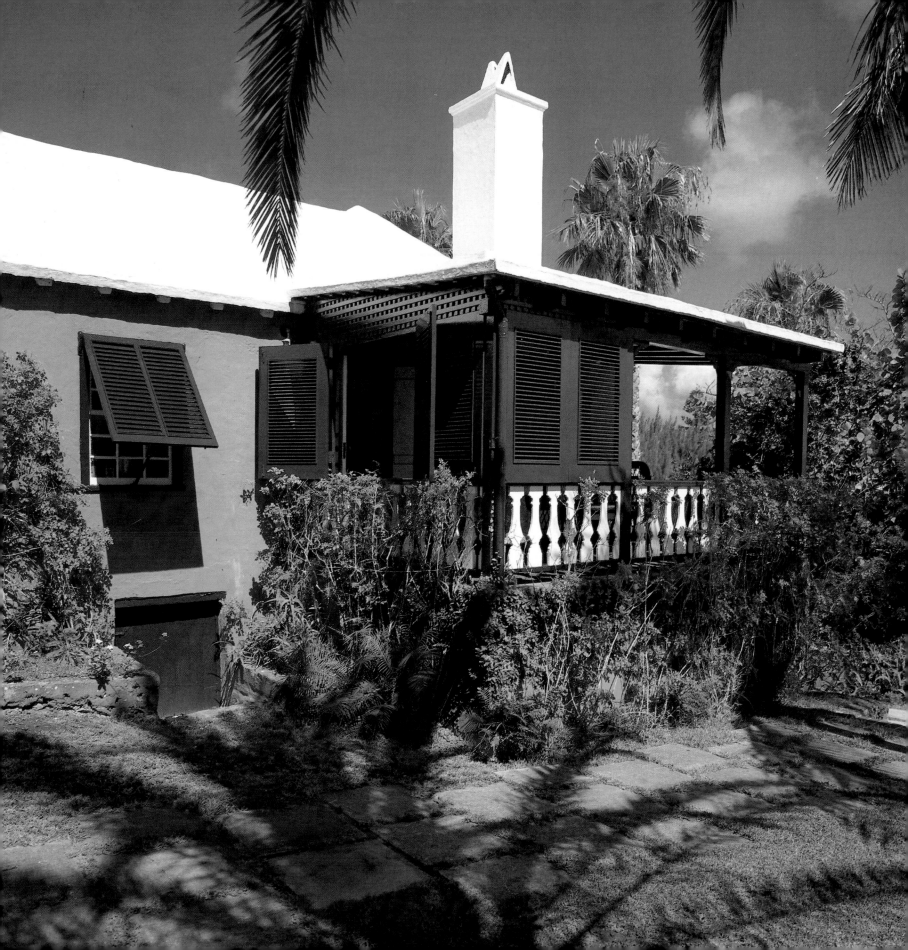

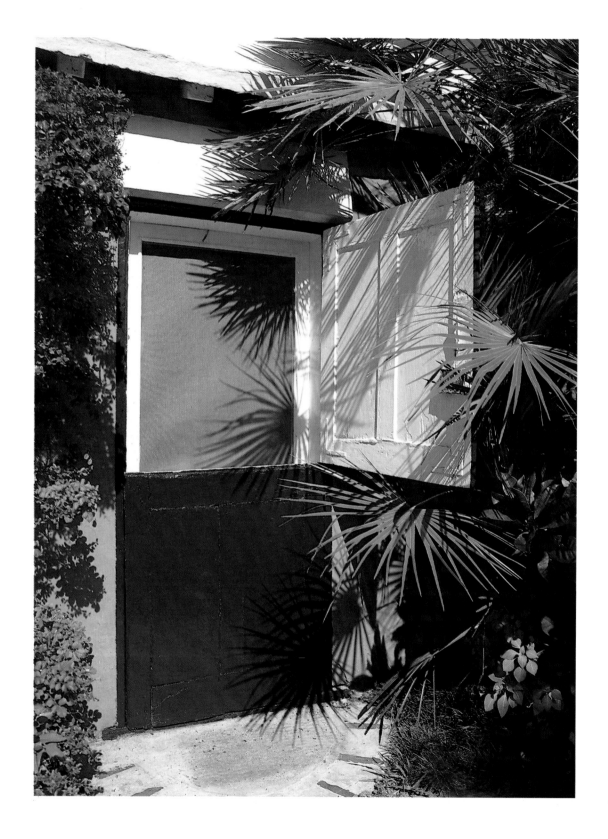

A double dutch door to
the kitchen at Peppercorn.
Chinese fan palms cast
their shadows on the screen.

The front porch, shaded by
a trellis, has a wooden
bench for waiting visitors.

Aloe plants grow in a barrel
beneath Peppercorn's small
cellar window.

The cellar door at Greendale, in Paget, with blue agapanthus against the brick-red limewashed walls.

The garden arch at
Greendale frames a view of
the two-story buttery, its
smooth, steep roof crowned
with a simple stone ball.

Greendale began as a
two-room cottage in the
eighteenth century. It was
enlarged around 1810 and
in 1938 was completely
remodeled by American
architect Robertson Ward,
who made sympathetic
vernacular additions. The
grounds include a large
walled garden and a pool
of carp and turtles.

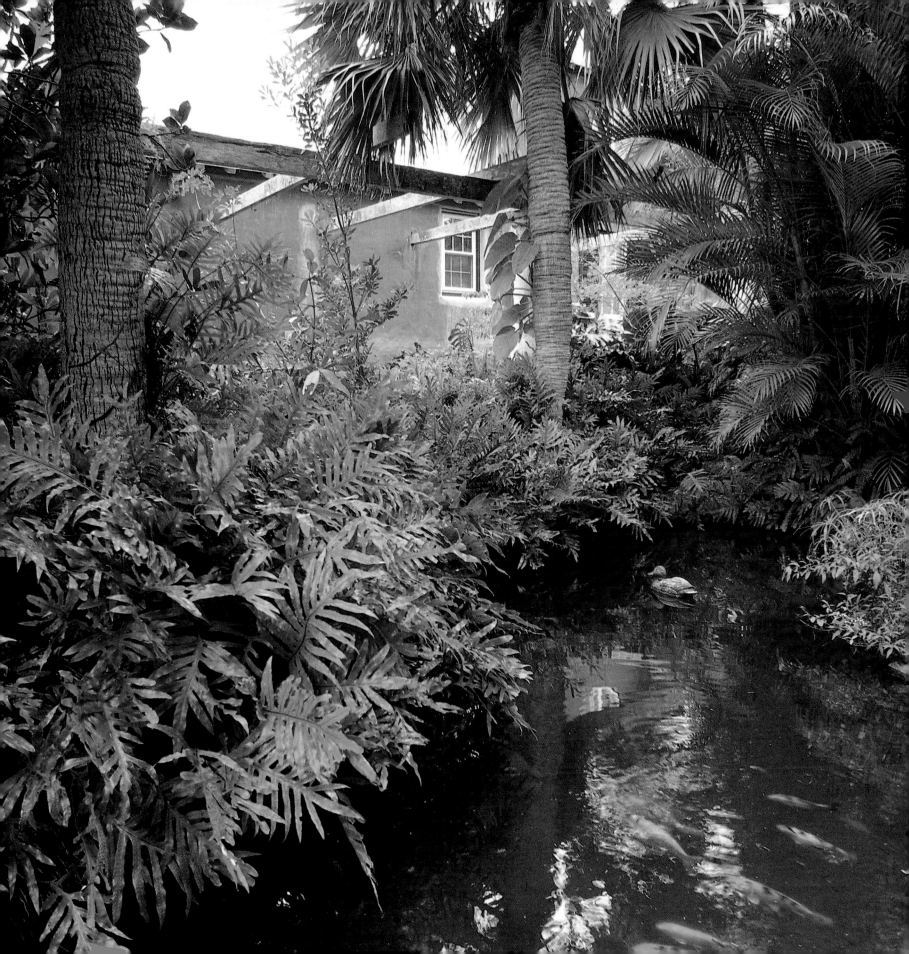

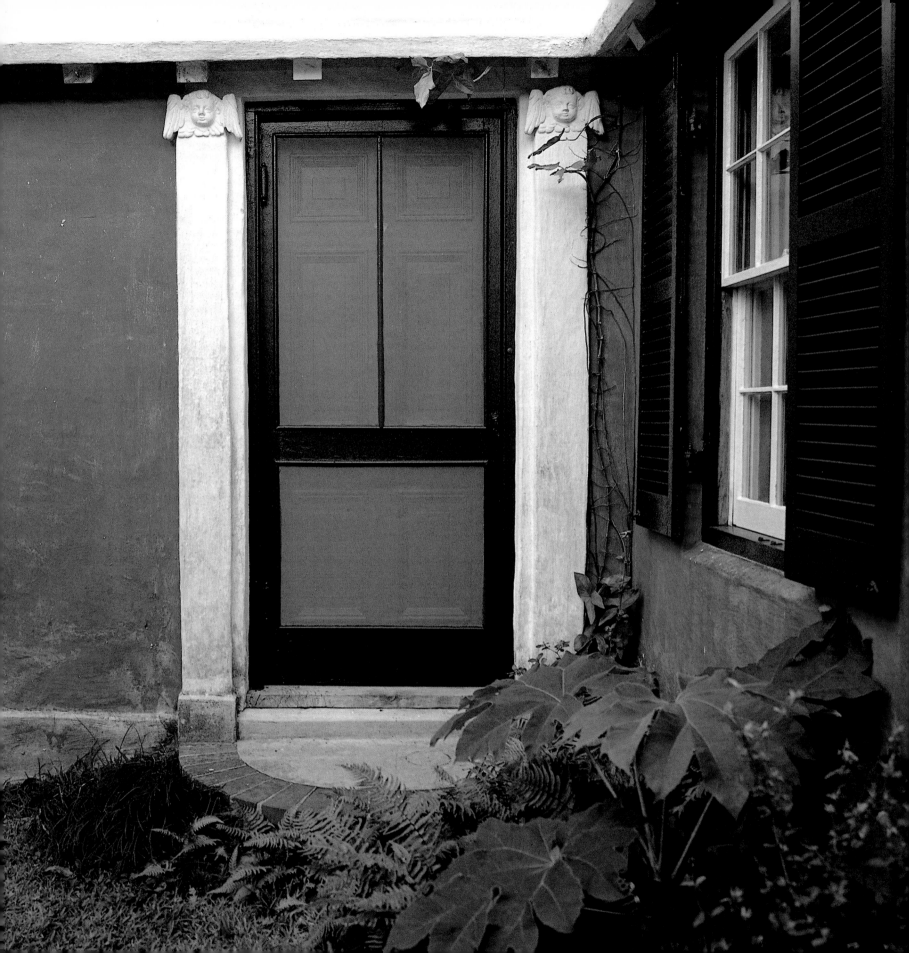

Greendale's cottage, Tally Ho, has charming pilasters capped with putti.

Seen through a decorative opening in the garden wall, the pergola at Greendale is now luxuriantly overgrown.

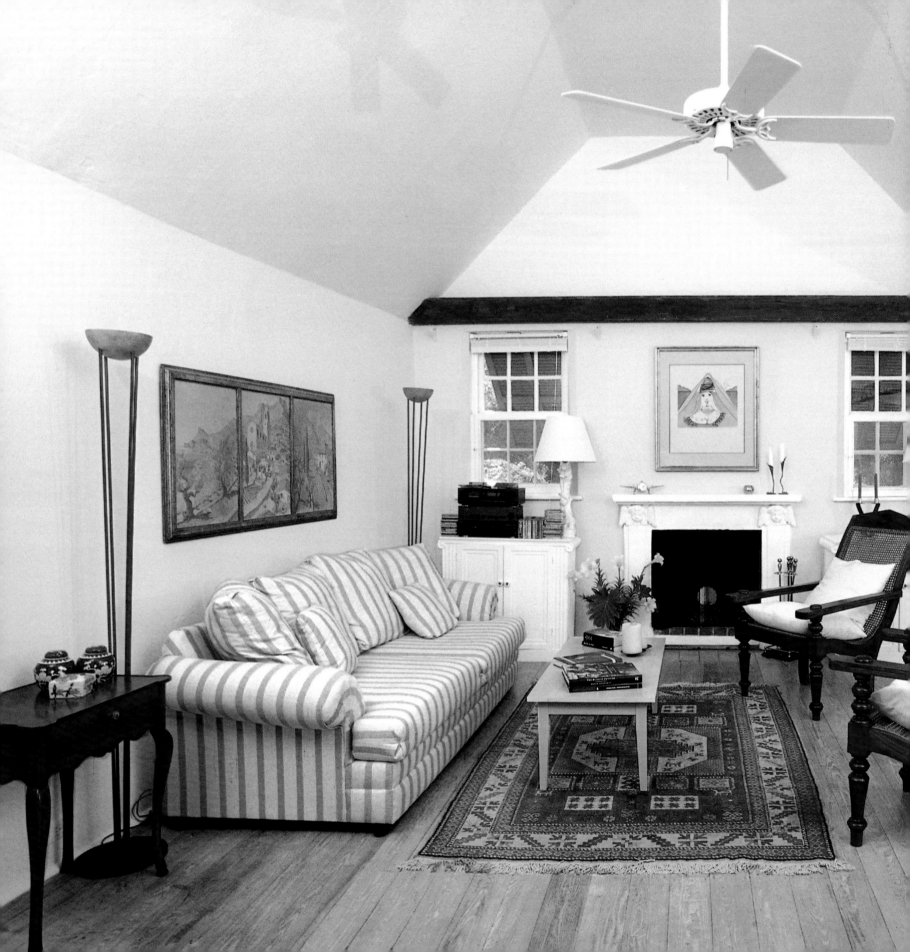

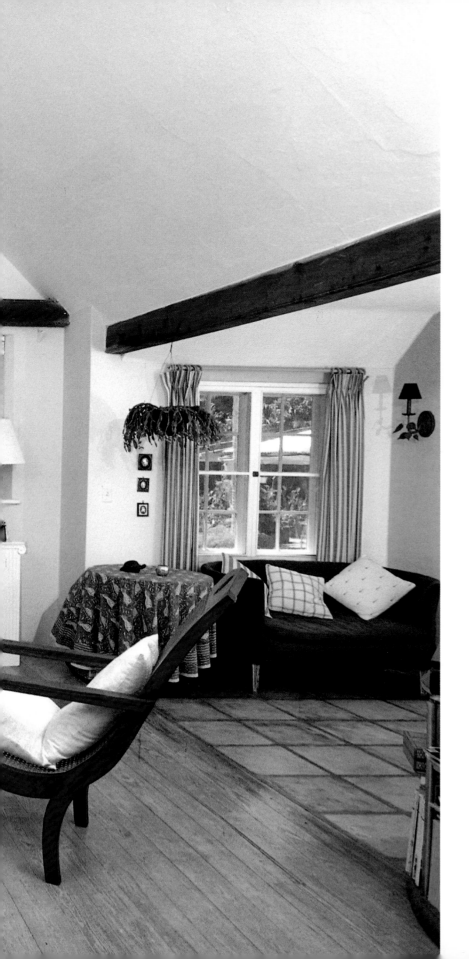

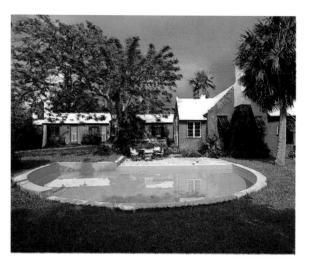

Historic Greendale,
with its modern swimming
pool, reflects old and new
Bermuda.

The eighteenth-century
sitting room at Greendale,
with imported furnishings
that include planters' chairs,
has a high "tray" ceiling.
An addition to the room, at
right, has exposed the cedar
wall plate.

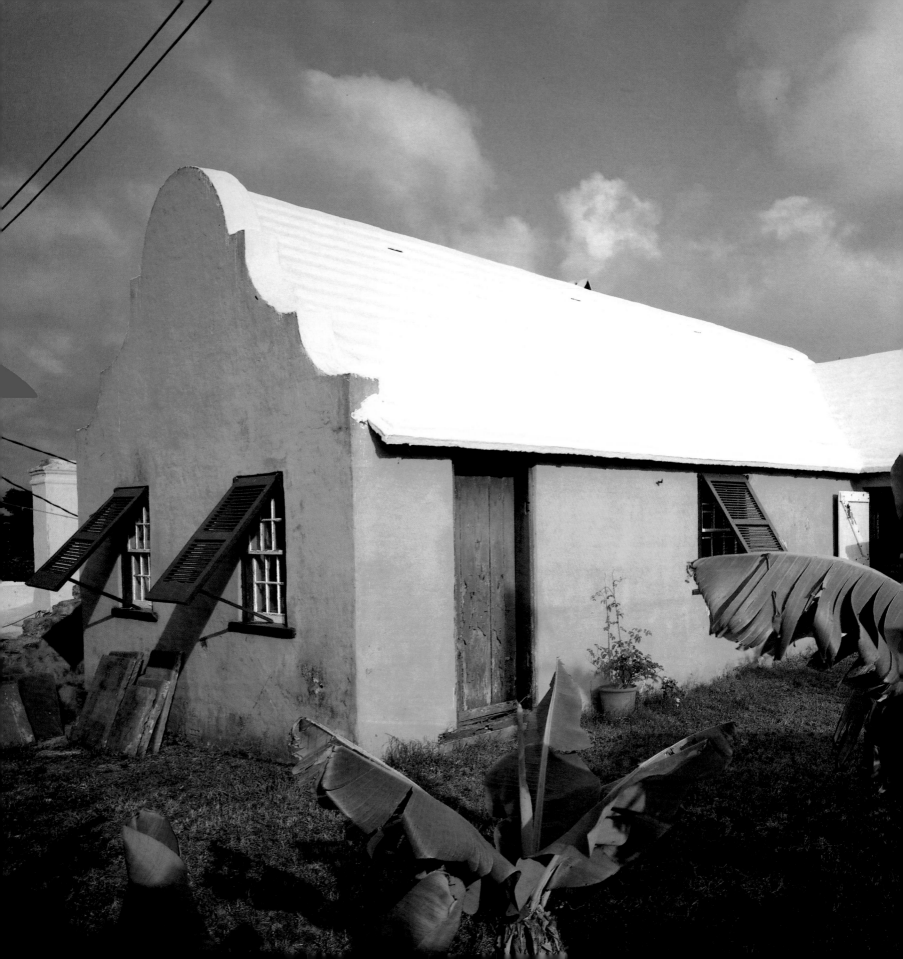

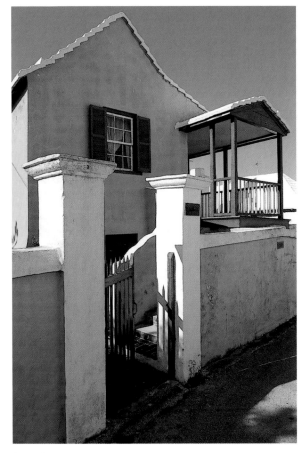

Stockdale, along with
about twenty other houses
in St. George's, is protected
by a preservation order
so the outside of the house
cannot be altered. A high
garden wall protects the
privacy of the occupants.

The back wing of Stockdale, with its scalloped Flemish gable. This small cruciform town house was built by Joseph Stockdale, who brought the first printing press to the island in 1783 and founded the *Bermuda Gazette*. Stockdale also ran a mail service from his house, employing riders to deliver packets to other parts of the island.

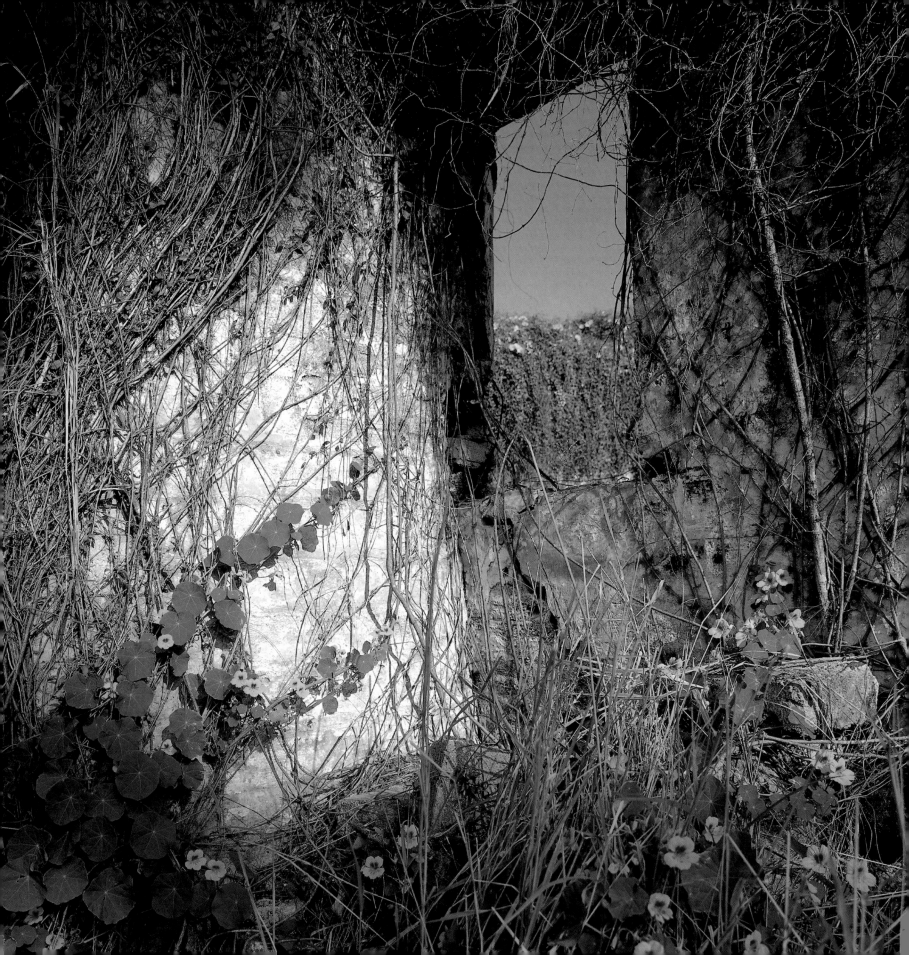

OPPOSITE: Outside the town of St. George's, Bermuda's original capital, there is no legislation to protect architecture from demolition or inappropriate alteration. A register of buildings of architectural and historic importance is being drawn up to ensure that the most important structures will be safeguarded in the future.

ABOVE: In early summer, naturalized nasturtiums grow wild over ruins and in banana patches.

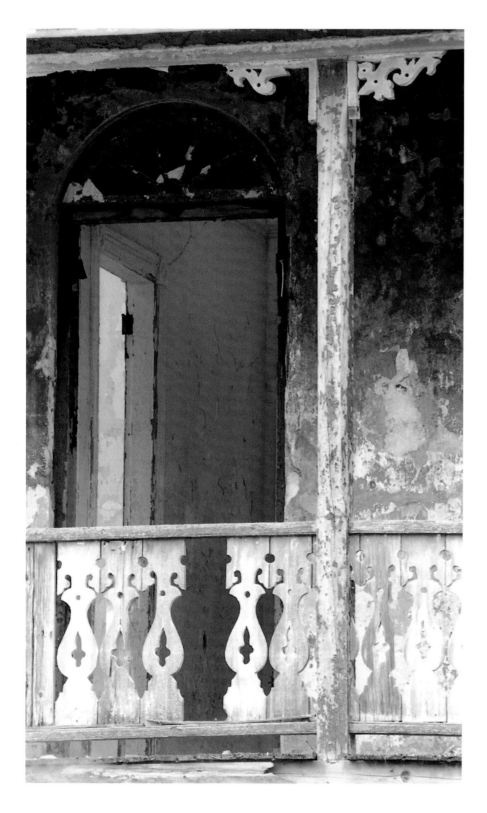

A gingerbread porch
in Pembroke.

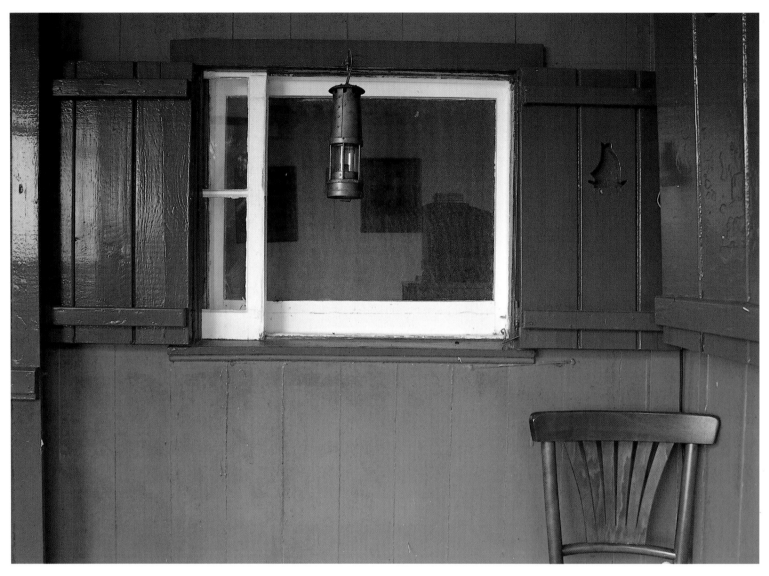

Jibsail, in Point Shares, was
built in the early twentieth
century as the last wooden
commercial building in
Hamilton. It was transported
by horse and cart to its
present location and
converted to a cottage.

Dennis's Hideaway,
a family restaurant in
St. David's, is one of very
few wooden buildings
remaining in Bermuda.

A printing press in the
studio garden of local artist
Alfred Birdsey, in Paget.

The circular stone moon
gate at Cambridge Beaches,
a luxury resort. If honey-
mooners walk through a
moon gate their marriage is
thought to be blessed.

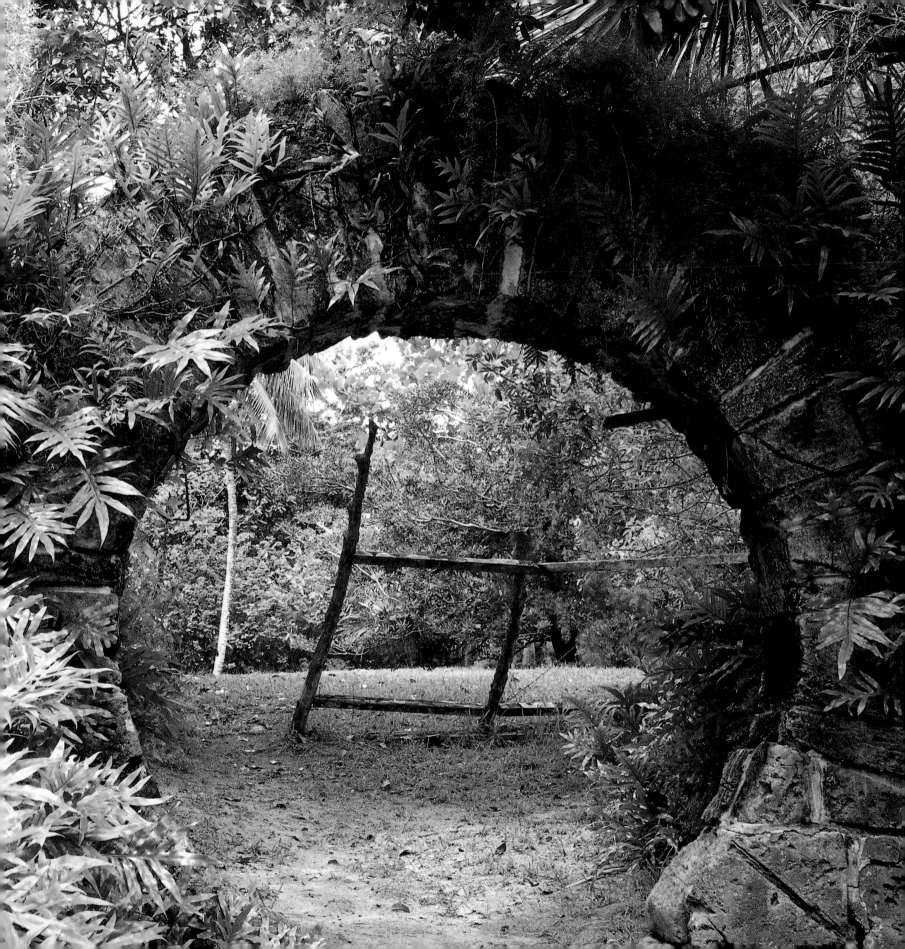

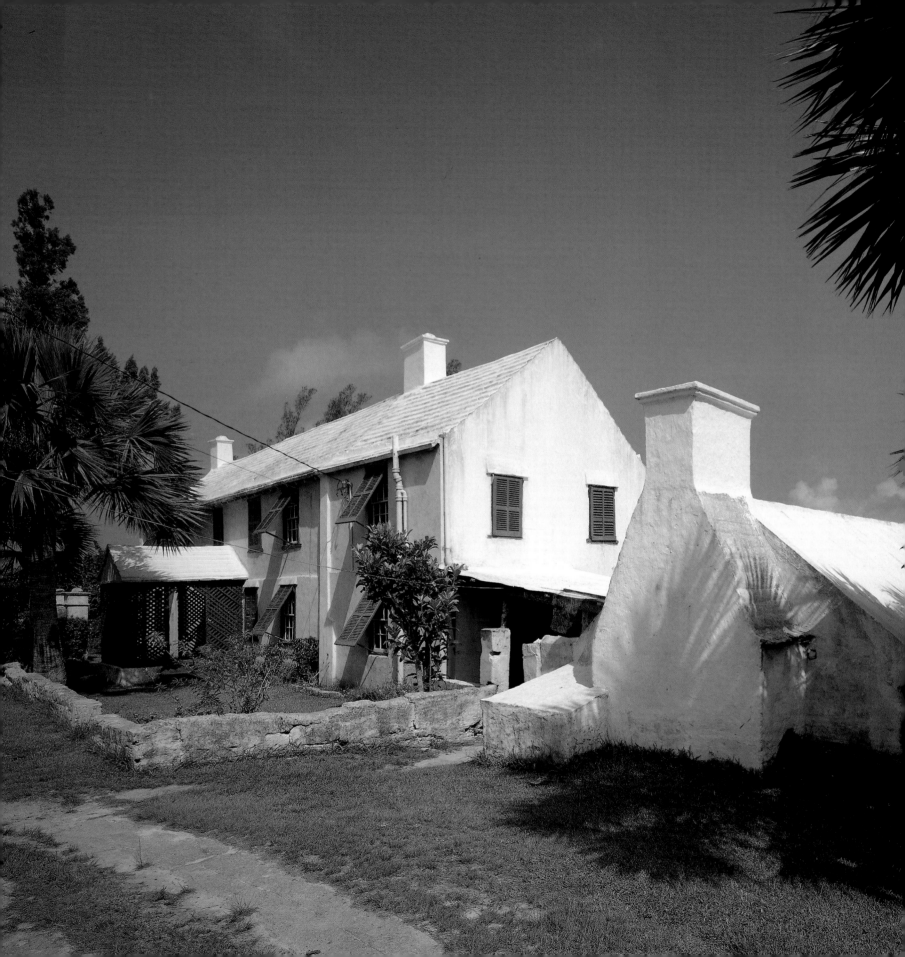

Marine Hall, an early
house on Riddell's Bay.
The detached kitchen
has a fireplace in its broad
chimney for cooking.

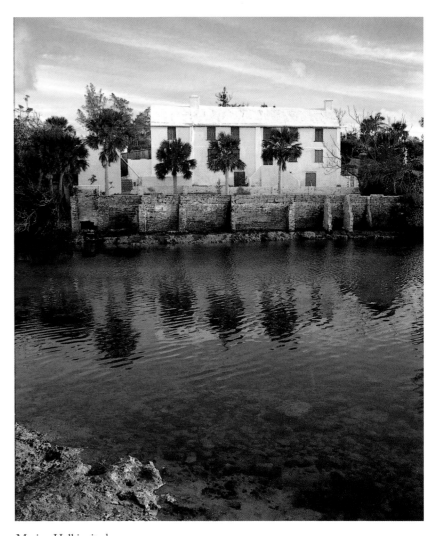

Marine Hall is sited on a
sheltered, deep-water
mooring. Sailing ships tied
up here and unloaded their
cargoes, to be stored in
the basement of the house.

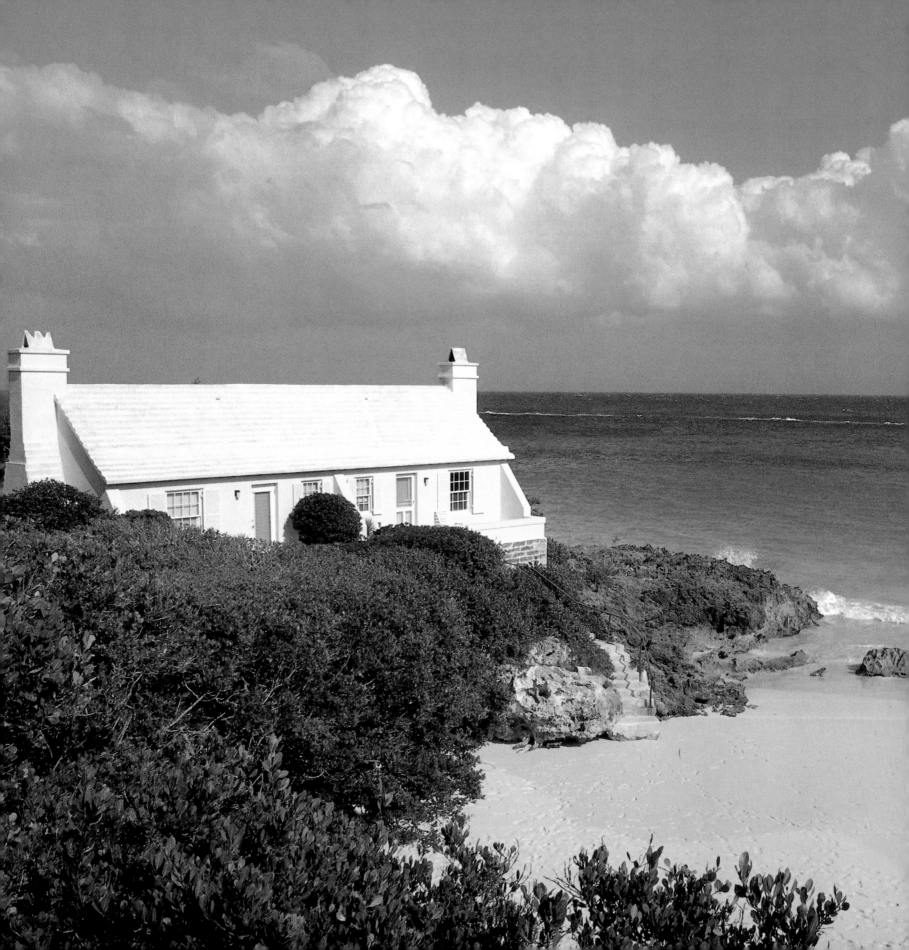

A rustic cedar gate.

Thunderclouds punctuate
the blue sky over John
Smith's Bay. Early settlers
did not usually build on
the exposed shore.

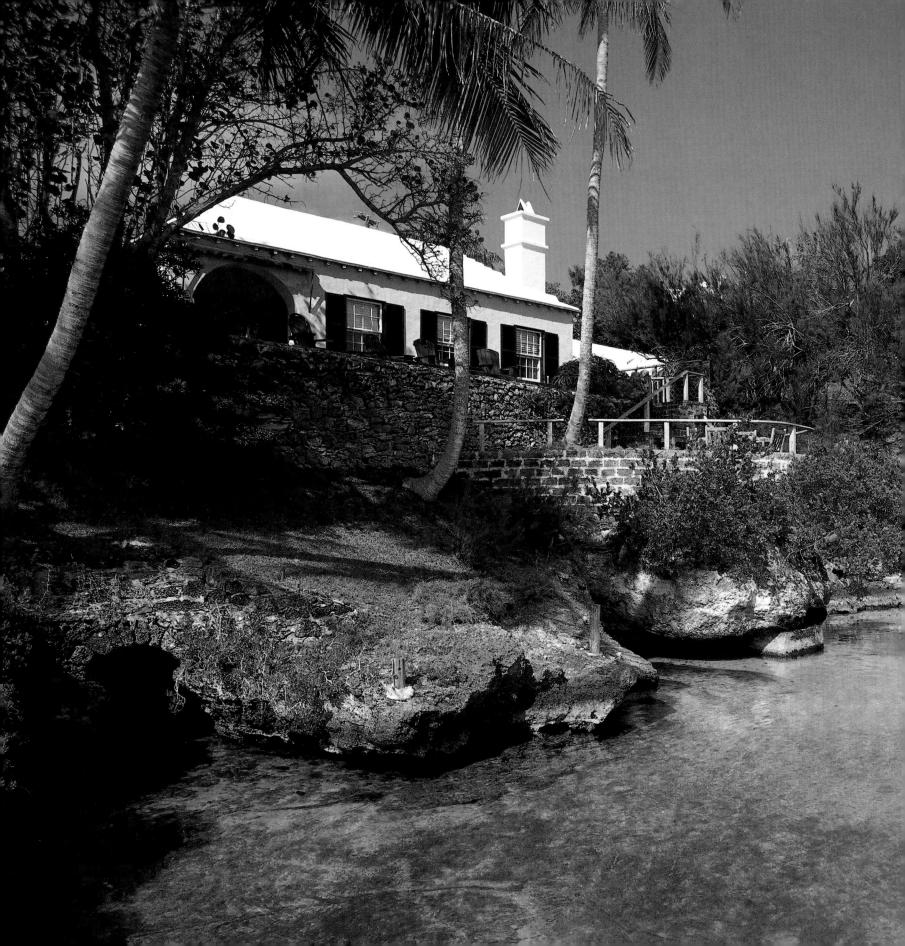

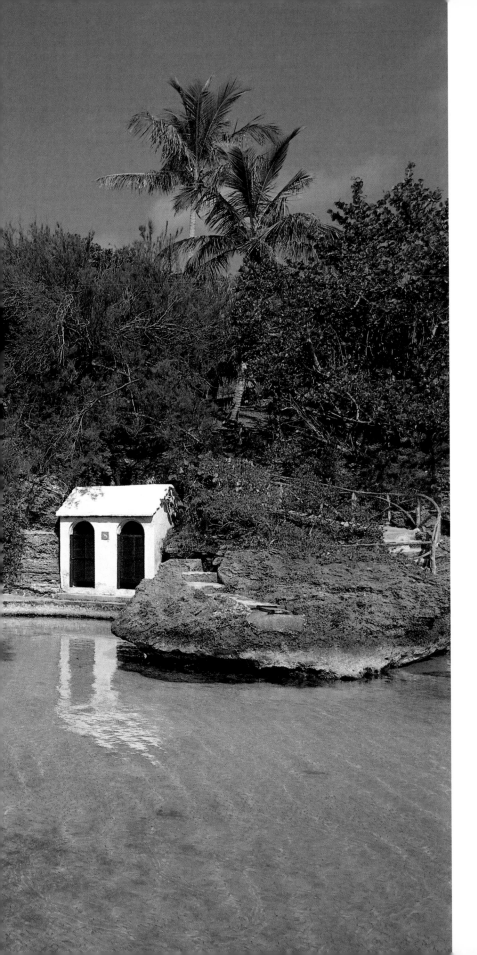

An arrangement of
shells on the patio table
at Coral Ledge.

Coral Ledge, on the still
waters of Harrington Sound,
was designed in 1932 as a
summer house by American
resident Josephine Dodge
Wharton with help
from local revival architect
Wil Onions.

A locally made cedar
dinghy beneath
coconut palms on the
Coral Ledge beach.

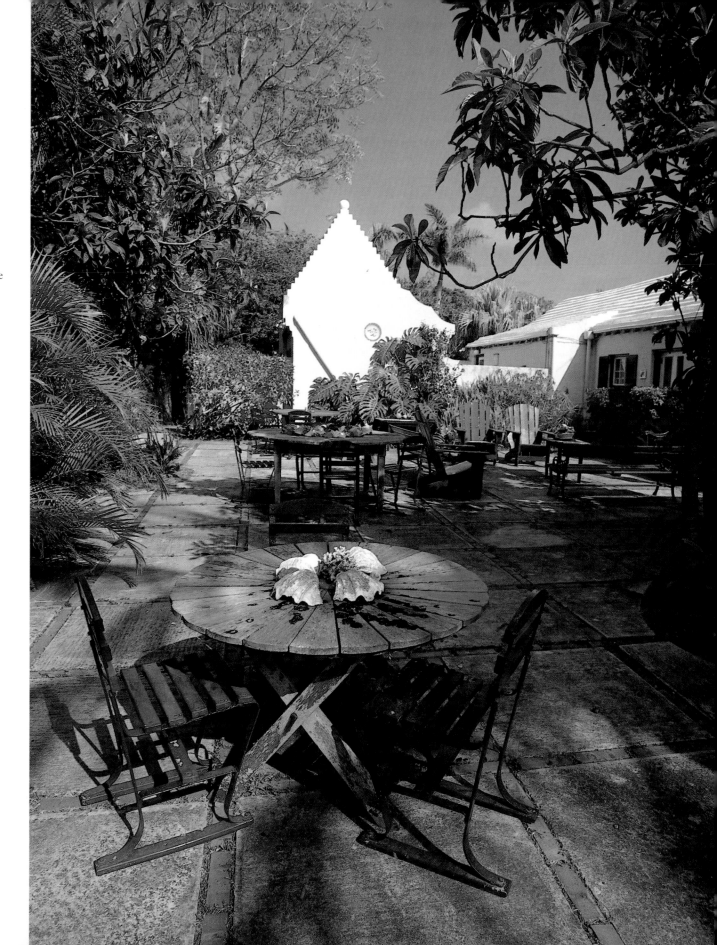

Coral Ledge is a split-level house with attractive outdoor spaces.

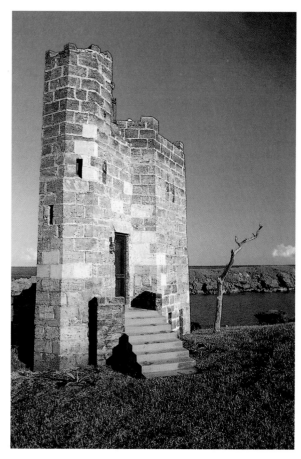

Frick's Point Folly, designed
by Wil Onions, nods to
the architecture of the forts
on nearby Castle Island.

Longbird Cove, a vacation
house in Tucker's Town,
looks onto the spectacular
Mid-Ocean Beach.

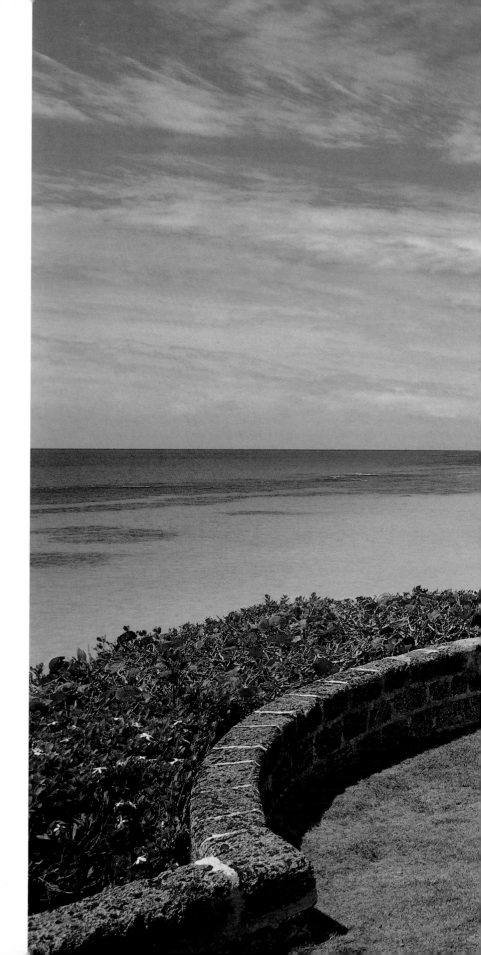

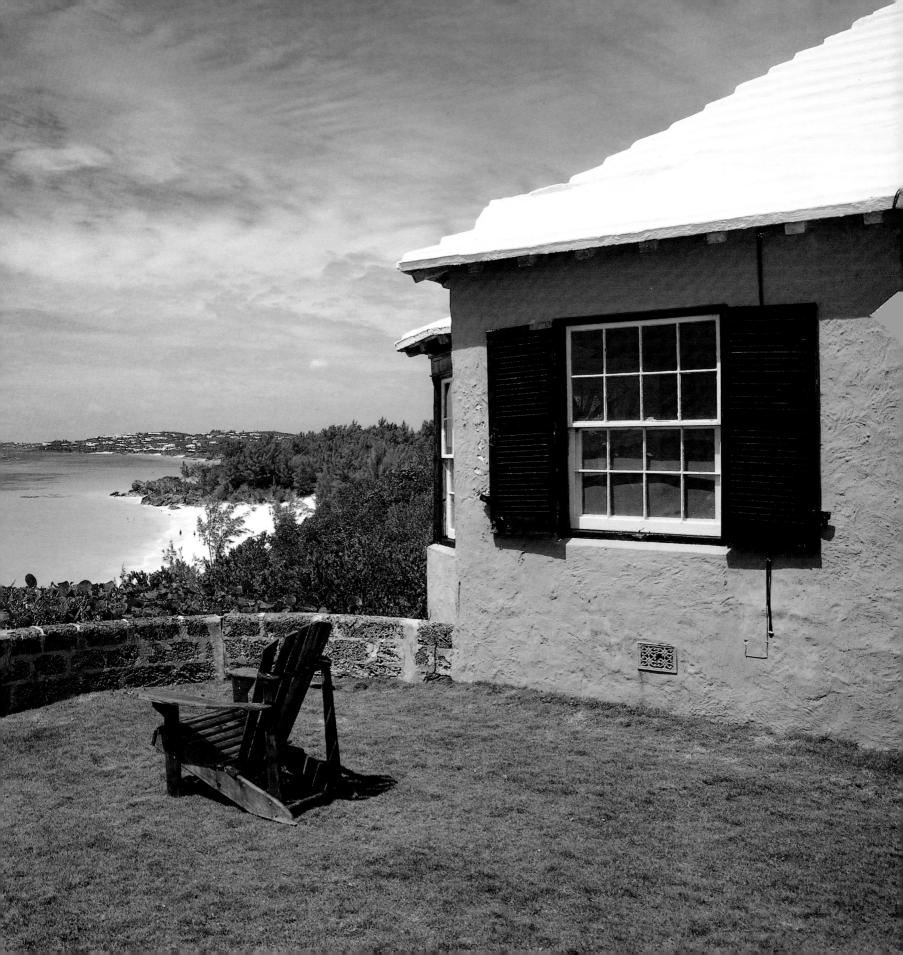

Wil Onions gave
But 'n' Ben all the charm
and atmosphere of an
old Bermuda cottage, with
an oversized chimney,
push-out shutters, and
strengthening buttresses.
It was one of the first
houses built in Tucker's
Town when tourism
was developed there after
World War I.

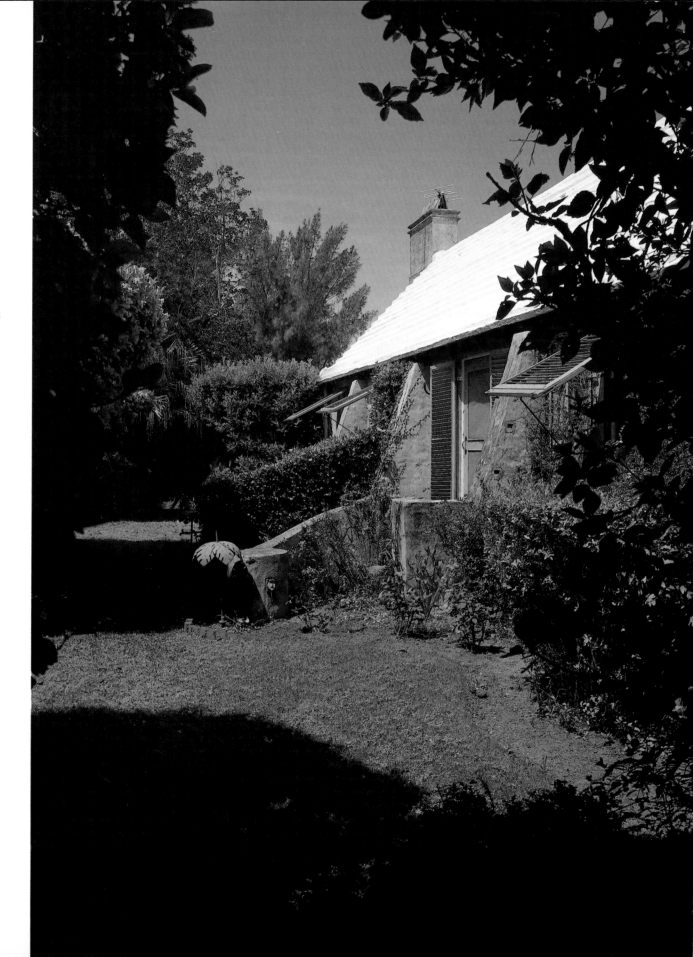

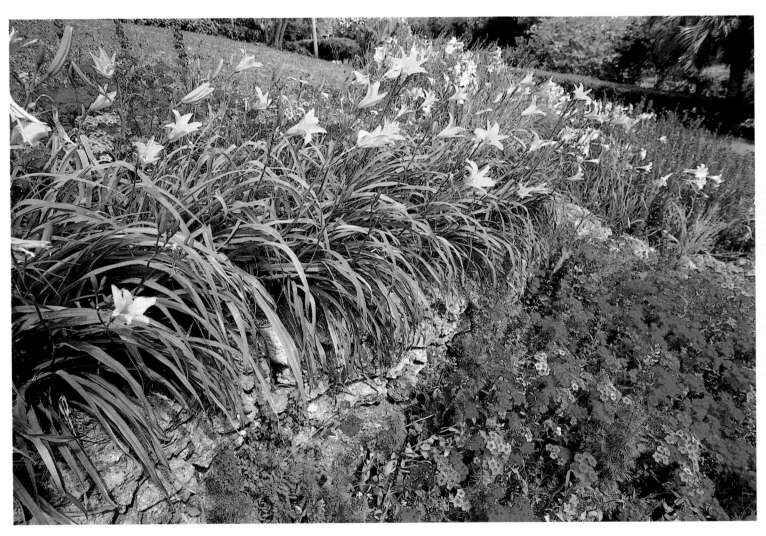

Day lilies bloom in the
spring in Bermuda.

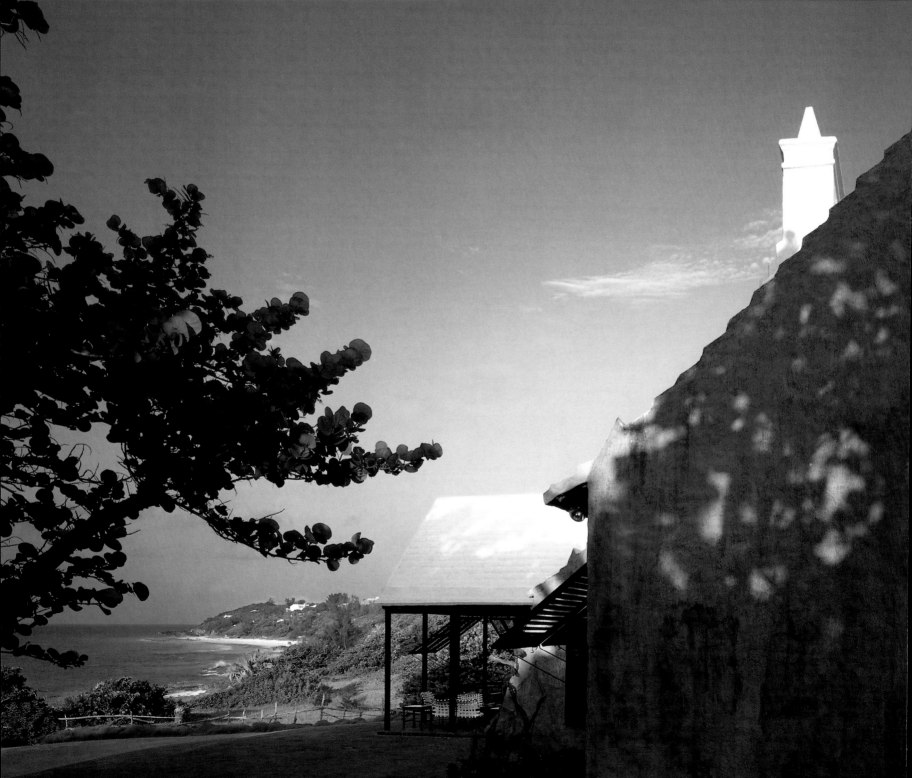

Picnic benches dusted with
bay grape seeds after a rain.

Woodstock Cove, over-
looking Grape Bay, was
built by Wil Onions in 1953.
Modeled on the revival
cottage architecture of
But 'n' Ben, but with more
modern refinements, its
elongated plan ensures that
every room has a view of
the sea. The dining porch
is a later addition.

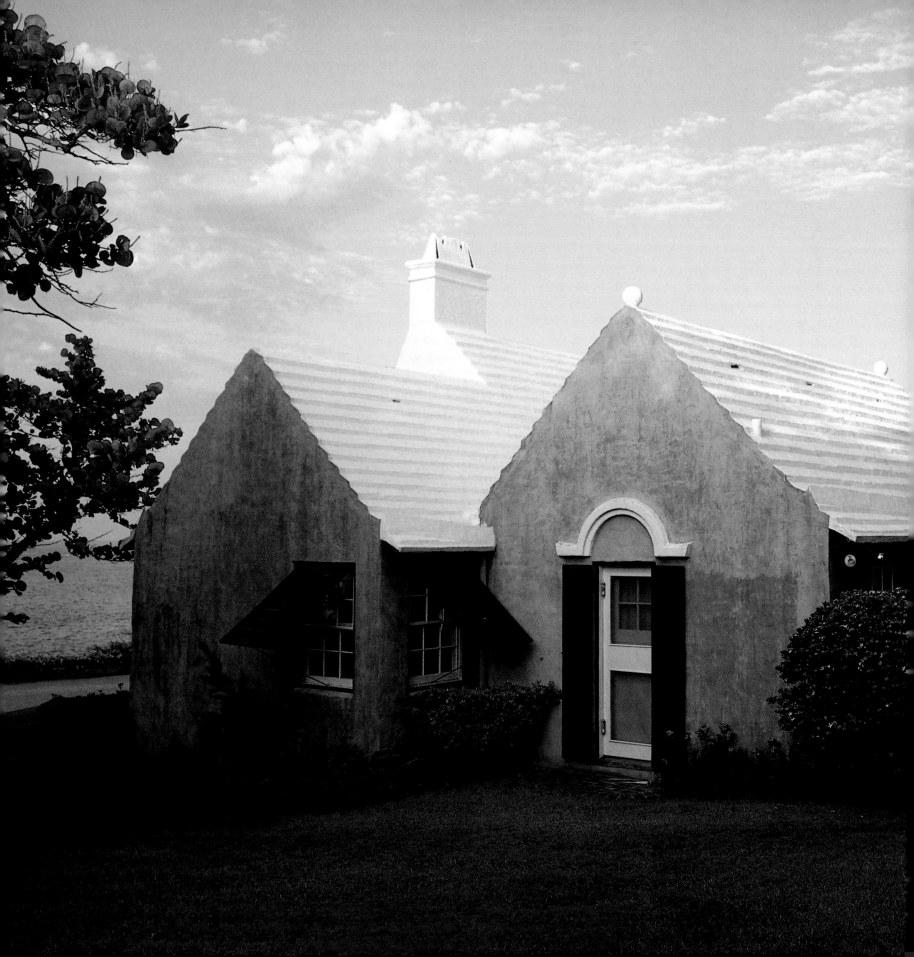

Shutters frame sash
windows, and a buttress,
picked out in white, braces
the cement-washed wall
at Woodstock Cove.

Wil Onions's attention
to traditional details, such as
the chimney moldings and
"eyebrows" over the doors at
Woodstock Cove, makes his
architecture an important
contribution to Bermuda's
heritage.

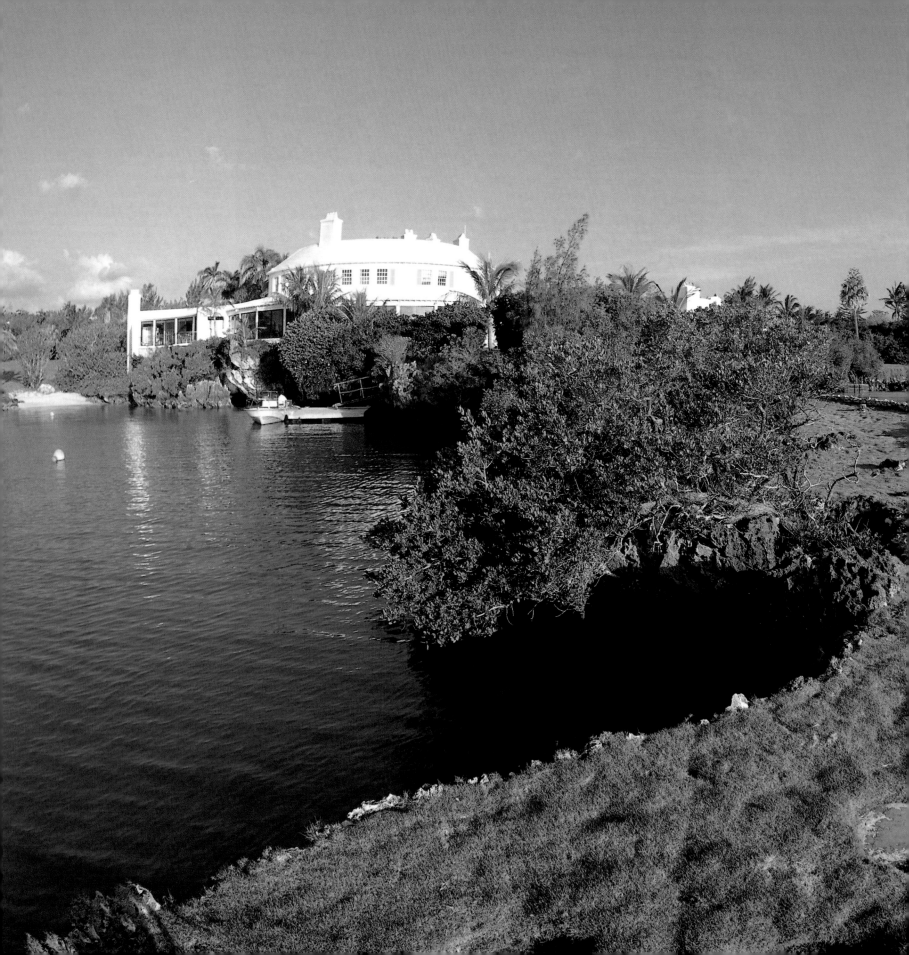

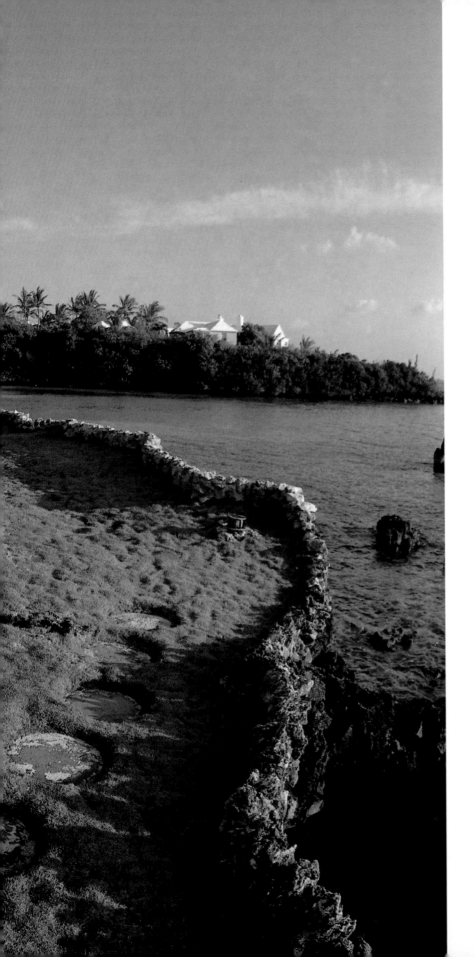

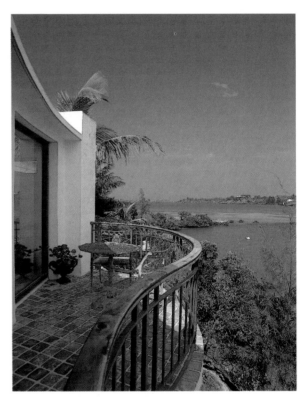

The view from the bedroom
balcony at Round House,
built for an American,
David Milton, in 1936.

Round House, in Tucker's
Town, seen from Lagoon
Point. The deep lagoon, once
a cave whose roof collapsed,
is home to colorful fish.

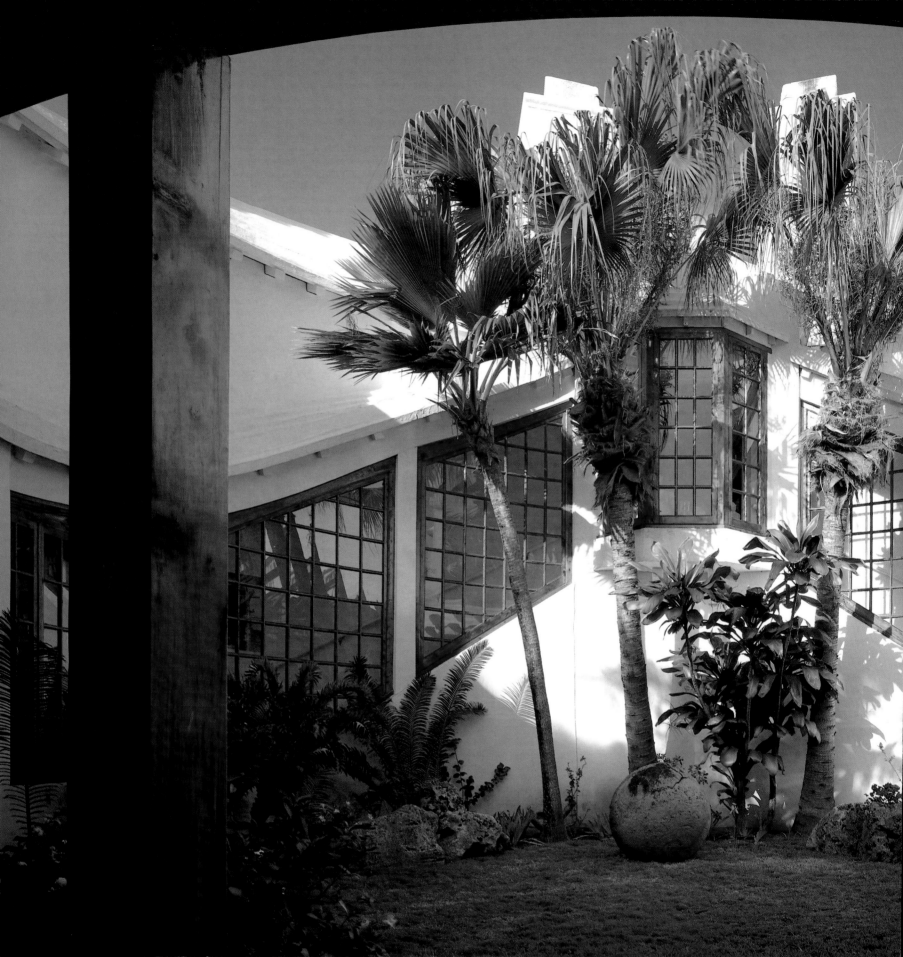

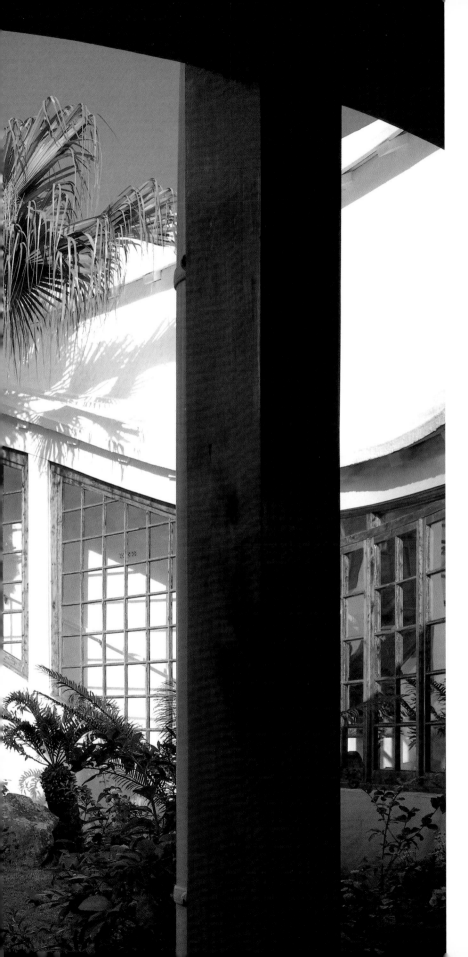

A former owner of Round House embellished the gardens with tropical cycad plants, a palmlike ancient species from Africa.

At Round House, American architect Wallace Harrison combined the flavor of Bermuda's vernacular with streamline moderne details.

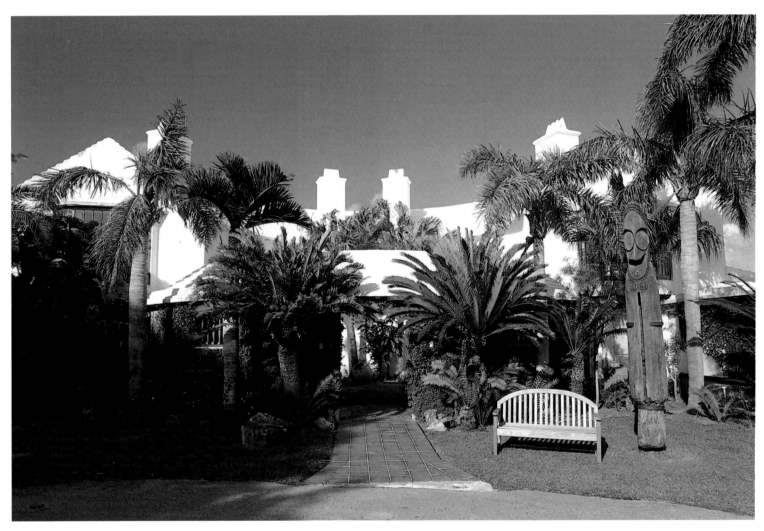

In front of Round House
is a hollow wooden drum
from New Zealand.

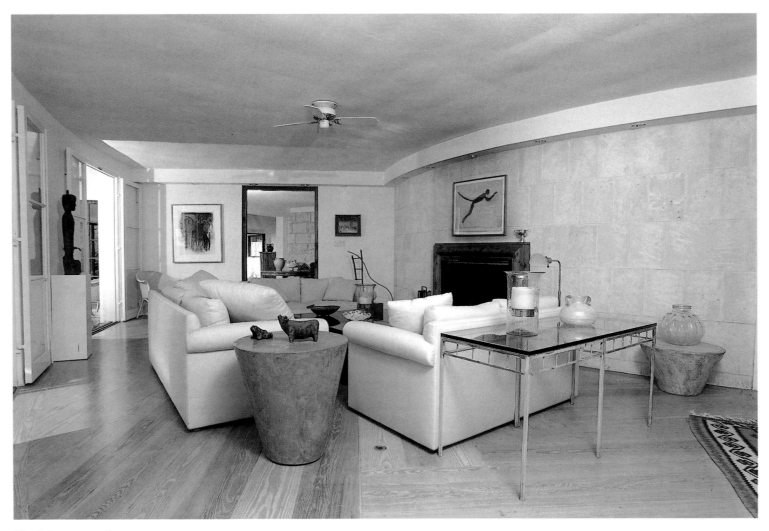

The living room walls
are faced with unpainted
limestone.

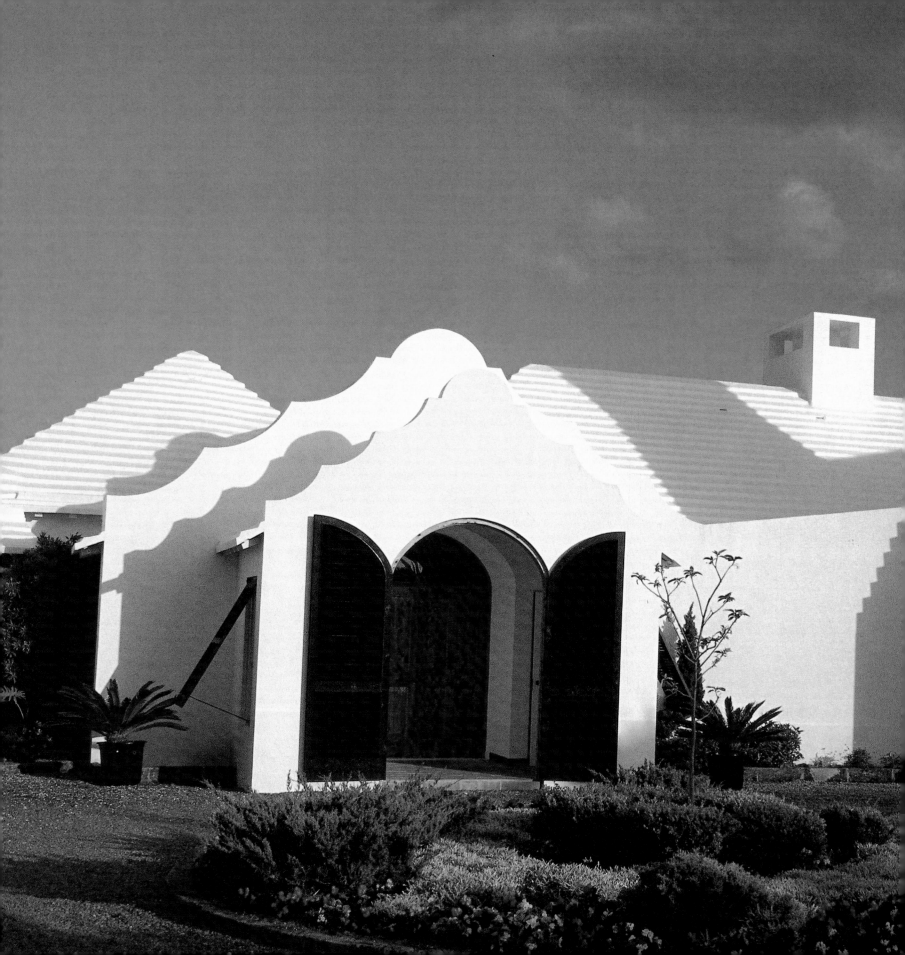

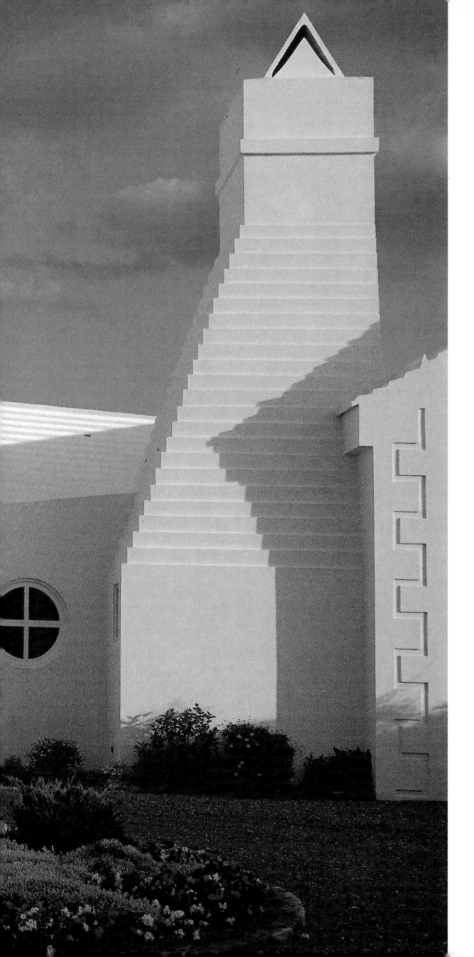

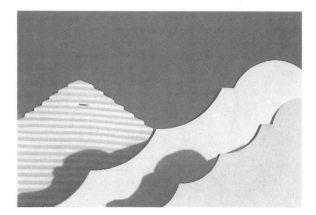

A double Flemish gable was recently added to the entry porch at Vertigo.

Designed by Venturi, Rauch and Scott Brown in 1975, Vertigo is a summer house that sits on a cliff with spectacular views of the South Shore. While following Bermuda's strict planning regulations, the architects used an unorthodox combination of vernacular elements to make a house whose self-conscious grace has attracted international critical acclaim.

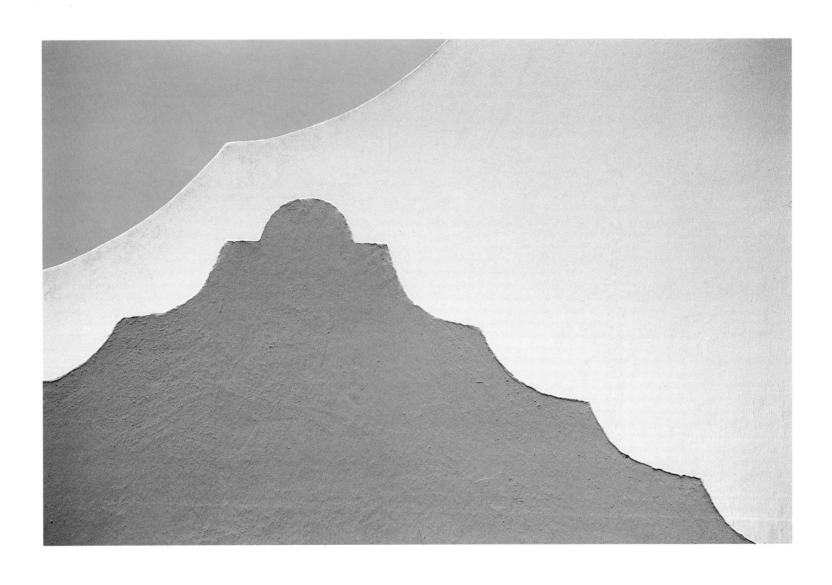

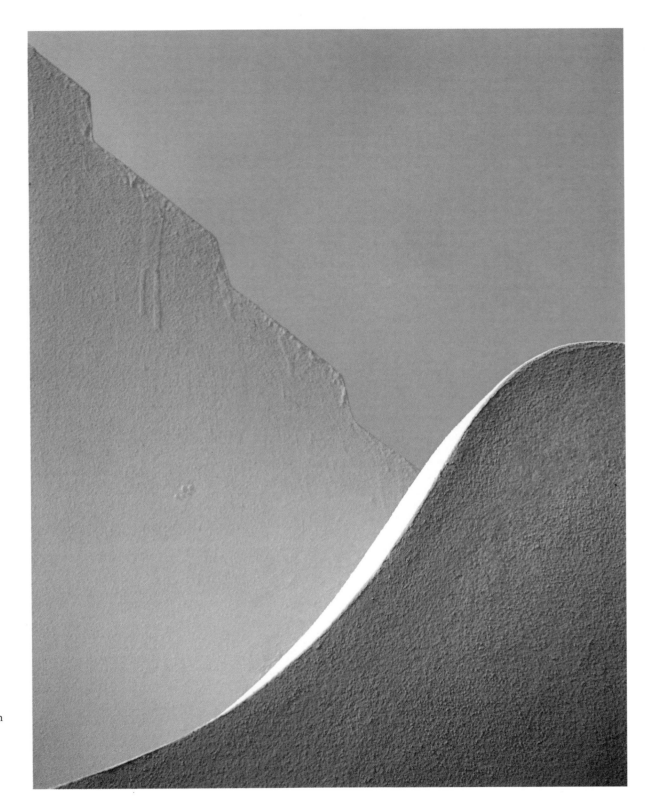

OPPOSITE AND RIGHT:
Bermuda's soaring Flemish
gables are part of the
vernacular tradition that
began in the seventeenth
century.

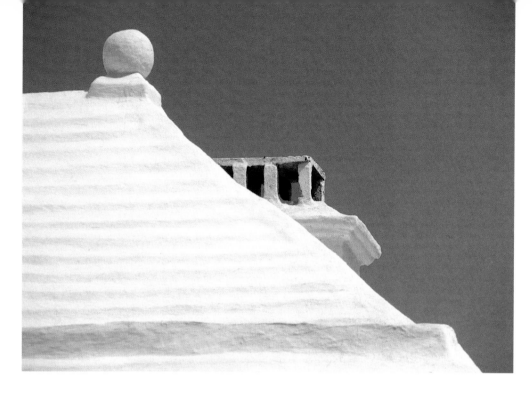

LEFT: Tom Moore's chimney.

BELOW LEFT: Murrell's Vale chimney.

BELOW: Nineteenth-century chimney at Boaz Island.

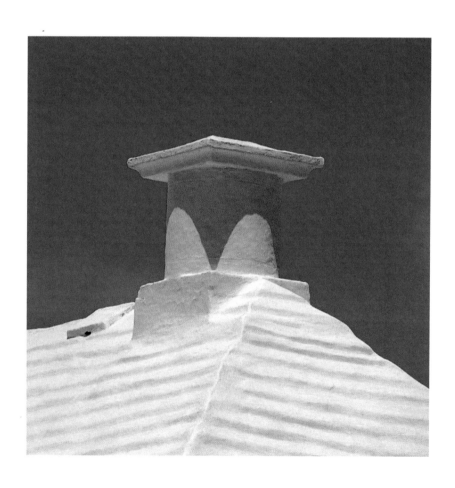

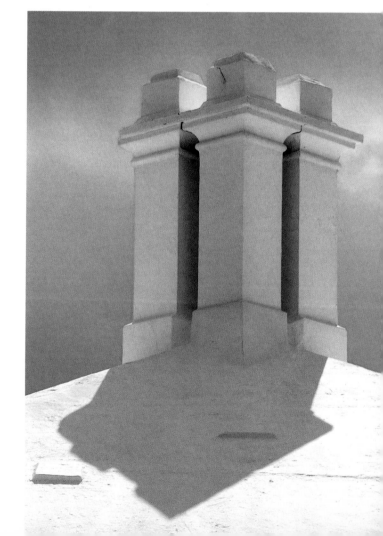

182

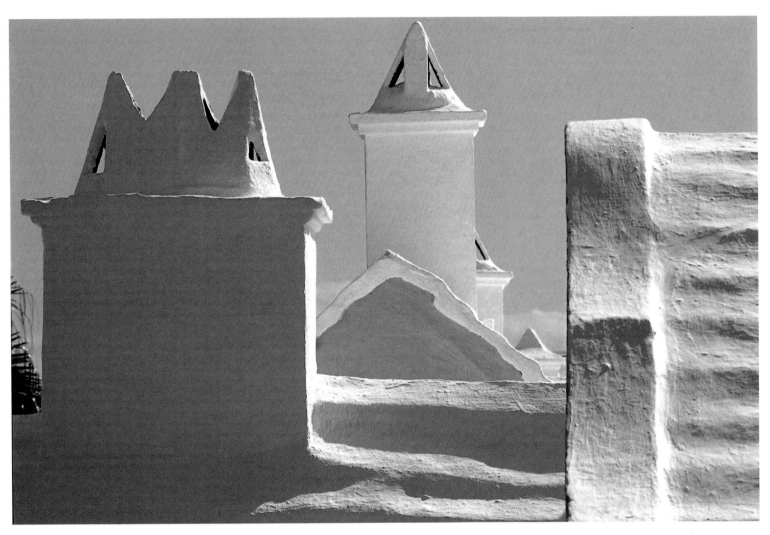

Fourways chimneys. Capped to keep the rain out, and to give a better draught to the fire, many of Bermuda's chimneys serve working fireplaces. In winter, the fragrant smell of burning cedar fills the night air.

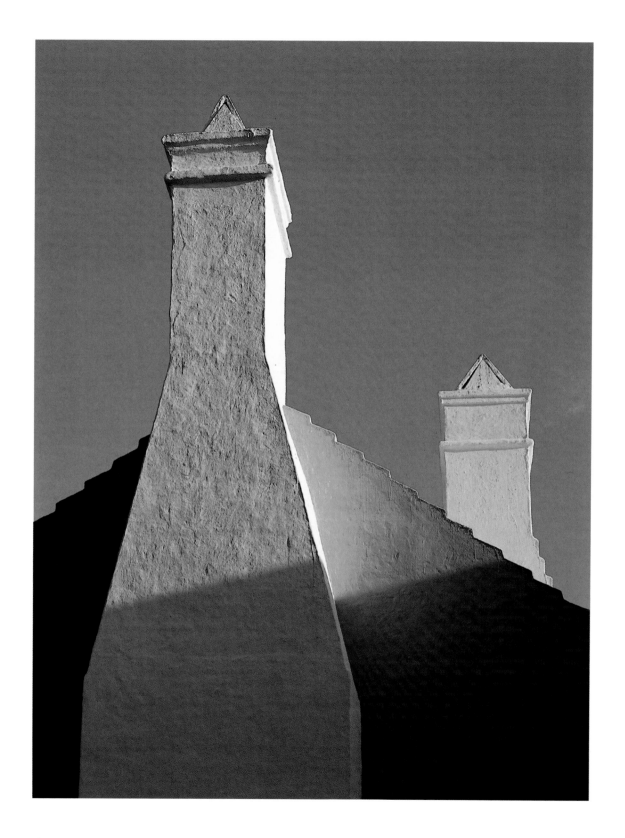

Devondale chimney.

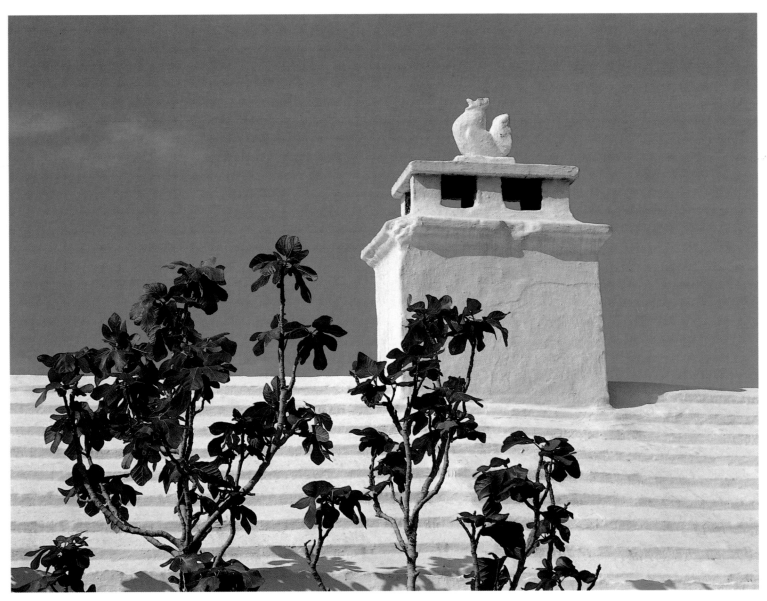

Cluster Cottage chimney.

Bermuda's louvred wooden
shutters provide a shady
habitat for lizards.

An angelfish is
cut into the solid
shutters at
Hampton Head.

The garden at Saltwinds,
seen through the screened
sash window.

Tomatoes ripen in a cottage
window in St. George's.

Maria's Hill, the eighteenth-
century rectory of St. John's
Church in Pembroke.
The house and its outbuild-
ings form a splendid
cluster of traditional forms.
The vaulted tank for water
storage is still in use.

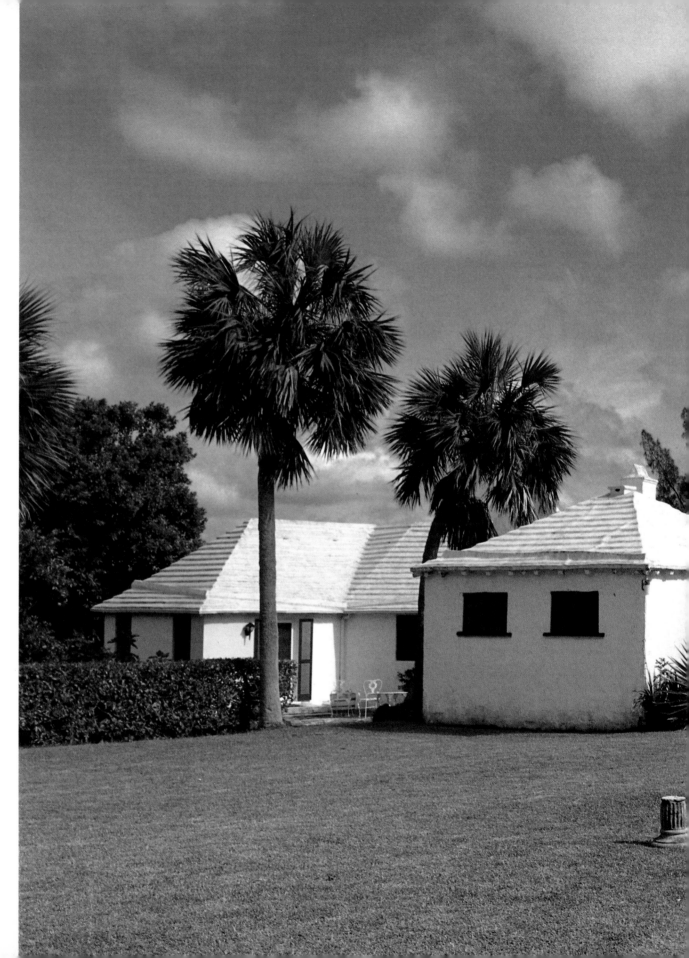

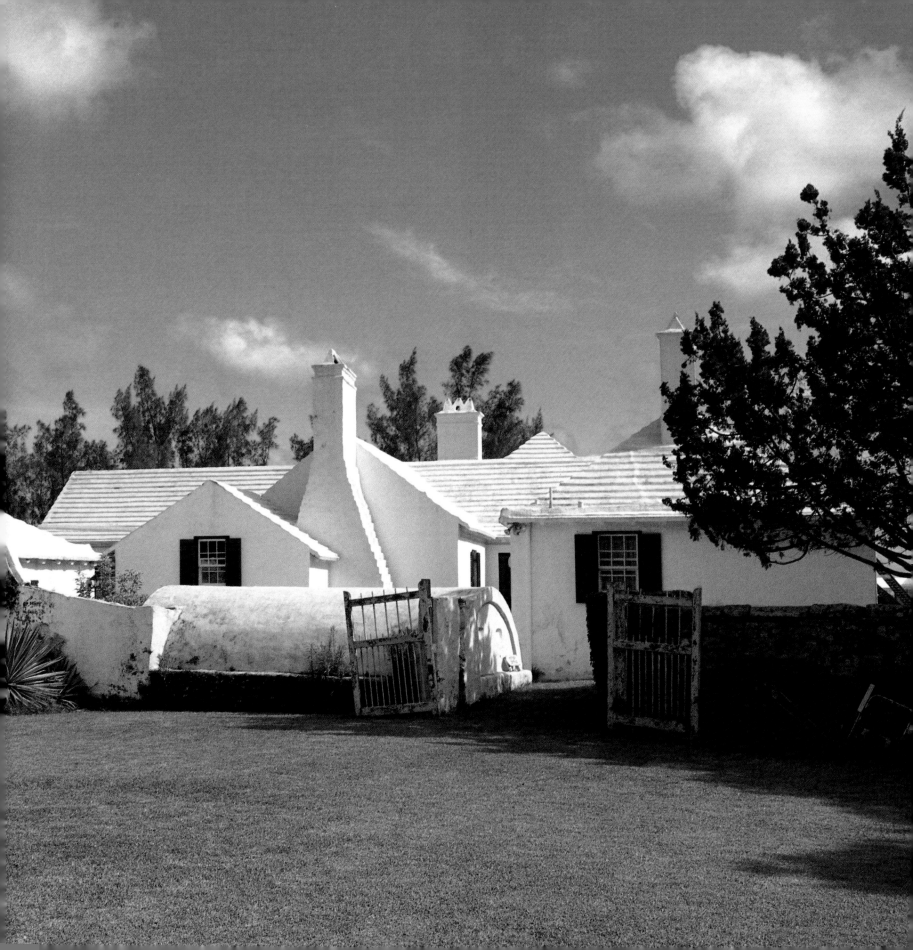

St. John's churchyard in the
evening light.

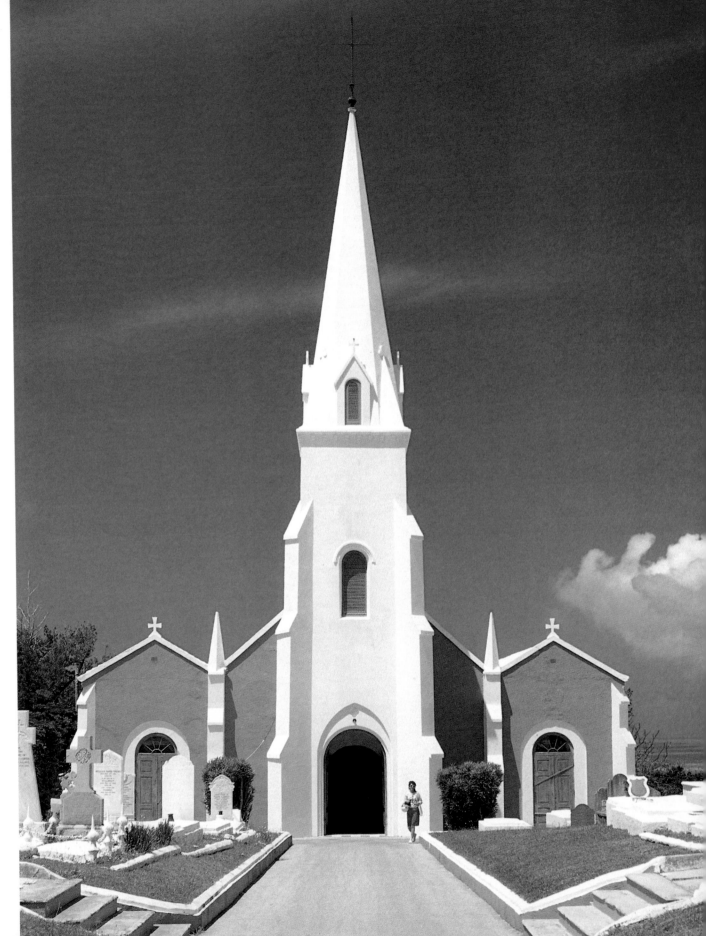

Like an iced wedding cake,
St. James Church (1789)
in Sandys's Parish stands
proudly against the sky.

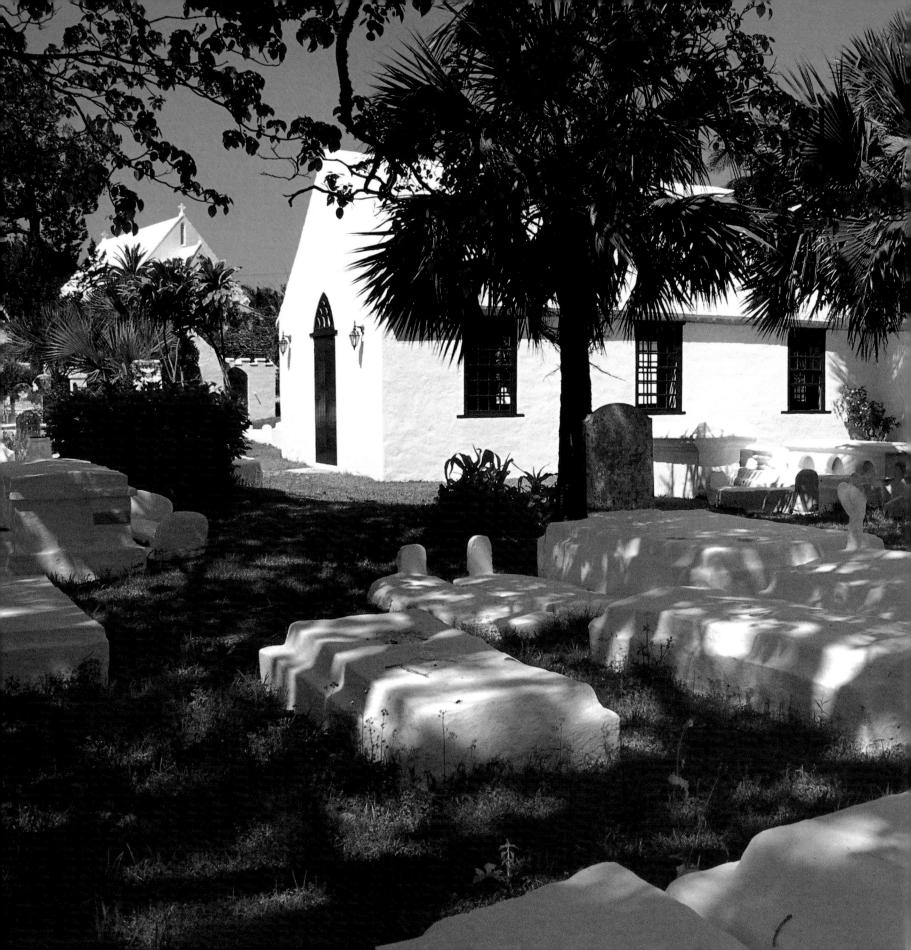

A simple double grave for a
husband and wife.

Dappled light in the
graveyard of Old Devonshire
Church, built from 1716.
Limestone vaults and tomb-
stones are whitewashed
regularly.

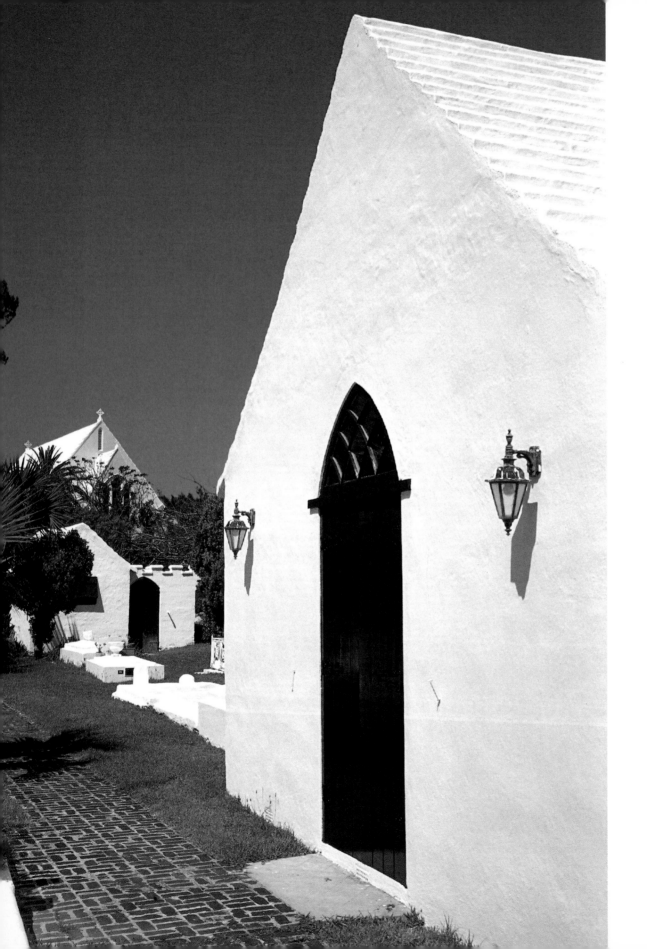

The Gothic door of
Old Devonshire Church.
Nineteenth-century
Christ Church, built for
an enlarged congregation,
is in the distance.

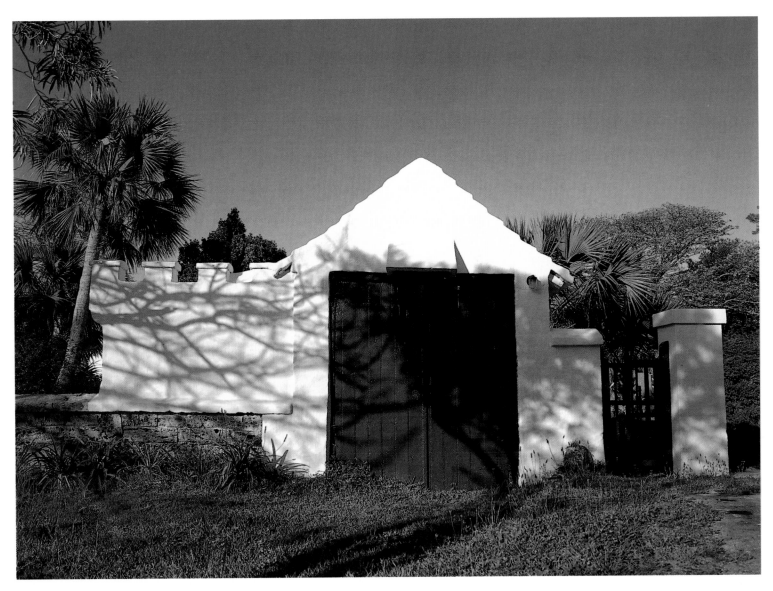

The carriage house door at
Old Devonshire Church
has slits for the long shafts
of a horse-drawn hearse.

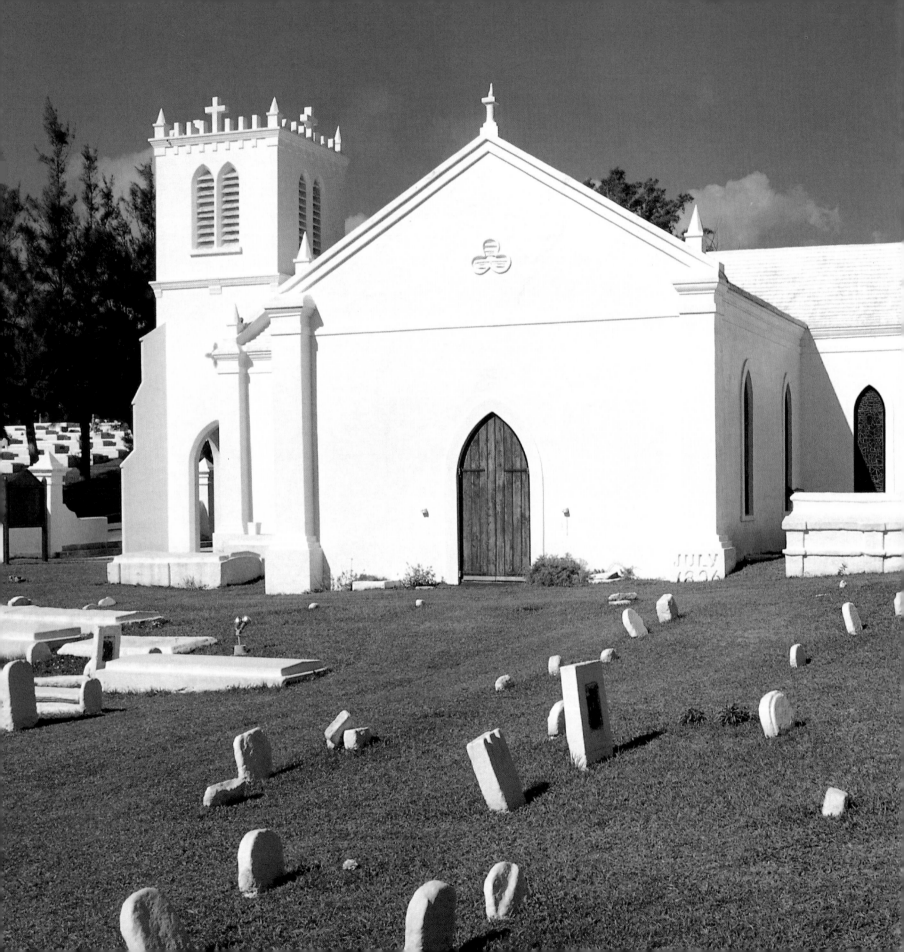

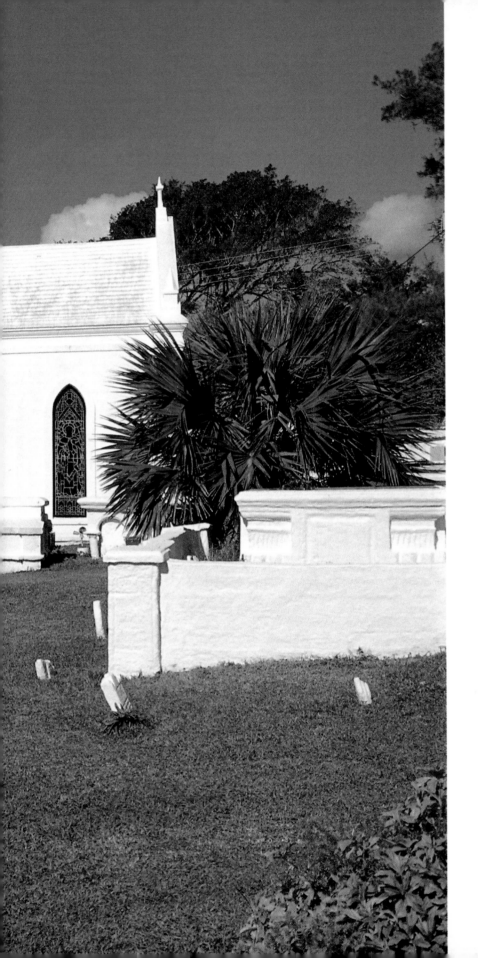

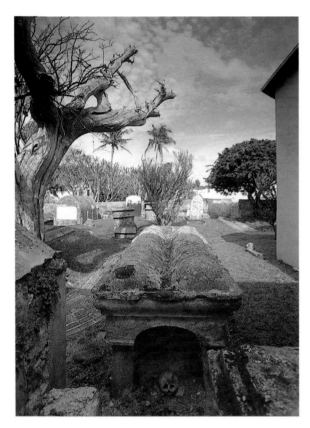

A vault in St. Peter's, beneath a standing dead cedar tree, has a carved skull, a grim reminder of man's mortality.

St. Anne's Church in Southampton was built in 1826. Its graveyard is dotted with weathered markers from an earlier church on the site.

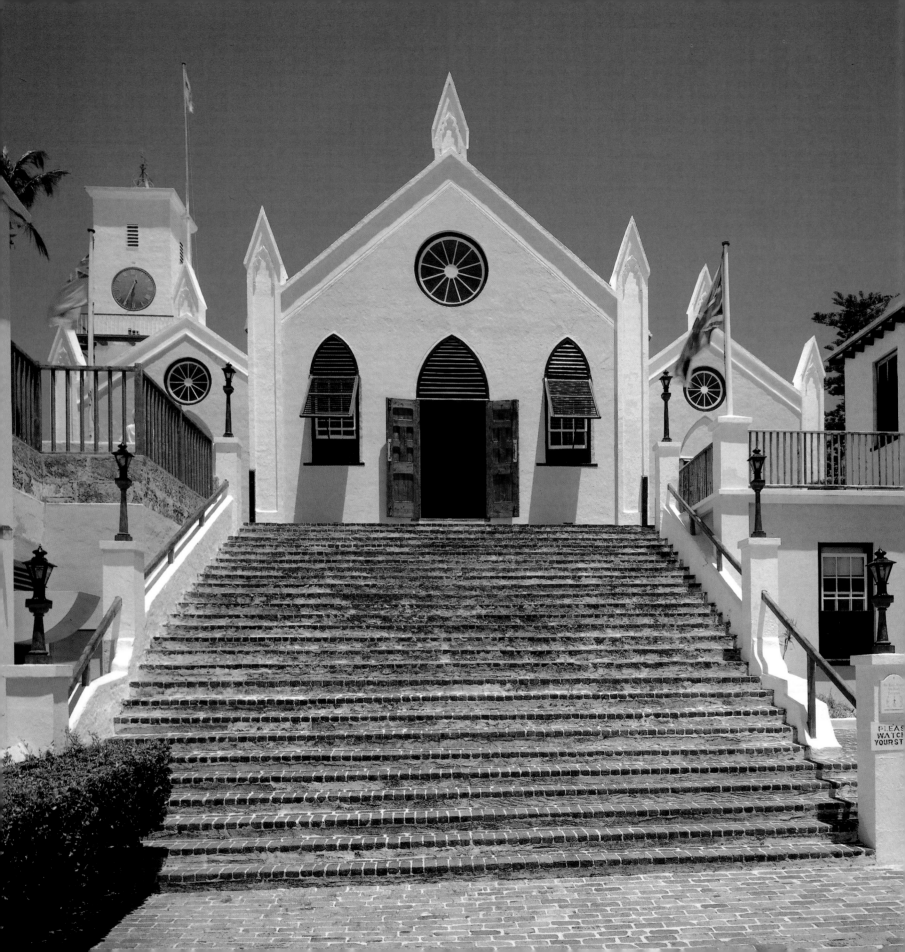

Bermuda's first church,
on the present site of
St. Peter's, was a framed
wooden structure with
a thatched roof. There has
been a church on the land
continuously since 1612.
St. Peter's was enlarged and
remodeled in the nineteenth
century in a local version
of ecclesiastical Gothic.

The stone moldings on
St. Peter's are picked out
in whitewash.

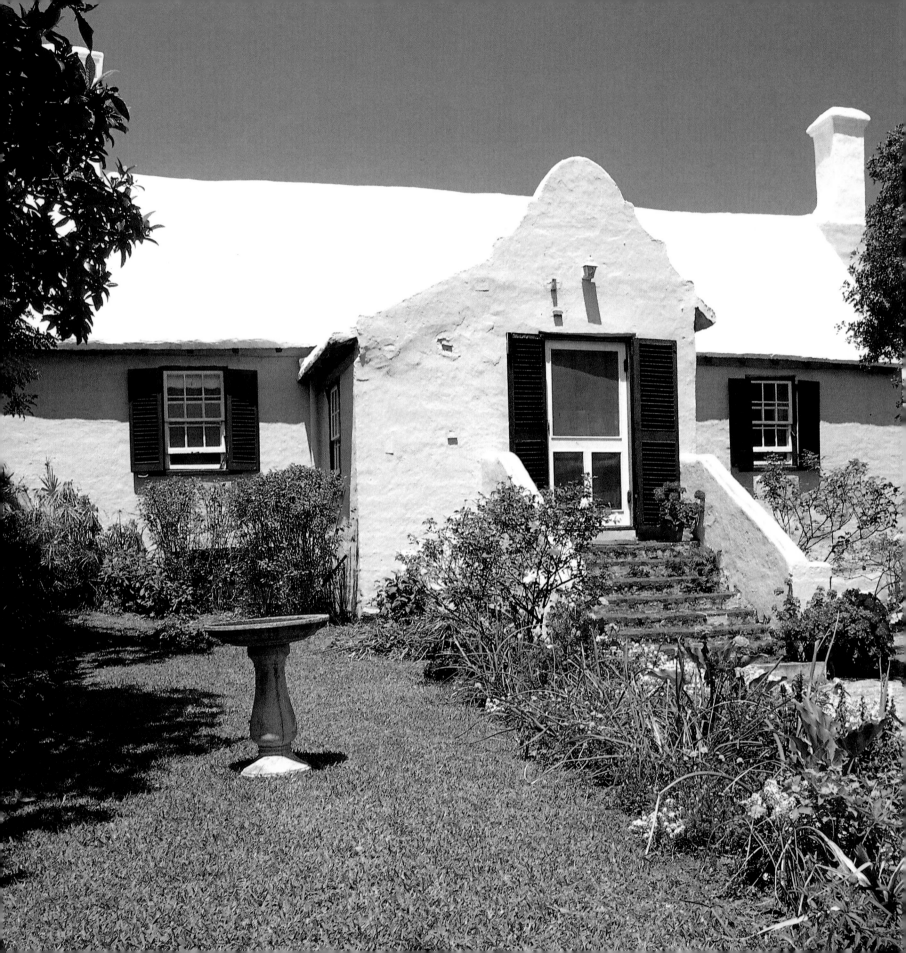

Bermuda's Easter lilies.

The charming Old Rectory
of St. Peter's, a hall-and-
chamber house from the
late seventeenth century,
is owned today by the
Bermuda National Trust.
A path in the bedrock leads
through the flower garden.

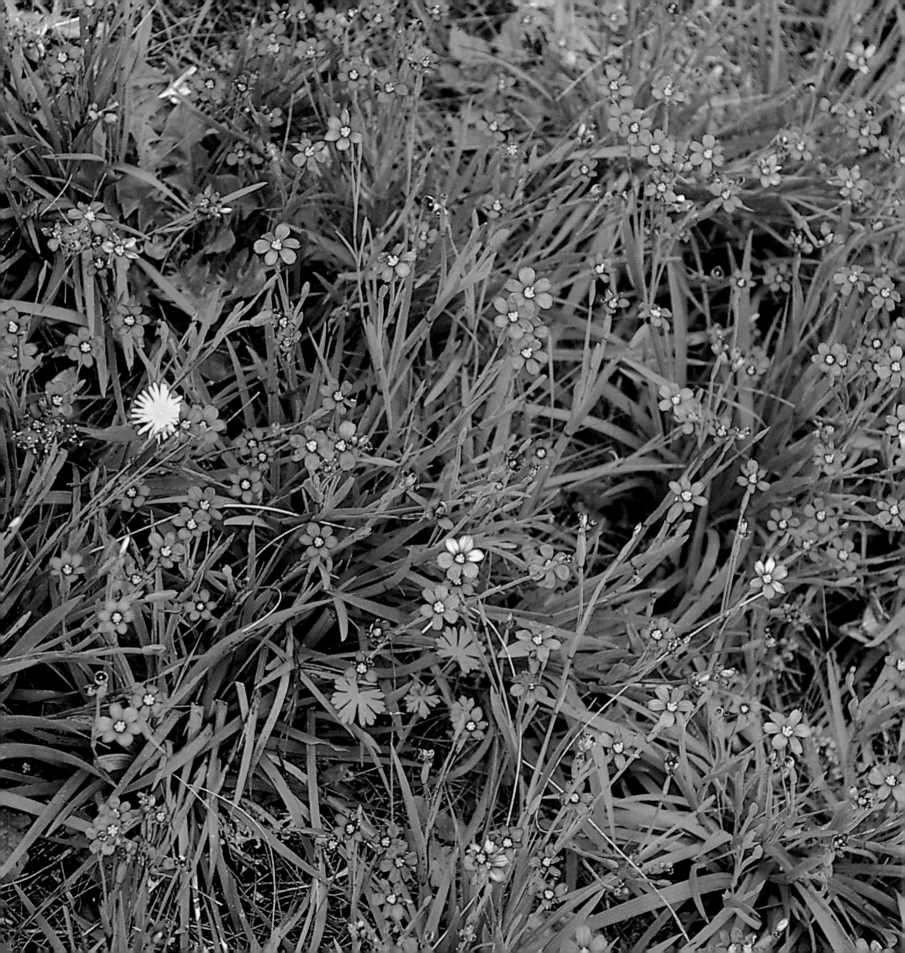